GREAT GOTHIC
CATHEDRALS
OF FRANCE

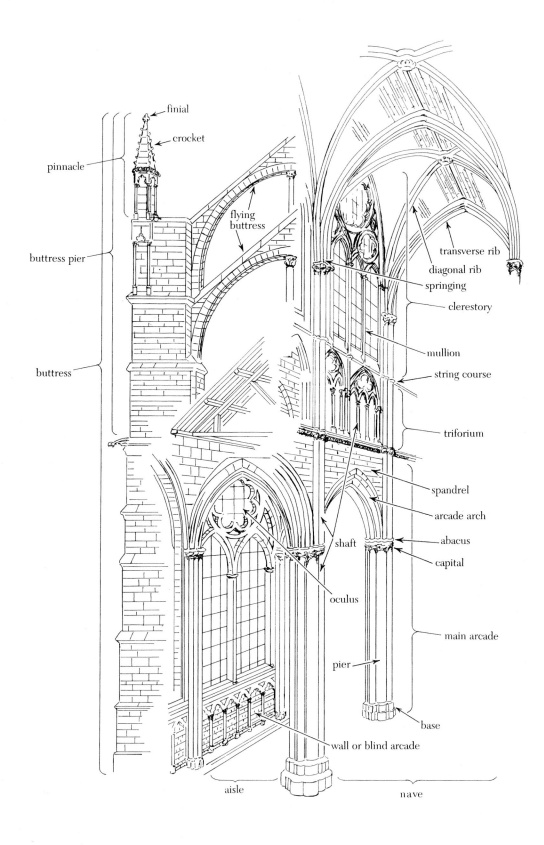

finial

crocket

pinnacle

buttress pier

flying
buttress

buttress

transverse rib

diagonal rib

springing

clerestory

mullion

string course

triforium

spandrel

arcade arch

abacus

capital

shaft

oculus

main arcade

pier

base

wall or blind arcade

aisle

nave

GREAT GOTHIC CATHEDRALS OF FRANCE

STAN PARRY

VIKING STUDIO

VIKING STUDIO
Published by the Penguin Group
Penguin Putnam Inc., 375 Hudson Street,
New York, New York 10014, U.S.A.

Penguin Books Ltd, 27 Wrights Lane,
London W8 5TZ, England

Penguin Books Australia Ltd, Ringwood,
Victoria, Australia

Penguin Books Canada Ltd, 10 Alcorn Avenue,
Toronto, Ontario, Canada M4V 3B2

Penguin Books (N.Z.) Ltd, 182-90 Wairau Road,
Auckland 10, New Zealand

Penguin Books Ltd, Registered Offices:
Harmondsworth, Middlesex, England

First published in the United States by Viking Studio,
a member of Penguin Putnam Inc.

First Printing, March 2001

10 9 8 7 6 5 4 3 2 1

Copyright © Stan Parry 2001
All rights reserved.

Map titled *Principal Regions of Capetian France* Copyright © 1995. From *Medieval France, an Encyclopedia*, William W. Kibler and Grover A. Zinn, eds. Reproduced by permission of Taylor & Francis/Garland Publishing. http://www.taylorandfrancis.com

CIP data available

Book designed by Marilyn Rey
Printed and bound by Dai Nippon Printing Co., Hong Kong, Ltd.

ISBN: 0-14-029707-3

**For my wife Melinda
and my sons Jeff and Chris
with all my love**

ACKNOWLEDGMENTS

Researching and writing this guidebook has been one of the most enjoyable journeys of my life. I want to thank the staff of the Caisse Nationale des Monuments Historiques et des Sites, Agence photographique in Paris, and Blanche Legendre in particular, for their diligent and kind assistance in selecting photographs from their vast archives. Judith Förstel of the Direction Régionale des Affaires Culturelles, Picardie (DRAC, Picardie), has been most generous in sharing her extensive knowledge and providing me with photographs and documentation on the northern cathedrals. I also wish to thank Marilyn Rey for the drawings in this book.

Unless otherwise indicated in the captions, all of the photographs are my own.

It has been my great privilege to work with Cyril I. Nelson of Penguin Putnam Inc. as my editor. His vision, knowledge, and insight in creating this book have been absolutely crucial, and I am deeply and personally in his debt. I will never forget the generosity and expertise with which he has brought this project to fruition.

There is no adequate way to express my appreciation to my wife Melinda for her years of support, encouragement, and understanding in what has been a labor of love for both of us in every sense of the word. Her knowledge of art and architecture has been the foundation from which I was able to explore Gothic architecture.

CONTENTS

PREFACE

The fall of 1985 was effervescent throughout northern France. The hills and vineyards of Burgundy were luminous from dawn until dusk. The dark clouds over the blue-gray hills of the Morvan at Vezelay created a marvelous sunset and the air itself felt like champagne. And yet, as we drove out of the western hills of Burgundy, across the Loire at Nevers, and onto the vast central plain of the Berry, rain descended in great sheets. We headed for the ancient cathedral town of Bourges at the geographical center of France.

I have the clearest possible memory of rushing past the five gabled portals on the west façade and exploding dripping wet into the nave of the Cathedral of Saint-Étienne. Inside, the experience was like being struck by lightning and being physically transported into another dimension of time and space. I had come home for the first time. The soaring arches with thin colonnettes, rising up to the towering vaults that seemed to billow down the nave almost made us queasy. Before I could reflect on what I was seeing, I intuitively understood that I was in the presence of a purity and genius I had not experienced before. I have tried ever since not to lose that sense of amazement and respect in looking at and thinking about Gothic architecture. And I have tried not to remain so distant and clinical that I, and hopefully the reader, remain unmoved by what we are seeing.

There are several fine general histories of Gothic architecture. Nevertheless, I felt there was a need for a personal guide to French Gothic cathedrals that gives the intelligent and informed visitor some practical assistance as he or she moves among the bones of these great buildings. I want readers to understand how the buildings were created, where one might sit or stand while contemplating certain aspects of the interior, how to relate the exterior to the interior structure, and how to appreciate the incredible ingenuity and experimentation that caused Gothic architecture to sweep across northern Europe during the twelfth and thirteenth centuries.

I have written this book because I could not find a guidebook that could help inquisitive travelers appreciate and understand what they are seeing. Most general guidebooks give brief descriptions of the history and structure of these buildings, but they do not have enough space to lead a visitor through the architecture, sculpture, and stained glass that surround them. That is my purpose.

Architectural historians have become more and more concerned with the specific archaeology of particular cathedrals and seem to have become skeptical of attempts to put together "grand syntheses" of the development and flowering of Gothic architecture. These new studies are extremely well researched and written and I recommend them to anyone with an interest in finding out how the buildings were actually constructed. However, they do assume a fairly broad knowledge of medieval art and history. I recently attended an all-day seminar for the general public on Gothic architecture and was struck by the fact that until the final speaker, a musicologist, no one had used the word "beauty."

We must never forget that we look back to the Middle Ages through nearly eight hundred years of history—and particularly the twentieth century—that shape our thoughts and perspective. We can only speculate as to what it was like to experience these buildings for the first time. We cannot fully comprehend how these buildings were used and what they meant to the society of the times. It is a humbling experience. It is also one of the most stimulating and satisfying experiences we can have.

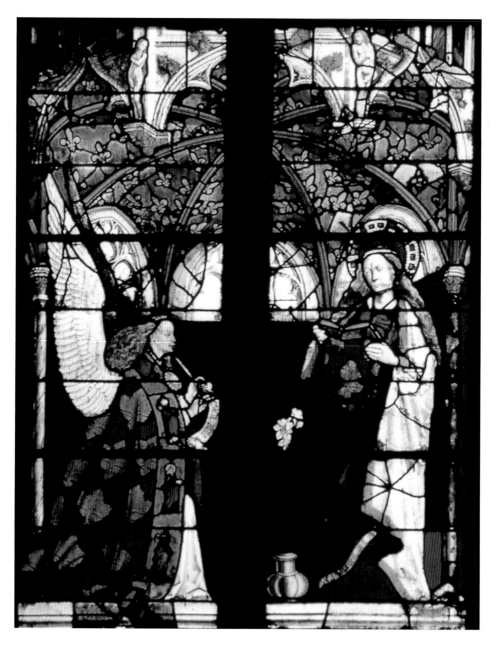

Detail of the Annunciation Window at Bourges Cathedral (see fig. 55).

INTRODUCTION

Great architecture, like most great art, comes from a dynamic and continuous interaction of technique and vision, of solving the practical problems of construction, and expressing a transforming imagination. To focus on one to the exclusion of the other is to deny the very nature of the creative act. In many ways, Gothic architecture, as it arose in the twelfth century, was the result of great technical innovation: the bringing together of the ribbed vault, the pointed arch, and finally the flying buttress. While the experimentation with the ribbed vault may have been the driving technical force, it was joined with equal energy by the need for a transcendental architecture to meet the religious and political requirements of an emerging French monarchy and nation.

Although it is true that Gothic architecture is profoundly different from its antecedents and successors, the medieval worshiper entering these great, soaring buildings would have found much that is familiar. "The bay system remains prominent, defined by columnar and vaulting elements obviously descended from the earlier period. Similarly, the basilican scheme of the church, its tripartite elevation, the plan of its eastern parts, are familiar medieval themes. Yet, having recognized the building's link with the past, the visitor would have been struck even more by its originality. The Romanesque wall, the layers upon layers of heavy structure, and the closed surfaces of Romanesque vaults have given way to skeletal forms."[1]

The Gothic format still has a major influence on our religious buildings, although modern technology has allowed architects to design great open auditoriums of concrete, steel, or even glass without side aisles or interior supports. The rose windows, the pointed arches, the stained-glass windows, and particularly the use of space and light are often the hallmarks of our religious buildings.

Nevertheless, visiting a Gothic cathedral can be a confusing and intimidating experience. The sheer size of the principal Gothic cathedrals can overpower us in a single moment. The kaleidoscopic effect of the stained glass, the sculpture, the arcades, and vaults opening up in every direction can startle us to such a degree that it is hard to gain our bearings. We can end up wandering aimlessly about, gazing blankly at one feature or another and leave both stunned and defeated. Many of the greatest Gothic cathedrals are also difficult to see because they are crowded and can be somewhat dark. Two of the most familiar and accessible, Chartres and Notre-Dame of Paris, are relatively dark churches and are usually quite crowded. In the dimness and confusion it is difficult to get a sense of the whole; we may focus on a few noteworthy details before we retreat to the outside.

In fact, these two great buildings are not entirely representative of other French Gothic cathedrals. Amiens, Beauvais, Bourges, Laon, Saint-Denis, and Soissons are great structures in which both light and space immediately draw us to their embrace. Even so, these great masterpieces of architecture cannot be read and understood in an easy glance. They require some preparation and some time. In return these cathedrals will be endlessly rewarding.

AN AGE OF EXPERIMENTS

One may say that the twelfth century was the great age of the Gothic experiments.[2]

The twentieth century was an epoch of transforming inventions: the airplane, automobile, radio, television, antibiotics, nuclear energy, and now the computer have completely changed the modern era. For the past hundred years the world has been and will continue to be remade by remarkable inventions. This book is about the consequences of a transforming invention of the Middle Ages, the ribbed vault, which led to a series of architectural experiments of transcendent vision that changed the very nature of architecture for all time. Totally eclipsing all previous architecture, the Gothic style became the quintessential religious architecture in the West.

Prior to Gothic architecture the interior space of even the finest churches "was generally an inert hollow within a massive stone shell. By comparison, the space of Amiens seems active and dynamic, an expansive force that lifts the ceiling high, stretching out the skeletal forms to their extreme thinness. It is as important visually as the stonework."[3] Compare these photographs showing the nave of the Basilica of Saint-Sernin in Toulouse with the south transept of Amiens Cathedral (figs. 1, 2).

It is this quality, in which the space itself becomes as significant as the structure of the building, that inspires us as much as the construction and decoration. In this sense, Gothic is not an ancient, dead relic but alive and modern, speaking to us in very immediate terms.

Looking back over seven hundred years, we tend to think of Gothic architecture as an unfolding vision, slowly evolving over the centuries—a leisurely, preordained process with hundreds of years spent perfecting each cathedral. But Gothic architecture came upon the scene with enormous force and suddenness, and the cathedrals were built fairly quickly.[4] The nobility, clergy, and builders were probably not interested in projects that were going to span hundreds of years. They were building for immediate religious and community needs as well as for the glory of God and posterity. They poured enormous resources into achieving their results within the horizon of living memory.

Amiens Cathedral, a colossal structure, was fully completed in fifty years (1220 to 1269). Chartres and Bourges, the two gigantic beginnings of High Gothic, were more or less finished within seventy-five years. Naturally, the cathedrals continued to be worked on, added to, and remodeled as tastes and techniques changed. Work started and stopped many times, depending on finances, political turmoil, or social stability, but generally they were built in a relatively rapid manner, considering the size of the projects and the elementary nature of the construction techniques. Even in terms of modern construction projects or the building of the principal cities of the twentieth century, it is staggering to realize that these same incredible feats of construction were going on all over France, not simply at Chartres and Reims, or at Paris and Amiens. Across western Europe a great industry came into being to support the gargantuan enterprise of the Age of Cathedrals.

While Gothic did not entirely eliminate the old Romanesque forms in one full sweep, inasmuch as Romanesque churches continued to be built well into the thirteenth century, Gothic certainly began to dominate the scene in a relatively short period. The major cathedrals of France were primarily Gothic after 1150. There was, however, resistance to the new architecture within the Île-de-France and particularly in the rest of France well into the thirteenth century. At every stage of development, older forms competed with new techniques and artistic styles. Often there was a fusion of the archaic and the modern, the conservative and the progressive. As we look back we may think that we see an orderly logical progression, but in reality both the Romanesque and Gothic styles were the result of constant and continuing experimentation.

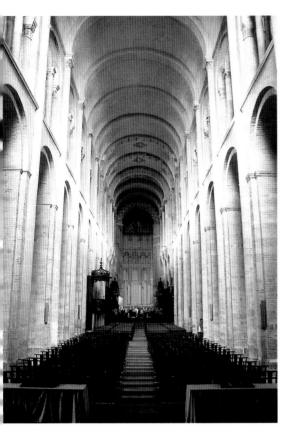

1. Toulouse, Basilica of Saint-Sernin, nave, after 1100.

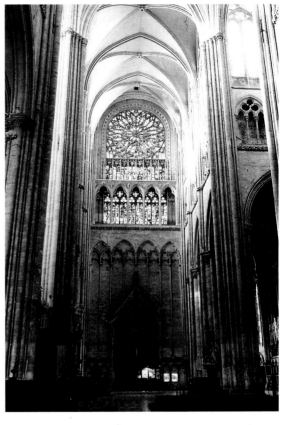

2. Amiens, Cathedral of Notre-Dame, crossing and south transept, ca. 1260s.

HISTORICAL BACKGROUND

In the eighth century, Charlemagne finally brought the beginnings of stability to what are now France and western Germany. He modeled his empire on Roman law and institutions and created a renaissance of learning. Nevertheless, his empire, divided among his sons and grandsons, disintegrated within two generations after his death.

The Norse raids on western Europe in the ninth century ushered in another period of disarray. The Norsemen gained control over what is now Normandy, where they and the Franks established so vigorous a society that it was able not only to subjugate Sicily and southern Italy but also to invade and conquer England in 1066. The majestic cathedrals at Cefalú and Monreale in northern Sicily, begun in 1131 and 1172, reflect the fusion of Norman and Byzantine styles.

The Romanesque period from the late tenth to the middle of the twelfth century coincided with the final containment of Islam in Spain, the Normans in western France,

3

and the defeat of the Magyars by Otto the Great in 934 and 955.[5] Although there was continuous conflict, the subsequent stability and the ordering of society by the establishment of feudalism and changes in agriculture led to an expansion of the population and commercial activity.

New religious or political institutions came into being during this time of development and prosperity. Monasteries, cities, universities, international trade, improved farming, and a variety of crucial activities have their roots in this period. Many of the basic institutions that have survived into the twenty-first century came into prominence in the eleventh and twelfth centuries.

In France the Capetian monarchy was established, but the country, fragmented into a variety of powerful independent duchies, was still far from what we envision as a nation-state. Louis VI brought peace to the Île-de-France by subduing the fractious little kingdoms surrounding Paris, and his grandson, Philip II (Philip Augustus), expelled the English from Normandy, Brittany, and most of the land north of the Loire River by the end of his reign in 1223. During the twelfth and thirteenth centuries the Capetians gained control over western France with the exception of Guyenne in the south and Calais on the English Channel. It would take hundreds of years of discord and warfare before Champagne, Burgundy, and the rest of eastern France were incorporated into the French nation (fig. 3).

The establishment of the celebrated Romanesque abbey at Cluny in Burgundy in the middle of the tenth century created a major reform of the church and established in France a political and economic force to rival and even exceed the power of the papacy. The third church at Cluny, known as Cluny III, was the largest church in all Christendom, exceeding old Saint Peter's in Rome. Cluny was the mother abbey of a vast network of Benedictine monasteries covering all of western Europe. During this period, the French church was dominant, and the Pope tended to be French rather than Italian, as has been the practice in modern times.

In order to shore up a faltering papacy, Pope Urban II launched the First Crusade in 1095 to defeat the Seljuk Turks who were threatening Constantinople. The First Crusade saw the establishment of the Frankish kingdom in Palestine with Jerusalem as its capital. The Second Crusade in 1147 was mobilized to lend support to this little realm that was always at risk. Crusades of one sort or another continued fitfully over four centuries. As a result, western Europe came into contact with the art and commerce of the Near East. Exposure to the pointed arch of Islam and the stylistic intricacies of Byzantine and Islamic art had a profound effect on sculpture and painting as well as architecture.[6]

One of the central experiences in medieval life in western Europe was the arduous pilgrimage to the burial site of the Apostle Saint James at Santiago de Compostela in northwestern Spain. Charlemagne had tried to regain Spain from the Moors in order to be able to make the pilgrimage, but he was driven out of northern Spain. The story of Roland's death at Roncesvalles, as Charlemagne retreated over the Pyrenees, became one of the most important legends of the Middle Ages. It was not until the tenth century that the pilgrimage to Santiago de Compostela became established as the duty of every Christian. It was as influential as the Crusades as a religious experience and one that led to the creation of major pilgrimage routes across the face of France.

Out of this came the remarkable pilgrimage churches at Tours, Limoges, Toulouse, Moissac, and Conques. Because Santiago de Compostela was under the control of Cluny, the important churches along the route have a very similar style and, along with Cluny III, became major monuments of Romanesque architecture.

THE IMPORTANCE OF TRADE
In the eleventh and twelfth centuries trade began to expand at a significant rate, which

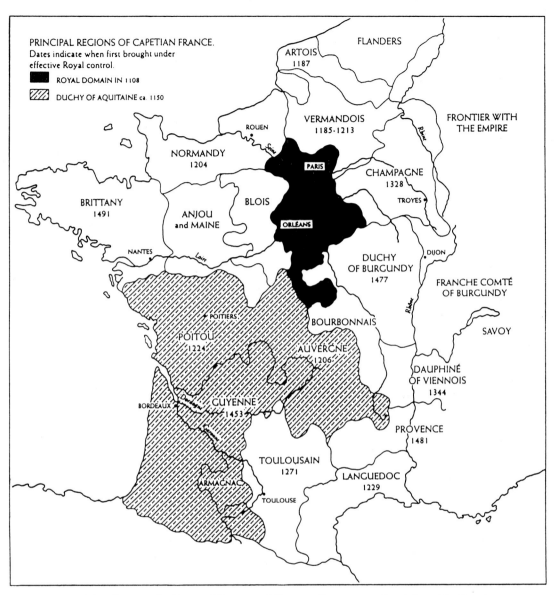

PRINCIPAL REGIONS OF CAPETIAN FRANCE.
Dates indicate when first brought under
effective Royal control.

■ ROYAL DOMAIN IN 1108
▨ DUCHY OF AQUITAINE ca. 1150

FLANDERS

ARTOIS
1187

VERMANDOIS
1185-1213

FRONTIER WITH
THE EMPIRE

ROUEN

NORMANDY
1204

PARIS

CHAMPAGNE
1328

TROYES

BRITTANY
1491

BLOIS

ANJOU
and MAINE

ORLÉANS

DUCHY
OF BURGUNDY
1477

DIJON

NANTES

FRANCHE COMTÉ
OF BURGUNDY

SAVOY

POITIERS

POITOU
1224

BOURBONNAIS

AUVERGNE
1206

DAUPHINÉ
OF VIENNOIS
1344

BORDEAUX

GUYENNE
1453

PROVENCE
1481

TOULOUSAIN
1271

ARMAGNAC

LANGUEDOC
1229

TOULOUSE

3. Map showing the Principal Regions of Capetian France, reproduced from *Medieval France, an Encyclopedia.*

had a profound effect on society and culture. The old system built around the self-contained manor began to break down under a variety of influences. Farming methods improved with new understanding about replenishing the soil with legumes and fertilizing with manure and ash. Crossbreeding improved the quality of livestock. Marshes and forests were converted to productive acreage. Throughout western Europe, rivers were harnessed, and even the sea was reclaimed. Across northern France trade fairs became important events for the exchange of goods from England to Italy and even beyond. An active trade route developed from London through Picardy, around the

5

north of Paris and through Burgundy to Switzerland. During the Middle Ages sea trade expanded. With the improvement of sailing vessels the route through the Straits of Gibraltar to England became a regular avenue of trade from the Middle East and the entire Mediterranean. International trade had existed for thousands of years, but it was during the Middle Ages with the rise of the merchant class that the modern equivalent of commercial trade between nations began.

THE FRENCH MONARCHY IN THE TWELFTH AND THIRTEENTH CENTURIES

From 1108 to 1226 three men ruled France: Louis VI (Louis the Fat, r. 1108–1137), Louis VII (r. 1137–1180), and Philip Augustus (r. 1180–1223), father, son, and grandson, all had unusually long reigns, a total of 118 years. The reigns of Louis VII and Philip Augustus nearly parallel the rise of Gothic from its beginnings at Saint-Denis to the culmination of High Gothic with Amiens Cathedral in the 1220s. In spite of this apparent stability, the Capetian monarchy had to struggle to maintain itself amidst a sea of competing and feuding duchies and principalities, many of which were more powerful than the monarchy itself. Not until the end of the twelfth century, under Philip Augustus, did the Capetians consolidate their power in any permanent sense and even then the struggle with the English and the Burgundians continued for another two hundred years.

After Philip Augustus died in 1223, Charles V reigned only three years. His son Louis IX assumed the throne in infancy and ruled for forty-four years (1226–1270). The Rayonnant style that emerged in the 1230s during his reign has also been called the "Court Style."[7] The Sainte-Chapelle on the Île-de-la-Cité in Paris is one of the supreme achievements of the Rayonnant style.

In the 1130s, when the first important Gothic churches were conceived, France was still very much divided. The Norman Conquest of England in 1066 was not that far removed in time, and it was still uncertain whether France would be ruled from the Île-de-France or from London. Or would both nations be ruled from Caen? Would France become the significant, unified nation we know today or would it be a collection of contested kingdoms and principalities similar to Germany and eastern Europe? Would the Capetians, with their relatively small territory of the Île-de-France, be the dynasty for France or would the Burgundians become supreme? The future was in doubt and would be contested for several centuries. Yet just before the start of building of the Abbey of Saint-Denis and the cathedral at Sens the future looked promising for the Capetians; Duchess Eleanor married Louis VII in 1137, bringing with her the vast and profitable Aquitaine, nearly the entire southwest of France.

After fifteen years of marriage, however, Louis divorced Eleanor, who quickly married Henry II of England and not only gave him sons but also the Aquitaine. It could be said that the King of England was far more powerful on French soil than the King of France. Four hundred years later Henry V would nearly succeed in his claim to the French throne at Agincourt, and the matter would not be fully settled until 1452, when Charles VII finally drove the English from French soil except for Calais.

In spite of this uncertainty, and in spite of the crusades and civil and religious wars, the heartland of France was where one of the most audacious building campaigns of Western civilization began with the Royal Abbey of Saint-Denis, just north of Paris in what is now an industrial suburb. Until the twelfth century, the Île-de-France had not been a particularly fruitful area for architectural endeavors. The notable Romanesque churches of the previous one hundred years rose in Burgundy, Normandy, southern France, and northern Spain—almost everywhere but the area around Paris. We will examine later what gave the French, and the Capetians in particular, the confidence to launch this incredible

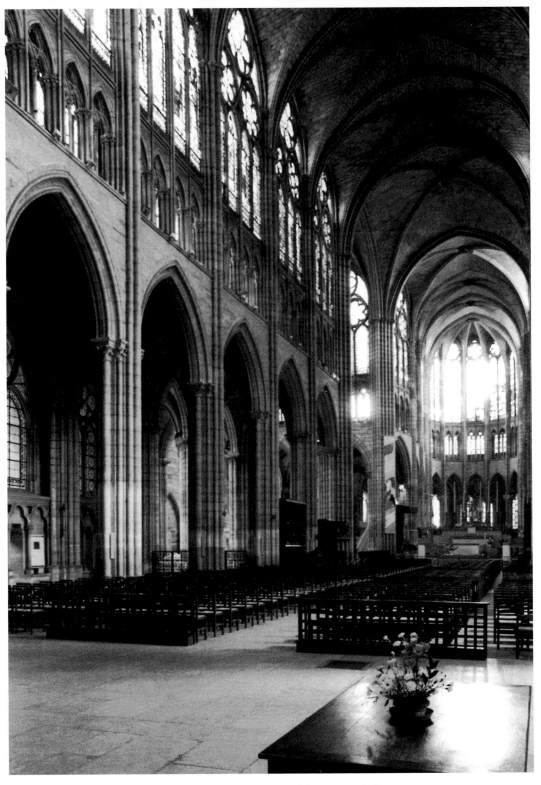

4. Paris, Cathedral of Saint-Denis, interior of the nave and choir, 13th century.

building crusade, which was to dominate Western architectural style for four hundred years.

THE SYMBOLIC AND THE REAL

When the world was half a thousand years younger all events had much sharper outlines than now. The distance between sadness and joy, between good and bad fortune, seemed to be much greater than for us; every experience had that degree of directness and absoluteness that joy and sadness still have in the mind of a child. Every event, every deed was defined in given and expressive forms and was in accord with the solemnity of a tight, invariable life style. The great events of human life—birth, marriage, death—by virtue of the sacraments, basked in the radiance of the divine mystery. But even the lesser events—a journey, labor, a visit—were accompanied by a multitude of blessings, ceremonies, sayings, and conventions.[8]

It is difficult, if not impossible, for us fully to appreciate how the people of the Middle Ages understood the symbolic and the real. We tend to view them as two completely different concepts, distinct and separate from each other. To the twelfth-century worshiper the religious symbols that surrounded him were not merely reflections of another reality; they were the means of experiencing the sacred reality that underlies physical reality. Cathedrals were considered veritable houses of God and the colored light that suffused them was the presence of God. "The Middle Ages lived in the presence of the supernatural, which impressed itself on every aspect of human life. The sanctuary was the threshold to heaven."[9] If we have trouble understanding this concept, it may be enough to recognize that what came together for Abbot Suger at Saint-Denis was the aspiration to bring the divine presence into his church through space and light. His genius was in reconciling both these spiritual and worldly needs. This

is, of course, often one of the primary goals of architects of every age.

The majestic basilica of Saint-Denis is predominantly a thirteenth-century church. All that is left of the original choir is the lower story of the ambulatory, a magnificent semicircle of stone and stained glass. The upper stories of the choir were expanded during the building of the thirteenth-century nave and transept, which were not built until nearly one hundred years after Suger's original choir was erected in the 1140s. It is challenging to imagine a much smaller Carolingian church where the sumptuous tombs of the kings and queens of France now rest beneath a soaring canopy of stone and glass. Instead of the sheets of glass rising above the pointed arches of the thirteenth-century church, we would have been in an extremely dark tunnel-like nave leading to Suger's Gothic choir (fig. 4).

This is one of the many reasons why Suger's choir at Saint-Denis must have been such a startling revelation. Imagine coming through a low and dark nave, with a few small windows, and stepping into a circle of luminous stained glass. Today such an experience might be best compared to going into a darkened movie theater and watching a kaleidoscopic explosion of color on the screen. Many of the space fantasies such as *2001* and *Star Wars* have used the technique of moving, computerized collages to dazzle our senses by surrounding us with constantly changing colored light. To the twelfth-century pilgrim the effect of the ambulatory of Saint-Denis must have been physically and spiritually overwhelming. It is still magnificent today.

ROMANESQUE PRECEDENTS

It has been said that Gothic had no predecessor and no successor, but if you look back from Gothic to Romanesque and even Islamic and Classical architecture, you will find the seeds of Gothic architecture. The basic ground plan of the Gothic cathedral is fundamentally the same as its Romanesque predecessors. A medieval worshiper would

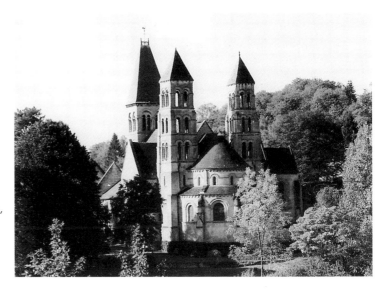

5. Morienval, priory church, exterior, after 1130.

have found himself at home in either setting. The bay system is still a principal feature with its succession of arches and piers. The use of a three-story elevation for the central space is typical of Romanesque churches, as is the arrangement of the eastern portion of the building where the main altar and choir generally are placed. Despite this use of earlier elements, Gothic seems to be a totally new style. Gothic master builders were able to accomplish a complete transformation of the architectural elements into an all-encompassing, transcendental vision of stone, space, and light.

Many of the key elements of Gothic architecture were well known to Romanesque builders. Islamic architects had used the pointed arch for centuries although with a totally different effect from what Gothic builders would achieve. The pointed arch, perhaps the best-known of all Gothic motifs, was beautifully utilized earlier in Burgundy at Cluny and Paray-le-Monial as well as Autun, where classical fluted piers give the Cathedral of Saint-Lazare a precise style that can easily be mistaken for Gothic, but is thoroughly Romanesque.

The ribbed vault was already in use in Italy and England, and by the time of the construction of Saint-Denis in 1137, it was being utilized in Normandy, Picardy, and in Paris at Saint-Martin-des-Champs.[10] Ribbed vaulting

was not yet a common technique, but its time was clearly approaching. Some of the earliest ribbed vaults were built at the exquisite abbey church of Morienval near Soissons (fig. 5).

We tend to view Romanesque as massive, heavy, often squat, and Gothic as light and skeletal. Cluny III, the great abbey church in Burgundy and the largest church in Christendom by the twelfth century, was nearly as tall as the Early Gothic churches of Notre-Dame and Laon. And not all Gothic cathedrals flaunt the skeletal look so commonly associated with the Gothic achievement. Stripped of the fragile-looking flying buttresses of the late twelfth century, the exteriors of most Early and High Gothic churches have a compact quality that relies on the use of solid mass to reinforce the empty core of the building (see fig. 95).

The Romanesque architects of Cluny and Paray-le-Monial were able to achieve remarkable height and size. They were, however, unable to open up the walls of their buildings to the audacious qualities of light and space that were to become the hallmarks of Gothic cathedrals. They had not yet mastered the use of the rib vault, and the discovery of the flying buttress was a hundred years away.

Although there are many Romanesque precedents in Gothic architecture, the very

nature and heart of the two styles are completely different. While they may not be as far apart in feeling and appearance as Victorian and modern architecture, they do seem to come from different times and sensibilities. Compared with the mural stonework of Romanesque churches, the interiors of the great Gothic churches are almost alive. It is this quality, in which the space itself becomes as significant as the structure of the building, that often inspires us as much as the glorious stonework and decoration surrounding us. In this sense, Gothic seems quite modern to me. Space and light, proportion and perspective, the very geometry of these buildings are common themes that have been worked and reworked in the centuries that followed the birth of Gothic architecture in northern France. The religious and spiritual vision that was the source of Gothic may seem dim and remote in our secular age, but the quality of thought and imagination that conceived and executed cathedral after cathedral over a period of one hundred fifty years is both familiar and awe inspiring eight hundred years later.

Even though Gothic architecture had many precedents in the Romanesque, it came upon the scene in northern France with a force and suddenness that still appears exceptional. The first Gothic accomplishments—experiments seems too tentative a word—also exhibited an unusual sureness and completeness that are as striking as the final achievements. The first fully Gothic choir at Saint-Denis is as well conceived as many of those to come over the following centuries. This precocious ability was to resurface over and over again throughout the history of Gothic. And what we often assume to be the farewell statement of one era may indeed be the opening salutation of the next. Saint-Denis and Sens, Notre-Dame and Laon, Chartres and Bourges were culminations of their era as well as the openings of new vistas. Yet each one of them has a quality of certainty and completeness that we often associate with final rather than opening arguments.

THE FORMATION OF THE GOTHIC STYLE

The key elements of Gothic architecture are generally considered to be the pointed arch, the ribbed vault, and the flying buttress. It must be remembered that the ribbed vault and pointed arch were present before Gothic, and the flying buttress was really a response to the demands created by those two elements that did not come into play until Gothic was well under way.

The Ribbed Vault—A Stroke of Genius

To understand Gothic architecture it is essential to take some time to consider the ribbed vault, which soon came to dominate medieval construction for a variety of reasons. The ribbed vault was as critical to the development of Gothic architecture as was the steel girder in the nineteenth century or reinforced concrete in the twentieth century. The ribbed vault gave the builders a flexibility of design and construction that was simply not possible with the barrel or groin vault. It was easier to construct than the barrel or groin vault, and it was stronger and more flexible (fig. 6).

The ribbed vault is made by combining three separate but connected arches. These are the transverse arches that span the ends of the vault, the lateral or longitudinal arches that span the length or sides of the vault, and the two diagonal arches that reach from corner to corner.

It was the development of the diagonal arch that was crucial to the development of the ribbed vault; the transverse and longitudinal arches had been used in earlier barrel and groin vaults.[11] The barrel vault, a series of arches running along a single axis, has round arches only on each end (figs. 7a, 7b). The groin vault, which is an intersection of two barrel vaults, has arches on the sides and the ends and seems to have a diagonal rib or seam reaching diagonally from corner to corner (figs. 7c, 7d). This is the "groin." It is not really an arch but a fusion of the two barrel vaults and is very difficult to construct.

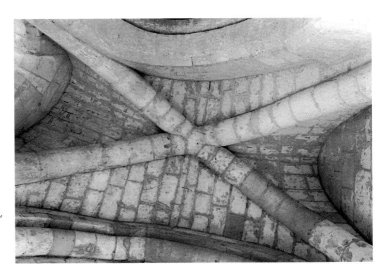

6. Morienval, early ribbed vault,
ca. 1130–1135.

Because there was no diagonal arch, or supportive bridge, the medieval builders had to span from side to side and end to end with a mixture of concrete and rubble. Thus the surface, or webbing, of the barrel or the groin vault had to support itself. There was no inner framework of arches to which to attach the webbing. The groin vault with its diagonal seam is very difficult to center and requires enormous wooden forms underneath the vault to support the concrete rubble that makes up the surface of the vault.

The diagonal rib or arch was a stroke of genius (figs. 7e, 7f). Instead of one large curved surface to cover with a webbing of concrete, the vault was divided into smaller sections or cells that could be filled with concrete. The builders quickly realized that by using cut stone instead of concrete, they could fill in each section without huge forms underneath to support the webbing. After the arches were in place, it was simpler to place the stones between the various arches or ribs. This is similar to constructing a curved brick wall within the frame of the intersecting arches (fig. 8).

The Pointed Arch—Flexibility and Strength

The second great advantage of the ribbed or arched vault was the flexibility it gave to the builder. This came about not by using a diagonal arch but by breaking the round arches. A broken arch becomes a pointed arch. The breaking of the round arch allowed the builder to vary the height of each of the three arches, the transverse, the longitudinal, and the diagonal. With the round arch the builder was constrained by the size and shape of the vault itself. The diagonal of a square or rectangle is longer than either of the sides. Thus, if all the arches are round, the diagonal arch must be taller to span the longer distance. The result is a domed vault with lower openings on the ends and sides than the height of the dome. To avoid this problem the builders would flatten the diagonal groin (it was not really an arch yet) and create a parabolic arch on the two diagonals. Another method was to put the shorter side arches on stilts. This required enormous centering and the result was somewhat unstable because the flat portion of the vault carried a disproportionate amount of weight.

The pointed arch solved this problem. Pointed arches, whether transverse, diagonal, or longitudinal, can be of different widths to span different distances and still have the same height because the pointed arch can be made narrower or wider to adjust to the width at the base. A sharper point for a narrow base on the ends of the vault can coexist with flatter pointed arches that support the

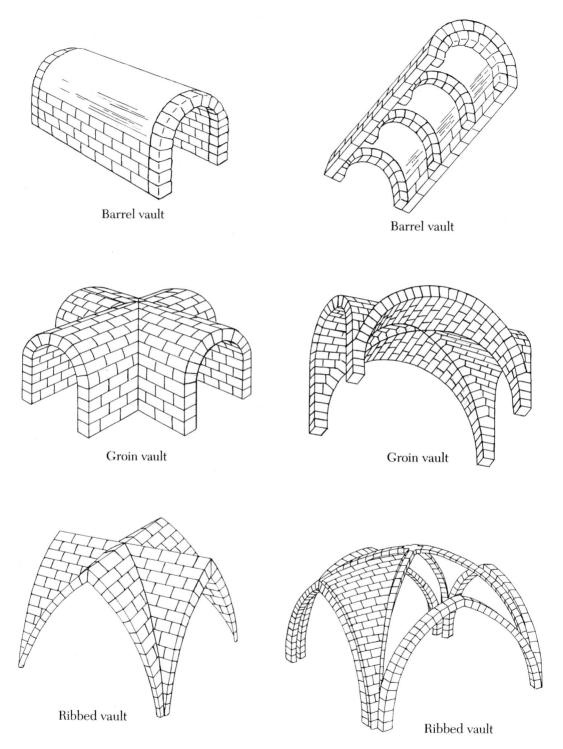

Barrel vault

Barrel vault

Groin vault

Groin vault

Ribbed vault

Ribbed vault

7. Barrel, groin, and ribbed vaults. The development of the ribbed vault allowed medieval builders greater flexibility and ease of construction.

sides. The diagonal arch is the flattest and longest of the three.

This gave the builders tremendous flexibility. They could create vaults over any sized rectangle or even over triangles, trapezoids, pentagons, or whatever the builder needed. This flexibility was crucial in the choirs and ambulatories of the churches where the aisles needed to curve around the eastern end. The development of the triangular vault allowed the designer to build a fan of ribs to cover the center of the choir vault. The ambulatory vaults of Bourges and of Notre-Dame in Paris are good examples of this flexibility (fig. 9).

Finally, a ribbed vault is inherently stronger than a barrel or groin vault. With the barrel vault the weight or thrust flows down through the entire surface of the vault to the sides. With the groin vault more thrust flows down the surface of the webbing to the corners. Using the pointed arch in ribbed vaults allowed the builder to channel most of the thrust down the ribs or arches to the four corners of the vault and down the piers to the ground. Once the combination of the rib and the pointed arch was understood, there was no looking back (fig. 10).

The Flying Buttress

Not all of the weight of the vaults, however, can be channeled downward. There is always lateral thrust as weight tries to spread outward. With the barrel vault the lateral thrust is considerable and has to be met with thick walls or with side aisles that serve as buttresses to the main vaults. In effect, the vaults of the side aisles served as raised buttresses. It was probably to be expected that the first vaults to be ribbed at Durham Cathedral in England and Saint-Étienne at Beauvais would be in the aisles (fig. 11). The ribs of the aisle vaults could reach over the aisles from the massive exterior walls, which allowed the builder to open the aisle arcade to the nave. Hidden under the aisle roofs, the aisle vault arches were really the first flying buttresses. In reality, the flying buttress is the arch of an aisle vault raised above the aisle

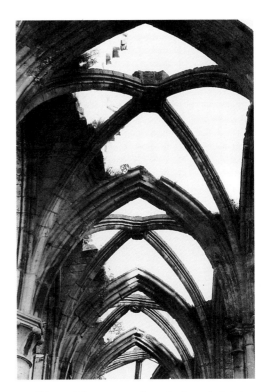

8. Abbey of Ourscamp, rib vaults in ambulatory ruins, 13th century.

roof to the position where it absorbs the most thrust from the main vaults (fig. 12).

The invention of the flying buttress was a later development, although there is now some academic debate as to the actual dates (fig. 13).[12] The master builders realized that to contain the spreading thrust of the gigantic vaults, they needed an external support to brace the upper walls and the vaults. While they may not have been able to determine the exact amount of thrust to be contained, they recognized the importance of bracing the upper stories. Following the lead of Paris, the architect of Mantes Cathedral, west of Paris, added flying buttresses during construction and considerably reduced the thickness of the outer wall. But neither at Notre-Dame or at Mantes were they ready to give up the structural support of the second-story gallery. They understood its bracing

13

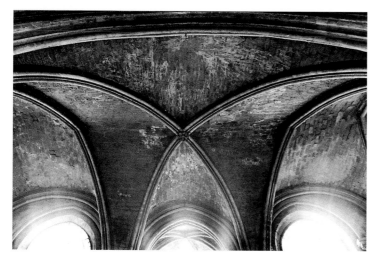

9. Bourges, Cathedral of Saint-Étienne, ambulatory vault, early 13th century. The butterfly shape of this vault demonstrates the flexibility that ribbed vaults have in spanning irregular spaces.

function for the walls and vaults well above the pavement.[13] With the monumental cathedrals of High Gothic, beginning with Chartres and Bourges, the flying buttress became an integral part of the architectural vocabulary.

THE DRIVE FOR SPACIOUSNESS

Today we recognize the incredible height of the finest Gothic cathedrals as a principal characteristic of this superb architecture. We retrospectively imagine that the master builders and their patrons were initially and continually striving to achieve this height from the beginning. However, the development of horizontal space may have at first been a more pressing concern. As Jean Bony points out, "the new Paris masters [at Saint Martin-des-Champs and Saint-Denis] turned to a systematic enlargement of the lateral volumes by doubling the depth of the ambulatory and aisles . . ."[14]

With the growing power of the Capetian dynasty, the Abbey of Saint-Denis, just north of Paris, had to be expanded to accommodate the needs of both religious and state ceremonies. The Capetian rulers wanted to establish the presence and power of the monarchy. What better way to do it than by creating great architecture? Monarchs throughout the ages have always done so. Abbot Suger needed more space to handle the increased number of monks at the abbey and the crowds of pilgrims and notables who were coming to see the relics. In addition, Abbot Suger wished to open the house of God to the "divine light."

MOMENTS IN STONE, MOMENTS IN TIME

Throughout the unfolding of Gothic architecture there appear and reappear distinct moments of creation and revelation that continue to speak to us today, over eight hundred years later. Standing in the choir of Saint-Denis, at the west façade of Chartres, or in the nave of Amiens, we can trace the changes the architects carried out. We can be in the presence of these moments of inspiration when there was a sudden fusion of what had come before and what would be a magnificent leap into the future.

The exquisite choir at Saint-Denis, the bold façade of Laon, the beginnings of High Gothic with Chartres and Bourges, the beginnings of Rayonnant Gothic with the upper stories of Amiens and Troyes cathedrals, and the rebuilding of Saint-Denis in the thirteenth century are notable examples of imagination that astound us with their inventiveness and their completeness, with their audacity as well as the sureness with which they were executed. They are the

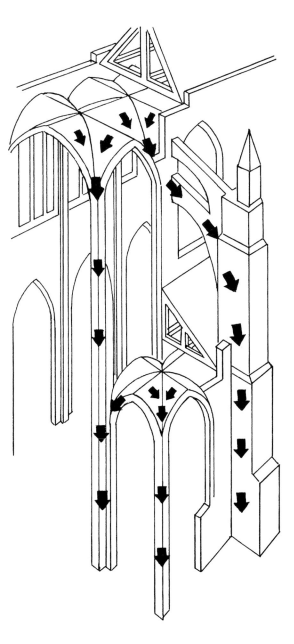

10. Pointed arch, lines of thrust.

moments when all the ingenious experiments accumulated over the previous decades came together and when the call for the following decades was sounded.

What is often so memorable about these initial moments in the various phases of Gothic development is not only the boldness of the vision they express but the assurance by which that vision is articulated and the adroitness with which the builders were able to carry it out. As we move through the maturing of Gothic architecture we will revisit this dual theme of suddenness and sureness that seems to lift Gothic architecture one step further along its divine path. These are the moments when we question how mere human beings could have taken this next step, and when we begin to dream of the possibility of divine intervention. In the chapters on individual cathedrals I will try to identify these revealing moments of change.

GREAT PAIRS OF CHURCHES AND EXPERIMENTATION

The evolution of Early and High Gothic architecture was characterized by great pairs of churches, contrasting experiments taking place at the same time. At critical stages in the development of Gothic architecture there appeared pairs of remarkable, yet differing churches: Saint-Denis and Sens in the 1140s; Paris and Laon in the 1160s; Chartres and Bourges in the 1190s; and Reims and Amiens at the beginning of the thirteenth century. Each building moved Gothic architecture forward, yet in a very different way. While one expressed the gravitas of Gothic, the other articulated the lightness of touch that finally came to dominate the style. Often one acted as a revelation of the previous age while the other expressed the motifs and formulas that would carry the style one step further. Frequently an individual church would exhibit both conservative and progressive elements, and look forward while holding on to the past. Chartres articulated the new arrangement of elevation that was to dominate subsequent churches, but held onto the

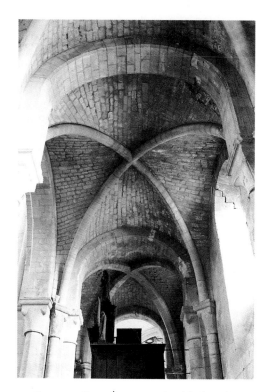

11. Beauvais, Saint-Étienne, aisle ribbed vaults, ca. 1130. An early example of ribbed vaults in France in a pre-Gothic church.

massive building techniques of the past. Bourges transformed essentially conservative motifs into a startling visionary architecture by using incredibly audacious building techniques. Bourges can be seen as a liberated futuristic look at the past; Chartres can be seen as a conservative projection into the future.

EARLY GOTHIC

Early Gothic architecture began primarily with Saint-Denis and Sens, although the importance of Saint-Martin-des-Champs (now part of the Musée des Arts et Métiers in the third arrondissement in Paris) should not be forgotten. While not yet Gothic in style, Saint-Martin-des-Champs eliminated the space between chapels common to Romanesque churches and created a continuous span of windows that was further developed

in the ambulatory of Saint-Denis (fig. 14).[15] This Early Gothic phase of experimentation lasted approximately fifty years, from the 1140s until the beginnings of Chartres and Bourges in the 1190s. After Saint-Denis and Sens in the 1140s there came the churches of the 1150s and 1160s: Senlis, Noyon, Mantes, and the south transept of Soissons. These important buildings paved the way for the accomplishments of the 1160s, but they are not the monumental achievements of the cathedrals of Laon or Notre-Dame of Paris.

The First Phase of Early Gothic
In the Île-de-France around Paris, the architects had traditionally favored a thin-walled mode of construction.[16] It may be this reason more than any other that caused Gothic architecture to take root in this area. It is interesting to speculate how, at this particular time in the twelfth century, different dynasties chose to express their power through architecture. The Normans, fresh from their conquest of England seventy years earlier and controlling much of western France, emphasized the massive fortress-like qualities of the conqueror. And yet the Capetians, in many ways the least secure and with the least promise for the future, chose an elegant light style that seemed to speak of hope and confidence.

Many things came together in northern France: the thin-walled construction, the ribbed vaulting of England and northwestern France, the desire for more space and grandeur, and Abbot Suger's wish to infuse his church with divine light.

Once it was initially underway, Early Gothic architecture made clear and complete statements of style at both Saint-Denis and Sens. Each seems to have had a different purpose and aesthetic, but they shared the ability to express in a fully articulated manner a sense of completeness. While Saint-Denis revealed new architectural forms and a new organization of lateral space, the cathedral at Sens was a more conservative look back to the Romanesque, yet in a Gothic mode.

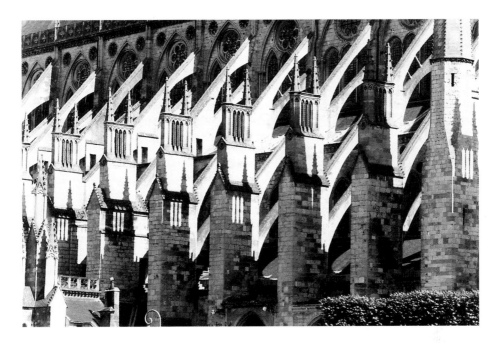

12. Bourges Cathedral, flying buttresses, early 13th century.

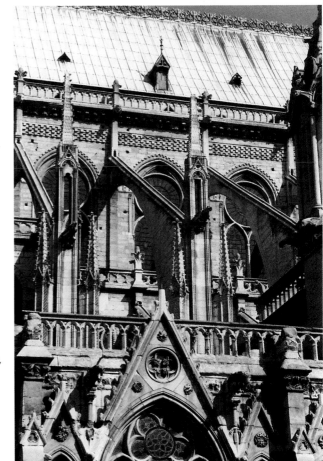

13. Paris, Cathedral of Notre-Dame, flying buttresses, 13th century, but rebuilt in the 19th century.

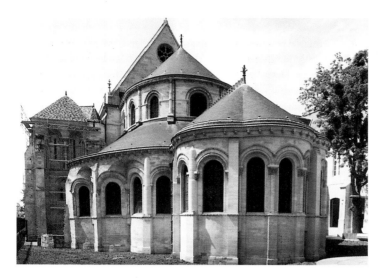

14. Paris, Saint-Martin-des-Champs, chevet, 1130s.

There are many Romanesque precedents to French Gothic, and both Sens and Saint-Denis played influential roles, but Gothic architecture really begins with Saint-Denis.

The choir at Saint-Denis focused on opening up the lateral space of the choir as well as envisioning the exterior wall as a wall of glass rather than stone. At Sens the architect concentrated on the longitudinal space of a nave without a crossing because the need for peripheral space was not a primary consideration. Saint-Denis brought into being a lightness of touch in its structure and decoration that was not echoed at Sens where the old massiveness of Romanesque continued in the new Gothic clothing.

The Second Phase of Early Gothic—Continuing Experiments

After the dramatic beginning of Gothic architecture with Saint-Denis and Sens there came a period from 1145 to 1160 where none of the buildings was able to "achieve the unity and lightness of Suger's ambulatory or the compelling scale of Sens."[17] This second generation of churches seemed to struggle to retain the massive qualities of Romanesque, while learning from Saint-Denis and particularly Sens. Noyon and Senlis, within fifty miles of each other north of Paris, again reflect the duality of the great pairs of Gothic

churches. Where Sens has a heavy triforium with small openings, Senlis uses one large opening to create a much lighter, less mural effect.[18] And while Noyon followed the plan of Saint-Denis, the treatment of moldings and the walls is so heavy as to create a totally different impression.

This habit of utilizing the ground plan of a church but infusing the elevation with different stylistic effects continued throughout Gothic architecture. It is as if the succeeding architect saw the same problem as his predecessor and adopted those solutions, but nevertheless came up with a different answer. Often it was a solution that deviated from the stylistic sensibilities of the earlier building.

The Final Phase of Early Gothic—The Birth of the Monumental

Noyon, Laon, Notre-Dame of Paris, and the south transept of Soissons each exploited the four-story elevation in its own distinct way to gain more height. Noyon's exterior retained the compact solidity of Romanesque predecessors while Laon exhibited a dazzling profusion of towers and transepts that housed an open four-story interior totally different in feeling from Noyon or Paris. At Paris we are constantly aware of the wall surface of the nave and choir, whereas at Noyon and Laon the first two stories reveal the deep aisles

behind the main interior elevation. A fine grid covers the solid stone of the interior at Noyon, while at Paris the flat surfaces of the walls are penetrated by punched openings. Laon gives us the sensation of being inside an elegant cage in which we can see outward in almost every direction.

HIGH GOTHIC

High Gothic architecture is said to begin with two of the most remarkable buildings ever erected on the face of the earth: the cathedrals of Chartres and Bourges. Chartres is by far the more famous. It is one of the most prominent of all Gothic buildings and was certainly more influential than Bourges (figs. 15, 16).

Even though both were superbly conceived and executed and set in their individual ways the direction for the next fifty years, they also reflected another dominant theme of Early Gothic architecture: the will to experiment. Like Saint-Denis and Sens and the great pairs that followed, Bourges and Chartres demonstrated the same striking theme that was to appear and reappear throughout the history of Gothic architecture: the creative tension between the conservative response and the progressive inclination.

At Chartres we see not just a refinement of earlier Gothic techniques but also a complete reformulation of the Gothic statement in a manner that was ultimately to revolutionize and dominate Gothic architecture for several hundred years. It was the Chartres elevation that became the model for future generations. With both the nave arch and the clerestory window of equal height, this was a fundamental shift away from the small clerestory of Sens or the four-story elevations of Laon and Notre-Dame of Paris. At Chartres the first architect also utilized the characteristic Gothic pier, called the cantonée pier—a central shaft with four attached shafts. The Chartres architect alternated their shape by using a round column with attached octagonal shafts for one, and an octagonal pier with attached columns for the other. The corners of the pier or column are thus positioned to allow the attached columns or shafts to rise from the pavement to the rib of the vault in a clear, integrated manner. We can compare this to a plain round column at Laon or at Soissons, where a round colonnette is attached to a round column that does not relate to arches and ribs above. At Chartres the architect used the cantonée pier to integrate the entire interior with a grid of interconnecting ribs and colonnettes.

With all this innovation, what was the conservative tendency at Chartres? The actual construction of Chartres, with its enormous piers, walls, and flying buttresses, is overbuilt, and the noticeable mural quality does not forecast the future but reminds us of Sens and even earlier Romanesque solidity. The ribs, colonnettes, and moldings are all quite heavy. This is particularly striking because at the same time the architect at Bourges was taking a very different approach to the conservative-progressive relationship. Bourges, in contrast to Chartres, utilized the most conservative structural scheme, the pyramid, to accomplish the most revolutionary result. And it was done as a glorious retrospective look back at the motifs and practices of earlier twelfth-century churches. Although we generally consider the pyramid to be the apotheosis of solidity, the Bourges architect dazzles us by using this form to create one gigantic void for the interior. Nowhere else can we experience the uninterrupted, continuous space of Bourges. It is an explosion of space and stone on a colossal scale.[19]

Bourges is an example of a conservative structure created with the most daring and revolutionary of building techniques. In particular, the flying buttresses are the lightest to date and among the lightest ever constructed in the Middle Ages.[20] The interior details of moldings and ribs have a delicacy of touch that gives a buoyant, lifting quality to the stone. The generous nave and aisle piers belie their size because the slender colonnettes rising to the slim capitals stress lightness rather than power.

19

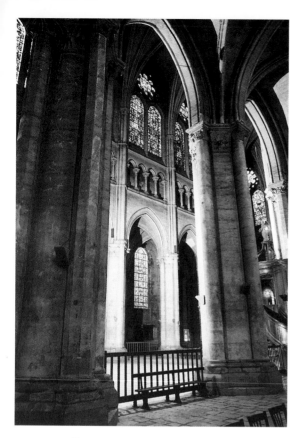

15. Chartres, Cathedral of Notre-Dame, nave elevation, 13th century. The Chartres three-story elevation became the model for later High Gothic cathedrals.

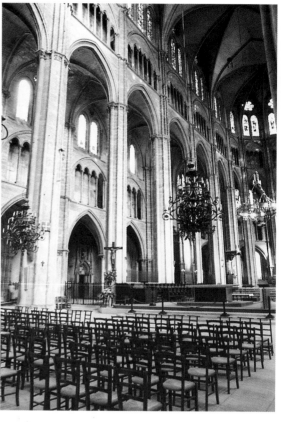

16. Bourges Cathedral, nave elevation, 13th century.

Where the Chartres master utilized the four-part vault to change the very nature of the building, the Bourges master retained the archaic six-part vault. At Chartres we find enormous stained-glass clerestory windows, while at Bourges the clerestory is quite small, almost squeezed up against the vaults. But the Bourges master more than compensated for this by raising the nave arches to an unprecedented height that astounds us to this very day. And instead of just one small clerestory, the Bourges architect repeated the entire nave elevation in the inner aisle, thereby creating three levels of light that flood the entire vessel and make Bourges one of the brightest of Gothic cathedrals, even on cloudy days. The Bourges ground plan seems to be based on Notre-Dame of Paris with two aisles on each side of the nave running the length of the building and meeting behind the choir to embrace the entire structure. In contrast to Chartres, with its magnificent

transept, Bourges has no transept. This allows the visitor to view the entire interior from almost any position in the church. It is a spectacular experience.

In essence, Bourges explored the utmost limits of the twelfth-century cathedral and realized a nearly complete revelation of what it could be. In this sense, Bourges is not like Chartres, the beginning of High Gothic architecture, but the wonderful culmination of the Early Gothic phase. Both Bourges and Chartres create a lasting sense of wonder but of a very different kind. After Bourges and Chartres came Reims, Amiens, and Beauvais, as well as Le Mans, Troyes, Metz, and Cologne by the end of the thirteenth century. Although they refined the original formula of Chartres and High Gothic may be said to culminate at Amiens, it would be wrong to conclude that these magnificent cathedrals surpassed the opening statement of High Gothic made at Chartres and Bourges.

RAYONNANT GOTHIC

In the 1230s, as the High Gothic nave of Amiens neared completion, the Rayonnant style came into being. This was a subtle but momentous change that was to affect Western architecture profoundly for the next three hundred years. It was not like the change from Early Gothic to High Gothic in the 1190s with Chartres and Bourges, when a structural transformation based on the key elements of Early Gothic architecture was made possible by the flying buttress.[21] The architects of the 1230s and 1240s, while still utilizing the fundamental forms of Early and High Gothic, made them more elaborate and, at the same time, simpler. The key elements of nave arcade, triforium, and clerestory continued to be the basic building blocks of the interior elevations. The colonnettes and ribs of the walls and vaults were employed in a similar fashion. One of the fundamental signatures of High Gothic was, however, changed forever.

In High Gothic architecture the builders tended to assemble the buildings in a manner in which the various parts were distinct even though the whole was integrated. For example, the nave arcade, triforium, and clerestory are easily read as separate elements while also working together to form the overall elevation. Although they are in a sense stacked on top of each other, the piers, colonnettes, and ribs tie the three elements and the vaulting together. The repetition of this particular "bay system" down the nave and around the choir creates a distinct rhythm while shaping the whole volume.

Rayonnant took these High Gothic elements and began to blend them together. Instead of treating the triforium and clerestory as completely independent elements, the architects began to pull them together by allowing the colonnettes and mullions to run through the dividing stringcourses. With the glazing of the triforium at Troyes Cathedral (fig. 17) in the 1230s and in the Amiens choir a few years later, the two units were more effectively merged. In smaller buildings such as the Sainte-Chapelle in Paris (see fig. 108), the triforium disappeared entirely and a cage of glass and stone was constructed.

Although this fusion of elements in some sense simplified High Gothic architecture, it would be a mistake to see Rayonnant as a streamlining of High Gothic. This is particularly clear in looking at the exterior of the nave and choir of Amiens. On the exterior, looking from the west to the east, the change is a dramatic contrast of the two styles, one that keeps faith with the original design. The flanks of the nave have a solid power reminiscent of Chartres but with much more vertical force. The north façade is the same. At the point where the north façade turns into the eastern side of the transept a gabled pinnacle appears, and where the entire chevet turns around to the south façade, the upper story of Amiens becomes an extravaganza of pinnacles, gables, and arcaded flying buttresses. While the Gothic builders were able to fuse the architectural elements together in a more unified format, they found new freedom to use decorative elements with abandon.

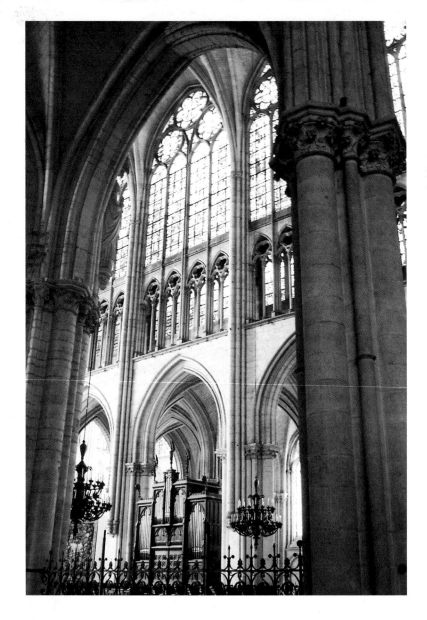

17. Troyes, Cathedral of Saints Peter and Paul, choir elevation, after 1230.

The development of the Rayonnant style allowed the builders to give a shrine-like quality to these massive buildings. It is as if the builders were primarily motivated by the small reliquaries we see today in the treasuries of the cathedrals. These elaborate metal boxes, often in the shape of gabled buildings, had a profound effect on their stone brethren. The interior of The Sainte-Chapelle in Paris gives us the feeling of being inside an exquisite box. The façade of Reims Cathedral with its thin gables and pinnacles and elaborate decoration gives the impression of a small reliquary made gigantic. It is an overpowering yet oddly delicate assemblage of the metal worker's intricate motifs. Rayonnant artists and architects did not abandon the forms of High Gothic, but they certainly transformed them.

AMIENS
Cathedral of Notre-Dame

Notre-Dame of Amiens stands as the culminating achievement of High Gothic architecture, a compelling synthesis of twelfth-century Early and High Gothic experiments in northern France, and an inspired anticipation of the Rayonnant style that dominated European architecture for the next three hundred years (fig. 18).

Robert de Luzarches, the first architect of Amiens Cathedral, was a genius who polished and heightened the heavy Chartres format as reinterpreted at Reims. Throughout the cathedral the architect took those earlier models and lightened them to create a completely new architectural statement. While he adhered to the basic ground plan and elevation of Chartres and Reims, he seems to have derived aesthetic inspiration from the lighter, more refined churches of Paris, the cathedrals of Laon and Soissons, and the abbey of Longpont.[1] De Luzarches created a miraculous experience of powerful vertical force perfectly balanced by marvelous vistas of lateral space, all encompassed by elegant architectural features. He was followed by Thomas de Cormont and his son Regnault de Cormont, who oversaw the second and third building campaigns. The Cathedral of Notre-Dame of Amiens has a combination of audacity and finesse that is truly exceptional. The incredible verticality of both the interior and exterior is met with perfect proportion and beautiful integration of detail. With some cathedrals, one or two features often capture our experience and remain in our memory. At Amiens the celebrated west façade, the exuberant east end, the towering interior of the nave and choir, the great rose windows, and the fabulous crossing all command our attention. As extraordinary as Amiens Cathedral's individual features may be, they never overwhelm its architectural unity. The overall effect is one of buoyancy and composure, of energy and stability.

The city of Amiens lies on a small hill above the river Somme, a lazy river that winds its way west from Saint-Quentin to the English Channel. During World War I, the British and French fought horrific battles against the Germans in the hill country of the Somme and Ancre Rivers east of Amiens. In 1918, the German army's great final offensive, called the "Kaiser's Battle," came within a few miles of Amiens. In the south transept of the cathedral there are memorial plaques to the British, American, Canadian, Australian, and New Zealand troops that defended this city in a battle that nearly changed the outcome of the war and the twentieth century. Although Amiens was not as severely damaged as Soissons and Reims and many other smaller cities and towns, considerable destruction occurred throughout the city. The cathedral was hit by numerous shells that harmed several chapels but did not seriously damage the structure of the building.

The site of the cathedral, on a hill overlooking the river Somme and the medieval district of Saint-Leu, is both dramatic and accessible. Throughout the Middle Ages Amiens was a major center for the manufacture of cloth and was famous for a blue dye called "woad." The river, which branches into numerous channels north of the cathedral, was an important source of water for the cloth mills and the market gardens called the

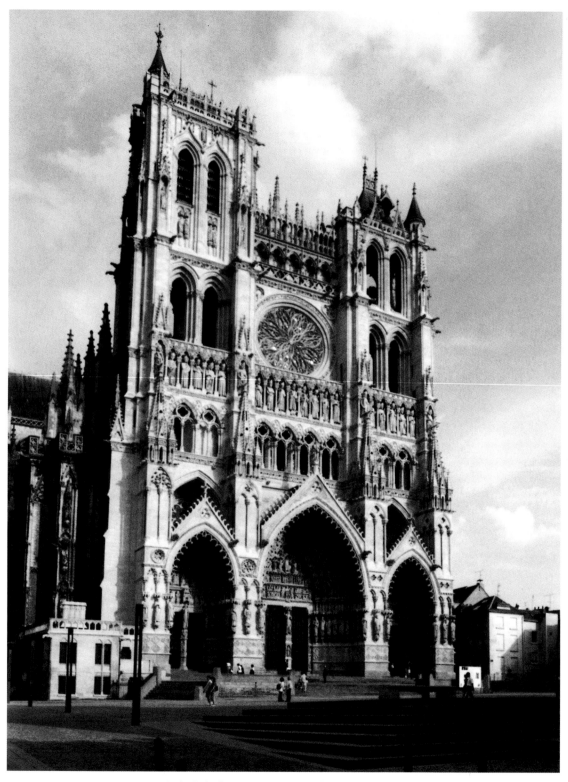

18. Amiens, Cathedral of Notre-Dame, west façade, 1230s and 16th century.

Hortillonnages. Known as "the little Venice of the North," Saint-Leu has recently been restored and is a very pleasant area of canals, parks, shops, and restaurants. The Hortillonnages are easily accessible by foot or boat and gardeners sell their produce along the quays below the cathedral on market days (fig. 19).

Until very recently it was commonly held that the nave of Amiens was completed in sixteen years between 1220 and 1236, and the church fully completed by 1269. This chronology was based on nineteenth- and early twentieth-century research by French historians, particularly Georges Durand of Amiens. This led to a tendency to think about stylistic change at Amiens in east-west terms: seeing the nave in the west as High Gothic and the choir to the east with its gables and pinnacles as Rayonnant. Stephen Murray has shown that the construction of Amiens probably did not occur in specific east-west building campaigns, but proceeded in a more continuous fashion, with several parts of the building being worked on at the same time from the 1220s to the 1270s.[2] The scholarly debate over the chronology of the cathedral's construction continues. There were modifications and major repairs over the centuries with the addition of the nave chapels and the completion of the west façade in the fourteenth century, but the cathedral was essentially completed in fifty years, a remarkable achievement.

A closer look reveals that the great stylistic change we see is not so much lateral, from nave to choir, as it is vertical. The changes in the arcade and upper stories of the nave reflect the move away from the robust three-dimensional and mural effects of Chartres and Reims to the dazzling open linearity that would be continued later at Troyes cathedral, the nave and transept at Saint-Denis, the transept façades of Notre-Dame, and the Sainte-Chapelle in Paris.

Although Beauvais is the tallest of all French cathedrals, Amiens is the largest, and the initial impression upon entering it is of extreme height. It is at least one story higher than Reims and has a considerably narrower proportion of height (139 feet versus 122) to width (approximately 45 feet for both naves). The nave arcade at Amiens is significantly higher than that at Reims (60 feet versus 53 feet), and is almost equal in height to the triforium and clerestory combined, in contrast to the Chartres and Reims elevations, where the nave arcade and clerestory are nearly equal. At Amiens both the nave arcade and the clerestory have been stretched. This becomes particularly clear on the exterior of the choir with the slender chapel and clerestory windows (fig. 20).

As tall as Amiens is, it never seems beyond our reach because of our sense of connection with the rising structure. The ascending quality of the nave is amplified by the flow of the pier shafts directly into the attached colonnettes that rise to the springing of the vaults. Unlike Chartres, Reims, and Soissons, where the wall shafts climb from the tops of the nave arcade capitals, at Amiens a single attached shaft ascends from the pavement to be joined by two colonnettes at the capital and another two at the base of the triforium. This arrangement of one, then three, and finally five shafts brings our gaze upward from the floor to the vaults in a way that creates a connection between us and the rising stone. "And because the lines of energy depart from the very pavement on which the observer stands, a profound empathy is created between the observer and the dynamically rising stone masses. No other Gothic building achieves this astonishingly bold and sophisticated synthesis of physical, cerebral, and psychological elements" (fig. 21).[3]

At Chartres and Reims the vaults seem to disappear into the darkness, but at Amiens we are immediately and intensely aware of the vaults as they float on the armatures of ribs that connect to the rising wall shafts. As we look upward from the nave arcade to the enormous clerestory windows, the forms become lighter and more insubstantial. Because of this, and because the triforium is slightly recessed from the wall of the nave

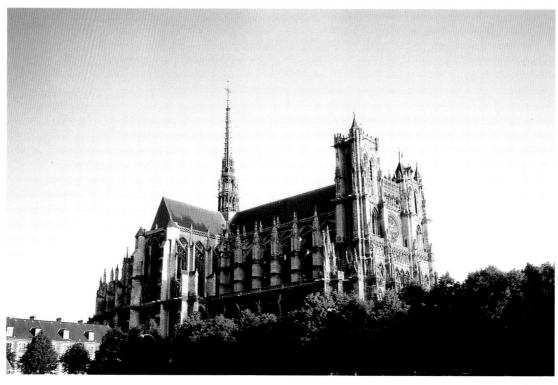

19. Amiens Cathedral, from the northwest.

20. Amiens Cathedral, chevet, 1220s–1250s.

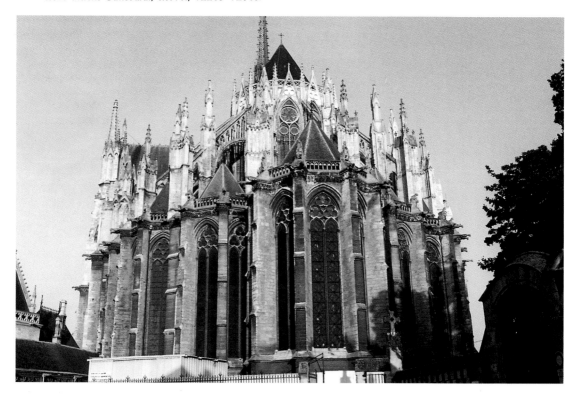

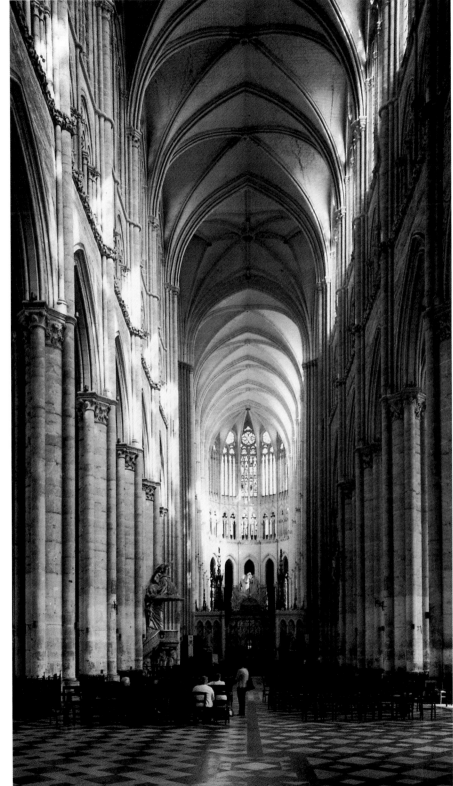

21. Amiens
Cathedral,
nave and choir,
1220s–1260s.

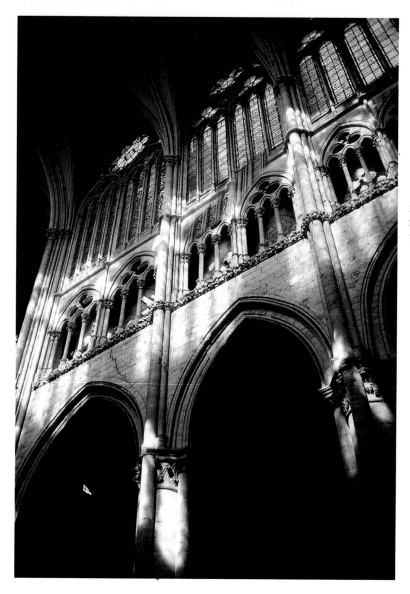

22. Amiens Cathedral, nave elevation, 1220s–1230s.

arcade, and the clerestory window is stepped back from the triforium, the upper stories do not loom above us as they do at Chartres and Reims. This progressive recession gives a lightness and balance to these three towering stories of stone and glass. Although much of the increased height comes from the tall nave arcade, the expansion and lightening of the clerestory windows create the illusion of a taller clerestory.

The great height never seems out of balance as it does at Beauvais. The nave arches are tall but not unreasonably so, and they retain a slightly mural appearance. The piers are the slender round cylinders of Soissons (see fig. 148) with sizable attached colonnettes on each axis. The point of the arch does not reach to the base of the triforium as it could, which provides generous wall space for the spandrels. The triforium, composed of two

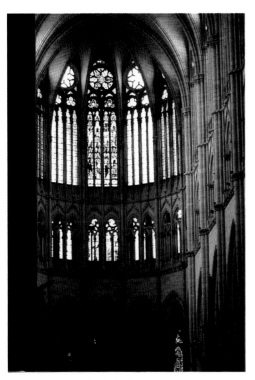

23. Amiens Cathedral, choir interior, 1230s–1260s.

arches containing three smaller arches, rests on a beautiful leaf-patterned, or foliated, stringcourse forming a solid base for the innovation above. The triforium is linked to the clerestory by a central colonnette that in effect merges the two upper stories.

It is at Amiens that progressive subdivision of the upper windows was first achieved. The heavy Chartres window of two lancets and an oculus was essentially copied in a lighter form at Reims. At Amiens the clerestory window was transformed; each lancet is subdivided into three lancets topped by a quatrefoil. The two tripartite lancets are themselves topped by a large rose. Even the small spaces between the oculus and the lancets are glass. The clerestory windows, as they continue down the nave, become an extended screen of glass. At the transept, there are four lancets within each of the two large lancets,

making eight slender openings. The walls in Gothic architecture are disappearing (fig. 22).

The nave arcade at Amiens is smoother and less pronounced than that at Chartres and Reims, where we experience the bays independently as they march down the nave, creating a strong, punctuated rhythm. At Amiens, because the wall surface is lighter and smoother, we perceive the nave wall more as a whole and although we are aware of its various parts, the visual rhythm is much subtler. At the same time, as we look diagonally, we see the generous height and width of the aisles (and side chapels with their outer walls entirely of glass) that allow the nave and aisle to merge. The lateral openness of the aisles gives us the sense of balance we need. The subdivision of the bays, vaults, and aisles quietly complements the overall strength of the great central volume. The aisle chapels were created in the late thirteenth and early fourteenth centuries. You can see the seams in the chapel walls where the masons extended the piers.

There are many great moments in Gothic architecture and being in the nave of Amiens for the first time is surely one of them. At the sixth bay we can look directly into the choir as well as both transept arms and the side aisles of the choir. Were it not for the choir screens and high altar, we could see the entire ambulatory and the radiating chapel windows. The crossing, choir, and aisles are a stunning ensemble of stone, glass, and space.

The east end of the nave facing the choir is one of the best places to experience this wonderful interplay of huge volumes and subdivisions. The great transept arms are three bays deep on each side. The bays are progressively smaller to the outside and more refined than in the nave. The triforium is glazed on the east side of the transept and the clerestory windows are further subdivided with an array of slender lancets under large glass trefoils and oculi. The window tracery is more delicate and intricate and appears superimposed on the glass rather than as part of the frame.

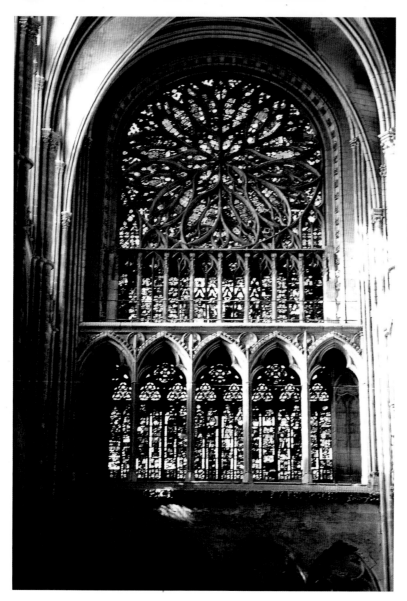

24. Amiens Cathedral, south-transept interior, 1240–1500.

The walls of the choir are lighter than the nave because of a recent cleaning.[4] What strikes the eye are the decorative gables above the triforium arches. The architect of the choir could not resist adding an ornamental note while retaining the classic format of the nave. To our eyes these gables may look somewhat Victorian and out of place when compared to the simplicity of the nave. For medieval architects the gable became a major device for creating the shrine-like qualities of these buildings. Ultimately, the gable motif would be used with great elaboration during the Rayonnant and Flamboyant phases of Gothic architecture. The monumental west façade at Reims and the transept façades at Notre-Dame of Paris are early examples. Saint-Urban in Troyes and Saint-Maclou in Rouen are two of the surviving Gothic buildings designed as shrines (fig. 23).

The choir of Amiens is partially blocked by a two-bay screen erected in 1495 that depicts the life of Saint Firmin, the first bishop of Amiens, on the south side and life of John the Baptist on the north. The rest of the choir is enclosed by a wrought iron and gilt screen with a sixteenth-century altar depicting the Assumption of the Virgin into Heaven. These distracting and overwrought altars were commonly erected from the sixteenth to the eighteenth centuries. The one hundred twenty sixteenth-century choir stalls contain over four thousand figures illustrating scenes from the Old Testament and the Life of the Virgin.

The three central chapels of the chevet were heavily restored by Viollet-le-Duc in the middle of the nineteenth century to reflect the "original" thirteenth-century style. As Stephen Murray says, "the aggressive paintwork and the elaborate liturgical equipment have not worn well,"[5] but these chapels give us a sense of how different these great cathedrals originally may have looked when painted. A more complete example is the Sainte-Chapelle in Paris.

The interior of the south-transept façade is a striking array of Rayonnant subdivision and window tracery. The lower portion is an attractive mural arrangement with four tall double-lancet blind arches framing a pair of doors within another set of arches beneath a gable. Above the doors are three trefoils with Saint Michael and two angels. The arrangement of the trefoils above the doors is quite appealing. The triforium is a five-bay glazed arcade resting on the delightful Amiens foliated stringcourse. The rose window, probably the third one, was built around 1500 and rests on a glazed gallery made up of small double-lancet arches above the triforium. Twelve almond-shaped petals, each enclosing two smaller petals, revolve around a beautiful six-petal core (fig. 24).

The south-transept façade (fig. 25) facing rue Robert-de-Luzarches is known as the portal of the Vierge Dorée or Golden Virgin, one of the loveliest and most influential sculptures of the Virgin in the Middle Ages. It is a particularly graceful statue with the Virgin resting the Christ Child on her hip. The sculpture on the portal is a copy; the revered original is inside the cathedral on a pier in the south transept (fig. 26). Several years ago I was fortunate enough to see the Vierge Dorée under restoration and capture the moment in a photograph. The intimacy and tenderness of this statue are particularly appealing.

The base of the interior of the north-transept façade is slightly less intricate than its companion to the south. The tympanum of the portal is fully glazed and framed by two extremely tall blind lancets topped with trefoils. The glazed triforium, gallery, and rose window, rebuilt in the fourteenth century,[7] reflect the stylistic intricacy and elegance of Flamboyant design. At the center of the window is a five-pointed star that radiates out to fifteen petals. The exterior of the façade (fig. 27), facing the Bishop's Palace, is less elaborate than the exterior of the south-transept façade. Of particular interest are the three exterior lancet arches that hold the rose window in place.

Every portion of the cathedral's exterior is worthy of our time and attention. The eastern and western ends are among the most dramatic in all of Gothic architecture. The great simplicity and strength of both flanks of the nave are perhaps the only minor notes on the exterior. The transept façades are not as remarkable as the awe-inspiring porches at Chartres, but they are significant structures, particularly the north façade where the hill falls away from the cathedral.

At the time of the building of the west façade at Amiens in the 1230s, Gothic façades had been designed to reflect the inner aisles and the stories of the interior elevation. The Amiens architect followed the arrangement established at Laon where the rose window, galleries, and the portals of the façade mirror those inside. The combined arcade and gallery of the kings running across its front reflect the triforium on the interior. The rose window and lower arches of the towers cor-

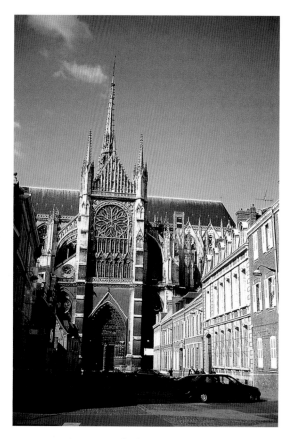

25. Amiens Cathedral, south-transept exterior, 1230s–1260s.

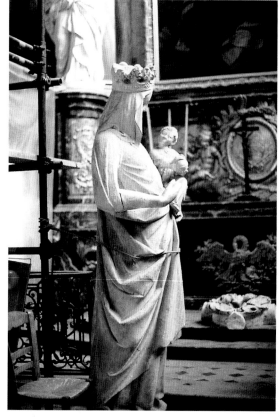

26. Amiens Cathedral, La Vierge Dorée, south transept, 13th century.

respond to the clerestory. To design these elements on the Amiens façade in a way that precisely coincides with the interior was impossible, however, because of the narrow dimensions of the interior.[5] The height of the nave and aisles would have made the doorways of the façade extremely tall and thin with awkwardly narrow proportions. To deal with this, the architect pulled the gables of the façade forward between heavy buttresses and put secondary arches behind and above on the proper face of the building. This cre-

ates some confusion and a play of various depths that is lacking on the interior with its flat surfaces. It is difficult not to be moved by the towering grandeur of the west façade. Nevertheless, as we look at the entire façade in detail, it is apparent that the pieces do not entirely fit together. The deep portals that project out from the wall of the façade seem to be hiding the glazed tympanums behind them. As beautiful as it is, the rose window is somewhat squeezed between the two towers and beneath a confused pair of galleries at

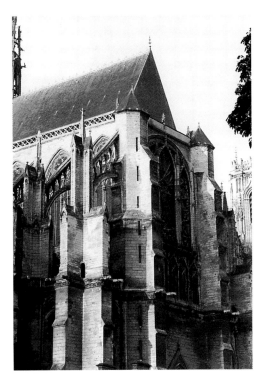

27. Amiens Cathedral, north-transept exterior, 14th century.

see the shift in style from one phase to another, our critical sensibilities are sharpened. By comparing one phase directly with another, we can appreciate both the similarities and the originality of each phase. This is particularly true at Amiens where we can contrast the strength and power of High Gothic with the dazzling virtuosity of Rayonnant.

The flanks of the nave have a solid power reminiscent of Chartres but with more vertical force. The side chapels were added later during the fourteenth century, giving the interior more depth and the exterior a flat surface. The north flank is like a screen of glass with a balcony at the triforium level over the large chapels of the nave aisles. The moment of transition is perhaps best viewed on the northern side of the cathedral. At the point where the north-transept façade meets the eastern side of the transept, a gabled pinnacle appears. From that point completely around the chevet to the south-transept façade, the upper story of Amiens is an extravaganza of pinnacles, gables, and arcaded flying buttresses turning and facing in almost every direction.

To the north of the cathedral is the Bishop's palace, now a research center, and a quiet park with tall trees that unfortunately block our view of the chevet. From here we can see the north-transept façade and the north tower. In the Place Saint-Michel next to the park we have a full view of the remarkable chevet of Amiens and can appreciate the changes made between 1220 and the 1250s. The slender first-story chapels retain the simplicity of High Gothic, but at the clerestory level the new style is fully revealed. At the roofline the windows are crowned with sharp gables that pierce the upper balustrade. Bony has commented, "The gables have become so insubstantial that they look rather like cutouts of plywood."[9]

Above the chapels the piers and flying buttresses create a forest of vertical stone that completely envelops the upper chevet (fig. 28). The upper buttresses have a simple base and a gabled top that supports yet another

the top. Nevertheless, the western façade of Amiens is remarkable in the very organization of its richness.

To spend an hour at sunset viewing the evening light glowing on the stone and shining on the glass of the façade is a truly memorable experience. The parvis or square in front of the cathedral opens to the north and the hill on which it sits falls away, allowing the visitor to gain a full perspective of the façade against the sky. The square is often uncrowded and, unlike in other cities with great cathedrals, traffic does not normally flow around it, so it is quite possible to get unobstructed photographs of the western façade.

At Amiens, both the interior and the exterior illustrate the change from the 1220s to the 1250s, from High Gothic to Rayonnant. Moments of transition are often the most intriguing in Gothic architecture. When we

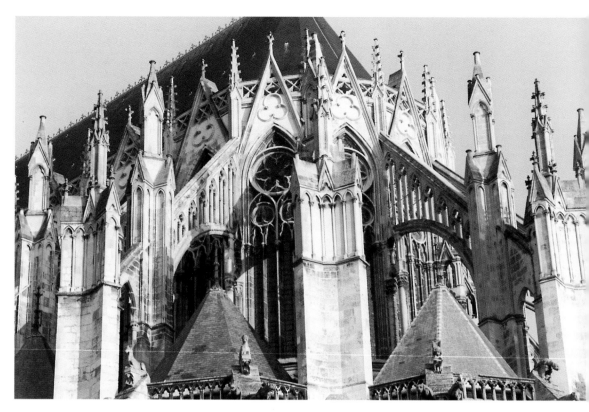

28. Amiens Cathedral, upper stories of the chevet, 1250s–1260s.

pinnacle. Unlike the buttresses of the nave, the choir flyers are slender and steeper with openwork that reflects the design of the upper choir and transept windows. As the buttresses and flyers march around the chevet, there is a sense of tremendous energy, complexity, and verticality. The upper and lower stories are completely different, and yet so complementary that they remain in harmony.

After having toured the entire cathedral, we look for the appropriate place to say farewell. Should it be here at the east end with its wonderful pinnacles? Or should we slowly retreat along the road on the northwest corner of the façade, stopping and savoring the splendor as the setting sun sparkles off the great rose window? It is difficult not to feel poetic as you leave this extraordinary expression of imagination.

BEAUVAIS

Cathedral of Saint-Pierre

At Beauvais we immediately recognize that we are in the presence of an intense striving for ultimate monumentality. As we approach and enter this great cathedral, we discover the many contradictions of that striving in both the spiritual and technical realms. People ask, "Isn't Beauvais the tallest cathedral?" Yes, the vaults are 159 feet high, twenty feet higher than Amiens and forty feet higher than Chartres. "Didn't it collapse?" Yes, partially. "Was it ever finished?" No. This combination of achievement and failure continues to intrigue us. Perhaps because Beauvais represents human limitations as well as worldly and spiritual aspirations, we continue to speculate and wonder about this colossal edifice (fig. 29).

Beauvais is an awesome fragment and fragile survivor of catastrophes. The original choir and the eastern aisle of the transept were completed in 1272, and some of the vaults collapsed in 1284. Reconfiguring and rebuilding began immediately in the choir, and by 1324 this work was finished. A 291-foot stone crossing tower with a wood steeple was completed in 1569 and collapsed four years later just after the worshipers had left the building. In the sixteenth century Martin Chambiges built the transept with its great façades, one of the supreme achievements of Rayonnant design. A five-aisle nave was contemplated many times over the centuries but never constructed.[1] Because of the site, any nave would probably have been short, possibly four or five bays in length. Part of the old Carolingian cathedral of the ninth and tenth centuries, called the Basse-Oeuvre (Lower Work), remains attached to the west side of the transept. At the beginning of World War II, Beauvais was nearly entirely destroyed by incendiary bombs in 1940. The cathedral suffered a direct hit but only the organ was seriously damaged.

Beauvais was begun during a period of architectural, political, and economic transition. Philip Augustus (r. 1180–1223), having driven the English out of France north of the Loire, was willing to tolerate the independence and strength of the bishop-counts in his realm. Changes in agriculture and the growth of cities had created great wealth for the clergy, which they used to expand their religious and temporal authority. This led to direct conflict with the monarchy during the time of Queen Blanche of Castille's regency and the reign of her son Louis IX. Many bishops claimed allegiance to a higher authority and used the power of excommunication to intimidate the secular establishment, particularly the monarchy. The Bishop of Beauvais, Miles of Nanteuil, provoked a clash with Blanche and Louis by accusing Blanche of sleeping with the papal legate and by proclaiming his allegiance only to Saint Peter, patron saint of his cathedral.[2] Unfortunately, the bishop was nearly insolvent due to the enormous expenses of building the cathedral, and he imposed oppressive taxes on the citizens of Beauvais, particularly the wealthy merchants. The riots of 1232–1233 led to his removal and brought the cathedral building campaign to a halt until the late 1230s or early 1240s.

Stylistically and structurally this delay had a great impact. During the late 1220s and the 1230s, the cathedrals at Amiens and Troyes

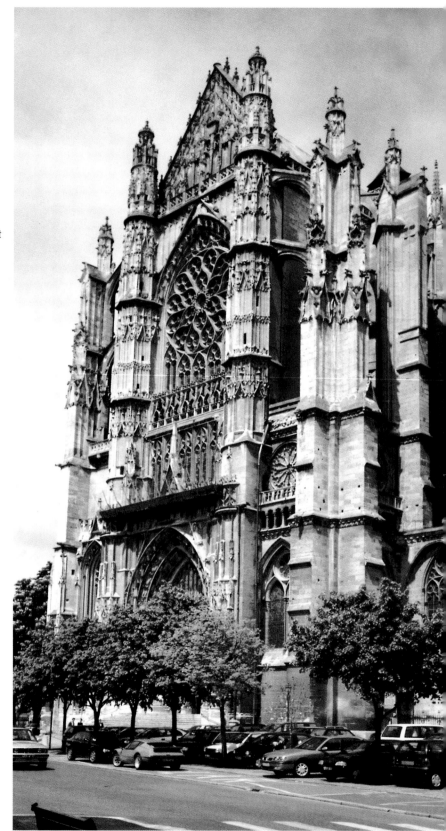

29. Beauvais,
Cathedral of Saint-
Pierre, south-transept
exterior, early 16th
century.

and the Abbey of Saint-Denis were moving away from the High Gothic massiveness of Chartres and Reims to the insubstantiality and linearization of Rayonnant design. This may have led the Beauvais architects of the second building campaign to provide inadequate structural support in an attempt to conform to the new, thinner style. Robert Mark proposed that the vaults probably collapsed because one of the external buttresses over an aisle pier was improperly placed and was cracked by wind stress, bringing down the flyer and the upper vaults as well.[3] Stephen Murray, in his comprehensive study of Beauvais Cathedral, has concluded that no one specific detail caused the failure, which he believes was the result of a number of decisions made during the original .design and subsequent building campaigns. "The collapse of the upper choir in 1284 should be seen in the context of a monument that embodied certain inherent weaknesses (the tendency of the slender aisle piers to bend inward) and the gigantic scale of High Gothic, yet with the structural elements reduced to conform to the metallic brittleness of Rayonnant."[4]

Beauvais demands that we embrace its astonishing height (fig. 30). The great verticality is so mesmerizing that it can overwhelm our ability to appreciate the other aspects of what is a truly remarkable architectural accomplishment. Because of the towering proportions and the relatively short length of the interior, it is difficult to gain a proper perspective and we tend to look at one thing or another and never obtain a coherent sense of the whole. Unlike other great cathedrals with fully completed naves, Beauvais makes us feel both lost in the great vertical void and constrained as we push against the west transept wall to try to attain an adequate view of the elevation and vaults. Because Beauvais has some missing chapters, it is not an easy church to read. The magnitude of the truncated interior can overwhelm us.

When the choir was rebuilt after the collapse in 1284, additional piers were inserted between the existing aisle and choir piers, and six-part vaults replaced the original four-part ones. The three broad bays of the choir arcade were replaced with six very narrow arches, effectively screening our view of the ambulatory and denying us the balancing effect of a horizontal space. The attenuated bays with sharply pointed arches seem squeezed into place, giving us an increased sense of verticality and instability (fig. 31). You can see the outline of the original arches on the masonry at the top of the choir arcade.

The ground plan of the choir and ambulatory at Beauvais is very similar to that of Amiens. The choir has six straight bays under three six-part vaults and seven openings on the hemicycle. The enormous central space of the choir is both wide and tall, in contrast to the confined space of the aisle, ambulatory, and chapels. The great screen of glazed triforia and clerestory windows and the spacious six-part vaults are one of the most fantastic achievements of Gothic architecture.

Visually as well as architecturally, the colossal height of Beauvais comes from the top down rather than from the bottom up as it does at Bourges. The top of the choir arcade is less than half the height of the total elevation. The vaults are so high and the ribbing so thin that the six-part vaults seem to float above the building (fig. 32).

There are two aisles along the straight portion of the choir and one around the hemicycle, which has seven shallow chapels. Unlike Amiens, where the axial chapel is deeper, all of the chapels at Beauvais are basically the same with some minor differences in size. The inner aisle at Beauvais is incredibly tall (69 feet) with a much lower outer aisle (fig. 33). The tall inner aisle of the ambulatory, opening onto relatively low chapels beneath a small lower-clerestory window and triforium, is more confined than the lateral spaciousness of Amiens cathedral.

The insertion of new piers after the collapse of 1284 not only screens our view of the ambulatory from the choir but also blocks our view of the choir from the aisle. The outer

30. Beauvais Cathedral, choir elevation, late 13th century. Reaching 159 feet above the pavement, the vaults of Beauvais are the highest in Gothic architecture.

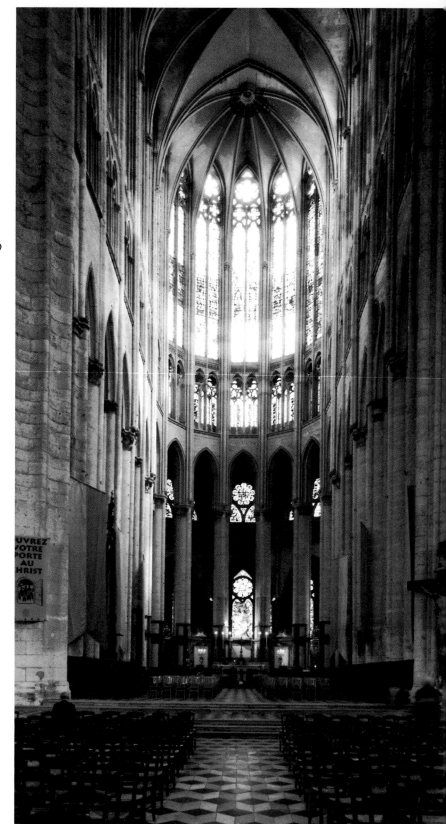

aisle on the south side ends abruptly at the first bay because a supportive wall was added in the fifteenth century. These later modifications severely limit our ability to appreciate the spatial continuity between the choir and the outer spaces, and make it much more difficult to comprehend the composition of interior space.[5] What was once an integrated if not totally unified space is now compartmentalized into inner and outer zones. Nevertheless, the view of the clerestory windows of the choir from the ambulatory is stunning.

At Beauvais the tall inner space of the choir is ringed by a collection of separate lower compartments of the outer aisle and shallow ambulatory chapels.[6] The outer aisles stop abruptly at the hemicycle, and as we enter the south aisle we are quickly channeled into the tall inner aisle while our view of the choir is obstructed by the narrow bays and ironwork screen. The low ambulatory chapels bring our gaze downward instead of upward into the inner-aisle vaults, which remain rather inaccessible. All in all, walking around the choir is a confusing experience because we are confined and do not have enough space to get a sense of perspective.

Very little stained glass survives, but on the south aisle there are two important scenes of the Crucifixion and Saint John on Patmos writing the Book of Revelation (figs. 34, 35).

Built in the sixteenth century under the direction of Martin Chambiges, the transept is, by itself, a monumental structure that projects one bay beyond the body of the building (fig. 36). Nearly 200 feet in length, the central aisle is flanked by single side aisles, each with its own three-story elevation, comparable to the tall inner aisle of the choir with some modifications. The east aisle now functions more as part of the choir than as a transept aisle because of the additional piers built between the crossing tower and the first choir piers after the collapse of the choir vaults in 1284. The vault over the crossing is wood, inserted after the tower collapsed in 1569; the adjacent vaults are six-part as in the choir, and the end vaults are four-part. The

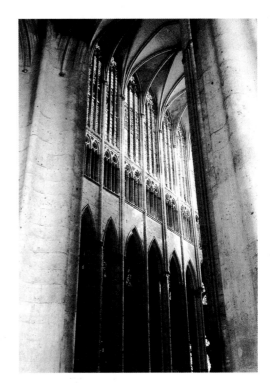

31. Beauvais Cathedral, north elevation of the choir, 1225–1350.

interior of the transept is sparsely decorated, particularly the sixteenth-century piers on the west side, which are of a molded or undulating design with no attached columns or capitals. This might be called minimalist-gigantic Gothic architecture, and is in direct contrast to the lavish design of the façade exteriors.

The low outer aisles and chapels below the tall upper stories of the choir called for very tall external buttresses. Because the builders chose fairly shallow flyers, the buttresses are by necessity extremely tall, and the decorative pinnacles reach above the top of the clerestory, creating a screen that surrounds the cathedral and gives the building a rectangular silhouette quite unlike the sloping exterior of Bourges or the chevet of Amiens.[7] These slender piers visually define the perimeter of the body of the building and narrow our view of the upper stories (fig. 37).

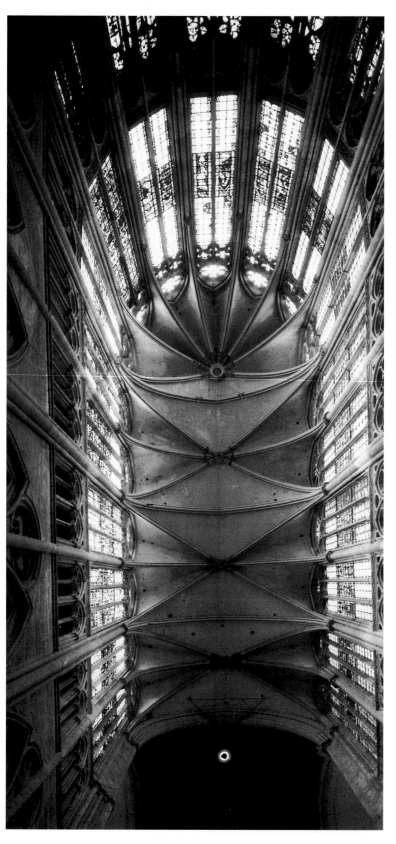

32. Beauvais Cathedral, choir vaults, 13th and 14th centuries.

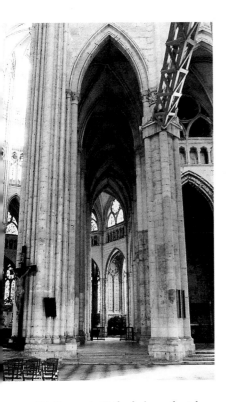

33. Beauvais Cathedral, south aisle, 1220s–1270s.

34. Beauvais Cathedral, choir, The Crucifixion, 1340s.

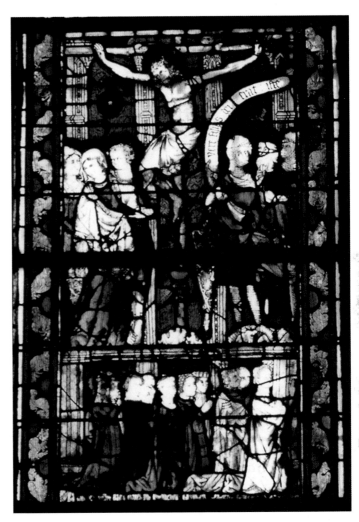

On the outside we have some distance with which to view the cathedral and can see more clearly that the colossal height of the upper stories is in marked contrast to the low first-story chapels. The aisle triforium and clerestory seem almost perched on the short chapels and stocky clerestory windows. The lower-clerestory windows look like full lancet windows and oculi that have been cut off at the shoulders with only their heads remain-

ing. Wider than either the chapel or upper-clerestory windows, they provide an awkward transition from one level to the next. The exterior does reveal the stylistic shift between the first-story chapels of the High Gothic 1220s and the glazed triforium and clerestory of the Rayonnant 1250s. The chapels, framed by heavy buttresses with plain drip molds, are in contrast with the slender lancets of the glazed triforium and clerestory, as well as

41

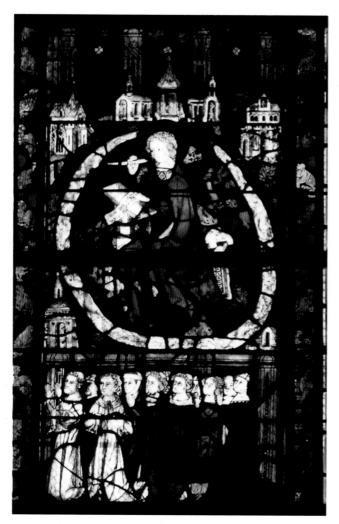

35. Beauvais Cathedral, choir, Saint John on Patmos Writing the Book of Revelation, 1340s.

36. Beauvais Cathedral, north-transept interior, early 16th century, modern braces.

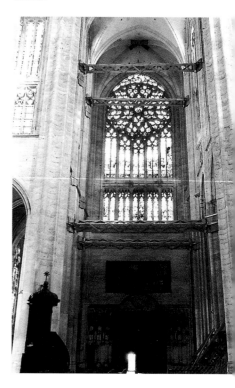

with the increased decoration on the upper portions of the buttresses. We need to remember that the straight bays of the choir were rebuilt after the collapse of 1284, and that we are seeing a span of construction that lasted over eighty years (fig. 38).

The builders of the thirteenth-century cathedral had intended to erect a pair of towers on each façade. This idea was abandoned by Chambiges, possibly because he recog-

nized that the great height of the façades did not require flanking towers. Instead he created highly decorated cylindrical piers that rise up beyond the crowning gable and more than compensate for the missing towers.

Every portion of the south façade is covered with a fine filigree of blind and glazed lancets, with the exception of the rose window, which is a monumental but delicate design. Beneath the rose are three levels of

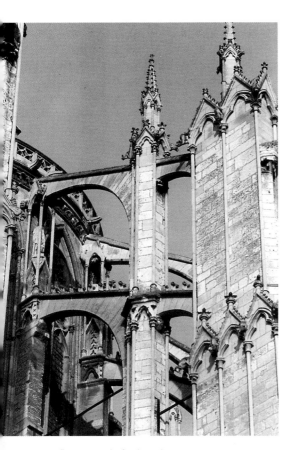

37. Beauvais Cathedral, flying buttresses of the chevet, 1220s–1270s.

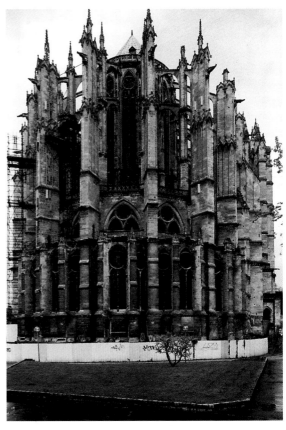

38. Beauvais Cathedral, chevet, 1225–1270s.

glazed lancets: triforium, gallery, and five double-lancet windows that support the rose. The crowning gable, composed of slender blind lancets and a gallery of open ones and little pinnacles on the peak of the gable, is magnificent (fig. 39). The north façade is a plainer version of the south, primarily because the flanking piers are unadorned in the High Gothic style. The decorative grid of the surface is also less intricate. The south

transept is one of Martin Chambiges's masterpieces, displaying the intelligence, wit, and virtuosity that made him the premier architect of early sixteenth-century Gothic architecture.

In spite of the tremendous achievements of the choir, transept, and transept façades, it is difficult not to see Beauvais Cathedral as being both a success and a failure. "Beauvais Cathedral is a truncated giant—a building

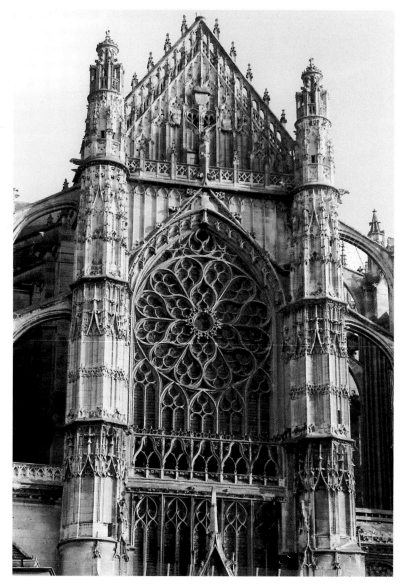

39. Beauvais Cathedral, detail of south-transept exterior, 16th century.

where tantalizing glimpses of the nearly sublime vision of its [original] designers are seen through the tangle of later additions and consolidations."[8] The collapses of the choir vaults and the great crossing tower continue to fascinate us as much as the staggering height and overall size of the building. The disrup-tion of the first building campaign in 1232 and the failure of the vaults in 1284 precipitated design decisions that structurally and visually compromised the interior in a manner the original designers could never have anticipated. Beauvais is a remarkable building of "what ifs."

40. Beauvais, Church of Saint-Étienne, Tree of Jesse Window, 1520s. The late Gothic choir of this church contains one of the finest collections of 16th-century stained glass in France.

Church of Saint-Étienne

The Church of Saint-Étienne in Beauvais is an important and rewarding building. The nave was begun in the 1220s, and the ribbed vaults in the aisles, among the earliest in France, may have had a significant influence on Early Gothic architects at Saint-Denis and Sens (see fig. 11).

Work began on the choir around 1500, possibly by Martin Chambiges just before he started on the transept and façades of the

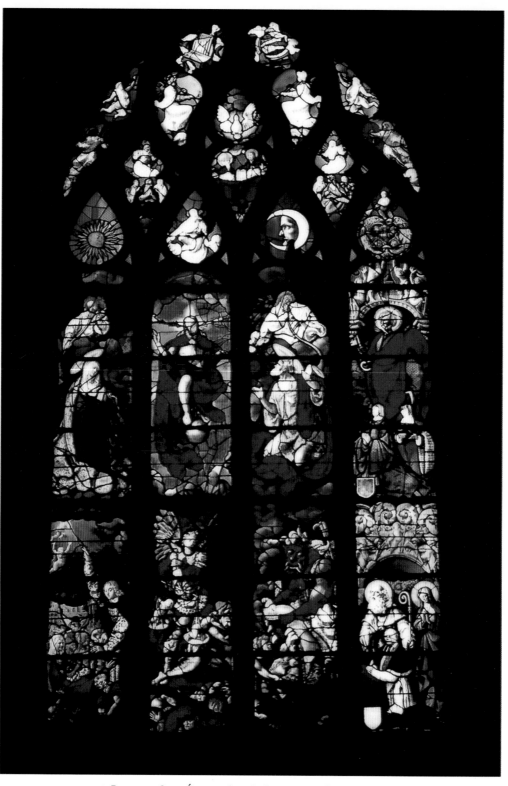

41. Beauvais, Saint-Étienne, Last Judgment Window, 16th century.

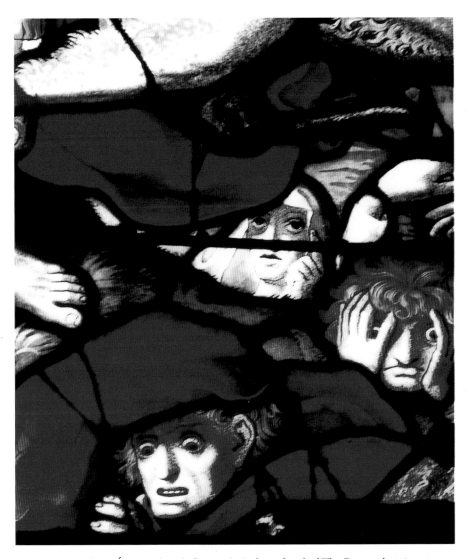

42. Beauvais, Saint-Étienne, Last Judgment Window, detail of The Damned, 16ᵗʰ century.

cathedral. The two-story elevation has simple broad arches with molded piers, similar to those in the transept of the cathedral, which rise uninterrupted to the vaults. The four-lancet clerestory windows are quite tall, flooding the choir with light. A Flamboyant rose window on four double lancets fills the upper east end. The flat ambulatory behind the choir has some of the most surprising and dramatic stained-glass windows in northern France. Designed by Engrand Le Prince in the 1520s, these windows are superb examples of the Renaissance style in stained glass (figs. 40, 41, 42). Saint-Étienne is a light and spacious church, one that should not be missed on any visit to Beauvais.

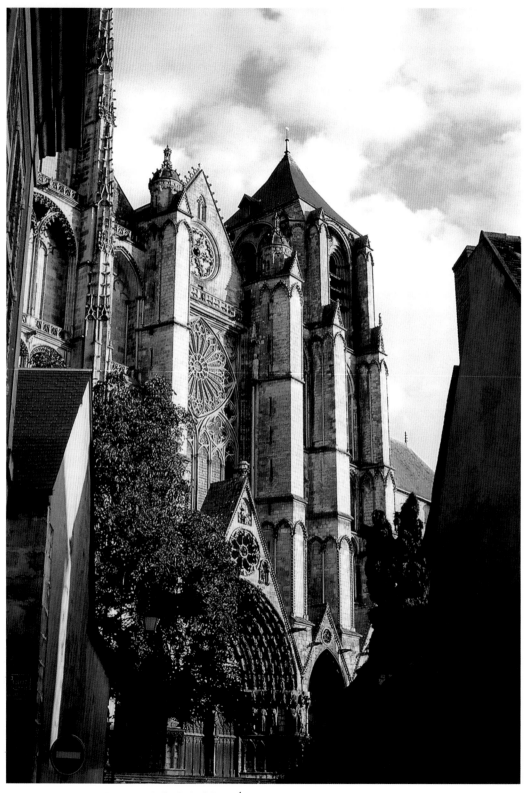

43. Bourges, Cathedral of Saint-Étienne, west façade, 13ᵗʰ and 15ᵗʰ centuries.

BOURGES

Cathedral of Saint-Étienne

The grandest, the most strangely and fabulously beautiful building in Europe
—Aldous Huxley

At the same time that Chartres was begun, another Gothic cathedral was rising in the center of France that was equally monumental, visionary, and architecturally daring. Less well-recognized and less central to the development of Gothic architecture than Chartres, it initiated a parallel High Gothic tradition of magnificent cathedrals. Thought by many French people to be the most beautiful in France, this cathedral was so complete in its conception and so remarkable in its execution that only a few cathedrals in western France and Spain took their inspiration from its transcendental vision.[1] This rising fugue of complexity and simplicity, of wholeness and detail, of space and light, of strength and lightness, of power and refinement is the Cathedral of Saint-Étienne of Bourges. It is one of the true architectural glories of Western civilization (fig. 43).

Situated near the precise geographical center of France, the city of Bourges is located in the rich agricultural region of the Berry, between Burgundy and the Loire. In medieval times, Bourges was the southern outpost of the Capetian kingdom, and during the height of English occupation in the fifteenth century it became the capital of France for a brief period. Somewhat off the beaten track, Bourges is farther from Paris than Chartres, Amiens, or Reims, which may account for the lack of recognition that is clearly due this great and very beautiful cathedral.

Bourges itself is a charming city dating from Roman times. During the Middle Ages the city grew rich from the manufacture of cloth and armaments. In addition to the cathedral, the Palace of Jacques Coeur is one of the most important and remarkable late Gothic domestic buildings to survive to modern times. It was the home and warehouse of the wealthiest man in Europe and the most influential merchant France may have ever had. Jacques Coeur imported goods from the entire known world, including the Near East, and he financed the royal treasury of Charles VII, Joan of Arc's king, whom the English mockingly called the "King of Bourges." Charles ultimately betrayed Jacques Coeur and imprisoned him on the ludicrous charge of having poisoned the king's mistress, Agnes Sorel. Derided as a weakling king in Shakespeare's *Henry V*, Charles was an effective monarch who finally drove the English out of France except for Calais, and made peace with the rebellious Burgundians. To his shame, Charles abandoned Joan when she was captured by the Burgundians and burned at the stake by the English in 1431.

Saint-Étienne of Bourges was begun in 1195, and its overall structure was completed in the 1270s. The first architect had to build over an early Christian church and the walls of the town, and his accomplishment reflects the genius of medieval architects in transforming existing limitations into magnificent and coherent buildings. Really a lower choir, the crypt was part of the first building campaign, and it is second only to that of Chartres in size. Because the crypt is not underground but on the side of a hill, it has large windows

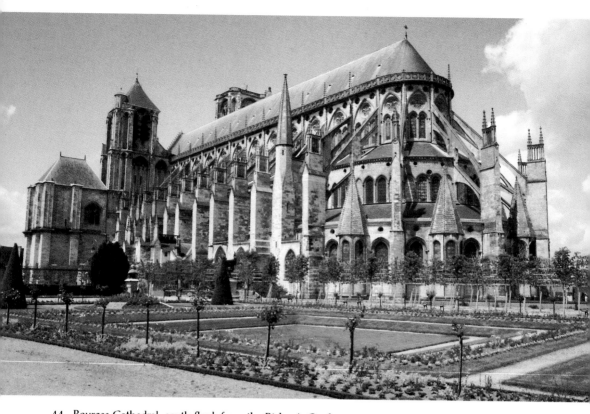

44. Bourges Cathedral, south flank from the Bishop's Garden, 1195–1300.

and is light and spacious rather than dark and closed. It is a beautiful, curved, vaulted room with wonderful columns and capitals as well as parts of the original rood screen, the marble recumbent figure of Duke Jean de Berry, and a sculptural group of Christ's Entombment.

Adjacent to the cathedral is the lovely Bishop's Garden that gives the visitor one of the most unobstructed views of any French cathedral. Approached from the garden, the cathedral's long flank looms before you like a tethered dirigible or an elegant mountain range with a long straight crest. The three levels of windows serve as foothills amid a spectacular forest of buttresses, windows, pinnacles, and conical towers. Although there are side portals, Bourges has no transept projecting beyond the perimeter of the building,

so the flank is one uninterrupted sweep (fig. 44).

The magnitude of the exterior is kept in balance by the building's proportions and the perfect ordering of the windows and buttresses complemented by the details. Nothing seems excessive or out of place. As you move toward either the front façade or the rear choir, you become aware of one of the great intangible features of Bourges, its rhythm. The buttresses march along the side in great dramatic strokes with contrapuntal accents of arches, windows, and lunettes. Even the nineteenth-century balustrade at the base of the roof, with its pinnacles and hollow rosettes, binds the building together laterally while it repeats the vertical motifs of the windows below. The pinnacles on top of the exterior buttresses also were added in the

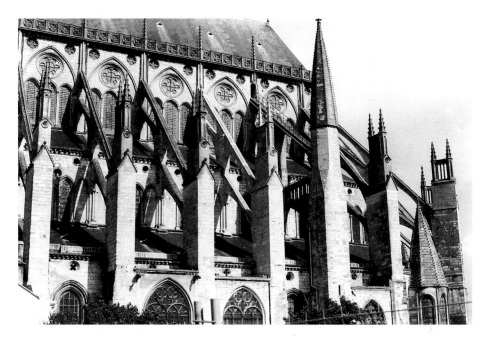

45. Bourges Cathedral, south flank
and choir buttresses, 1195–1230s.

46. Bourges Cathedral, chevet,
1195–1214.

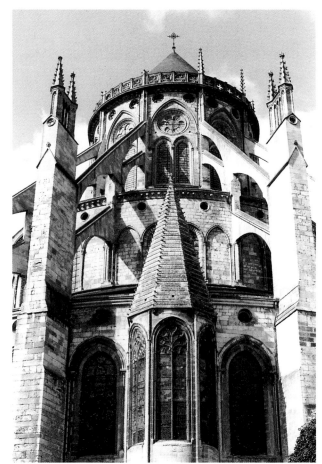

nineteenth century. All of this grandeur flows naturally along the side, punctuated by a large conical pier as the flank curves around the choir (fig. 45).

The eastern end of Bourges floats like a queen's crown at a great height. The exterior rises in three tiers of windows that narrow as they rise to the top, separated by steep flying buttresses that reach to the middle of the upper clerestory zone. The radiating chapels project from the wall like small detached towers with steep conical roofs. At the second level the twin lancets and small oculus of the lower clerestory are framed by blind arches that create a continuous arcade. Finally, at the top, the upper-clerestory lancets and oculus within a framing arch dominate the exterior elevation. Plain shed roofs cover the upper and lower triforium spaces, forming two horizontal bands around the end of the cathedral. The nineteenth-century balustrade is an elegant tiara beneath the steeply sloping roof (fig. 46).

If this sounds complicated and baroque, it is not. The exterior has a traditional feeling to it that suggests the interior structure and repeats the theme of one grand totality, an overall, almost classical framework that is amplified by superb integration of space and detail. We are nevertheless unprepared for the radical nature of what waits inside.

The vaulting at Bourges is the same height (118 feet) and the nave is slightly shorter in length (395 feet) than Notre-Dame in Paris. In spite of this, Bourges seems longer on the outside and much larger on the inside. The bishops of Bourges and Paris were brothers, and there is much speculation that Bourges was heavily influenced by Notre-Dame, which was begun thirty years earlier. Both are five-aisle churches with a central nave and two surrounding aisles on each side. They are, however, very different churches because Notre-Dame's arches and twin aisles are rather low while the nave arches and inner aisles of Bourges are among the tallest in France. Bourges's great impact comes not only from its height but also from its great width. At 130 feet, it is the widest church in France. The two side aisles are visible from the nave and, indeed, from any point in the entire church. This combination of great height and width creates a spaciousness in every direction that rivals the greatest cathedrals.

It is revealing to contrast the architectural solutions that the masters of Chartres and Bourges developed to take Gothic architecture to the next step. The flying buttress allowed them to abandon the second-story gallery and use the three-story approach that had been employed at the beginning of Gothic at Sens and refined at Braine. Their solutions, however, were based on entirely different concepts and resulted in completely different buildings.

The Chartres architect took those three stories and increased the height of the nave arcade and clerestory, with a strong triforium in the middle. The arcade and the clerestory are the same size, giving the overall elevation a balanced look. At Bourges, the master kept the triforium and clerestory short and achieved monumental height solely by raising the nave arcade to the astonishing height of 69 feet. This allowed him to place a tall inner aisle completely around the nave and choir, giving that aisle the same three-story elevation as the nave, and with an outer aisle to create three levels of windows to flood the interior with light.

While there is an ineffable mystery and dark grandeur about Chartres, at Bourges we have the sense of transparent openness and uniformity of volume. Chartres is a compartmentalized building with a massive stone framework and many fabulous parts. As we enter Chartres our attention is drawn down the length of the nave to the great clerestory windows of the choir. From there our attention moves from place to place, each one leading us to another marvelous experience. The sources of light at Chartres are the high clerestory windows along the nave, the

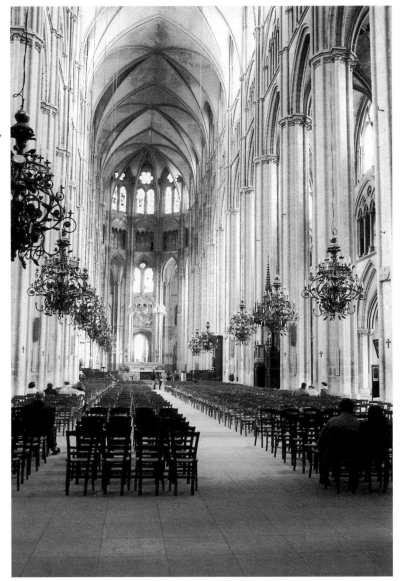

47. Bourges Cathedral,
nave and choir,
1195–1255.

aisle and ambulatory windows, and the great rose and lancet windows above the front façade and at the ends of the transepts.

In contrast, Bourges creates an overwhelming sense of open space and light of nearly classical proportions. Rather than being drawn in a particular direction, we are likely to stand in one place and take in the entire interior at once. As Jean Bony has said,

"At Bourges there is only one spatial unit, the whole building."[2] More than any other French cathedral, Bourges has the feeling of simplicity and of complexity at the same time. We first experience all of its dimensions in the great totality of its interior space and then each dimension in turn. The shock of the whole is profound; we are stunned by the height of the nave arcade and the nave vaults,

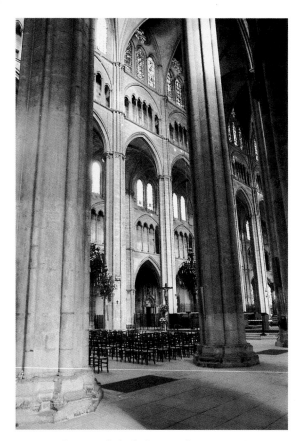

48. Bourges Cathedral, nave elevation, 13th century.

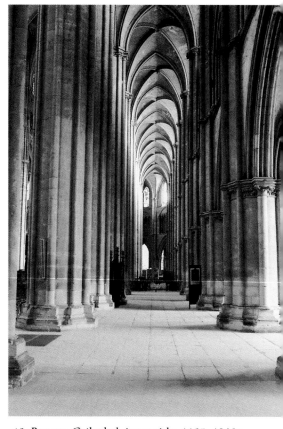

49. Bourges Cathedral, inner aisle, 1195–1260s.

the long uninterrupted sweep down the nave and choir to the open altar, and finally the sense of lateral and diagonal movement into the inner and outer aisles (fig. 47). We see its totality and at the same time understand how each element interacts with the whole.

The nave arches, 69 feet tall, open the interior volumes in a remarkable way. The tall ovoid piers with their slender colonnettes let the space flow around them into the aisles. The full shape of the piers continues up the wall through the triforium to the springing of

the vaults. The nave piers have no capitals on the nave side and the attached shafts rise uninterrupted to the ribbed vaults.[3] Where you would expect a capital at the springing of the nave arch, the architect placed a delicate floral molding running behind these shafts but relating visually to the arch and aisle capitals. A full capital would have been inappropriate, but no capital at this point would have created a slightly barren impression. The subtlety and finesse with which the Bourges architect conceived and executed such details

are extraordinary. The convex shape of the piers with attached colonnettes rising from floor to vault gives the interior a delicate but wholly articulated verticality. The Bourges architect chose refined decorative elements to balance the incredible scale of the interior. It is at once transcendent and human. The piers do not project into the nave, which gives Bourges a "weak bay" system. In contrast, at Chartres and Reims the enormous piers and colonnettes jut into the nave and each bay is fully delineated from the pavement to the vaulting. The effect at Bourges is a much smoother arrangement and the rhythm of the bays is more subdued than at Chartres. The height of the nave arch defines each bay; projecting piers would have been incompatible with the smooth linear values of the interior (fig. 48).

The tall nave arcades open onto singularly tall inner aisles that run, along with the outer aisles, the length of the nave and choir, meeting at the main axis of the church. At Bourges there are two sets of elevations because the very tall inner aisle duplicates the nave elevation with arch, triforium, and clerestory mirroring those of the nave. If the nave vessel were removed from between the aisles, the remaining church would still be very tall. Looking from the outer aisle across the nave, we see two sets of arcades, triforia, and clerestories with the full windows of the outer aisles at the bottom and recognize that Bourges essentially has a five-story elevation, a unique achievement. These twin elevations, along with the windows of the outer aisles, provide three levels of light that permeate the entire cathedral.

The tall inner aisles echo and expand the great vertical space of the nave, creating lateral and diagonal vistas in every direction. The dramatic prospect of the nave is fully matched in the inner aisle in a more compressed, telescoped form. When we stand in the aisle, we have an almost unobstructed view of the nave as well as an astounding perspective of the tall, narrow aisle running the length of the cathedral. Flanked by both the

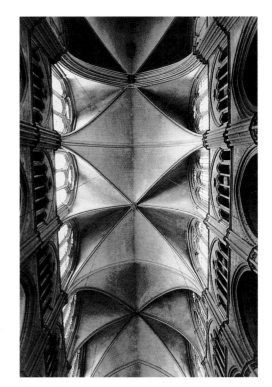

50. Bourges Cathedral, nave vaults, 13th century.

nave and outer aisle, the attenuated space of the inner aisle has an intense energy and strength of its own (fig. 49).

Because there is no crossing and the choir is not screened off as at Chartres and other cathedrals, the choir and nave are seen as one unified space. There was a stone choir screen across the nave in medieval times, but it was removed in the eighteenth century. Remnants of the screen are located in the crypt. The way in which the two aisles embrace behind the choir continues the spaciousness of the nave while giving the ambulatory a more intimate feeling than we experience in the colossal nave.

Part of Bourges's perfection comes from an appreciation of the architectural details and the way they contribute to the overall effect. "The use of linear values is particularly subtle at Bourges . . . A tight but light grid of thin lines—shafts, ribs, stringcourses, and mold-

51. Bourges Cathedral, ambulatory,
1195–1214.

52. Bourges Cathedral, ambulatory,
1195–1214.

ings, all delicately drawn, not too dark, rather blond in tonal value—runs over the surface of the whole structure, piers and vaults and arches and wall surfaces alike. . . . Bourges is a highly elaborate work of art, complex in its interrelationships and handled with superior artistry."[4]

The height of the nave and inner aisle is balanced by the gracefully arched triforia, which have a broadening and balancing effect just above the tall columns of the two arcades. Some critics have seen the triforia as a design defect at Bourges, crowded into the space between the arcade and the clerestory. My own belief is that the dual triforia of the nave and the inner aisle bind the entire interior horizontally and give balance to the great height of the vaults and arches. It seems clear that the architect's intention was to give predominance to the incredibly tall nave arcade and to provide light at the second level.

Crowning the nave are the magnificent six-part vaults, each spanning two bays below. The ribs of the vaults seem ready to spring into motion and create a sensation of pulsating rhythm moving down the nave vault by vault like a series of billowing sails (fig. 50). The six-part vault was somewhat old-fashioned and was being replaced by the four-part vault at the end of the twelfth century. It is interesting to speculate as to why such a visionary architect would choose the older form. Although the simple ovoid piers function as major and minor piers appropriate for six-part vaulting, they are visually so similar that it takes a moment to realize they are not quite the same. Four-part vaults, as at Chartres and Reims, would have created a choppy, rectangular effect inappropriate to the expansive, open aspect of the great interior. The six-part vaulting, with its buoyancy and sprung rhythm, works magnificently. The central cells of each vault are broad and shallow, creating a sail-like impression as they move down the nave. In contrast, the outer cells are quite deep and creased to accommodate the arches of the clerestory windows. The light playing upon them in the afternoon can be quite dramatic. By looking directly above, we can see, of course, that they are all the same size, but as our gaze follows them down the nave they appear to change, becoming narrower until at the end of the choir they appear to be thin slits. This combination of broad central and narrow outer cells creates a double or contrapuntal rhythm. The increasingly quick rhythm of the outer cells is countered by the leisurely cadence of the central ones. The thin transverse arches do not break the flow of the vaults down the nave and choir. The overall rhythm seems to accelerate at the end where the narrow vaults of the hemicycle are tightly grouped. It is both dynamic and restful at the same time, and remarkably graceful.

The double ambulatory around the choir at Bourges continues the uninterrupted coherence and unity of the nave by utilizing the same piers throughout. The result gives predominance to the array of stained-glass windows, but the piers, vaulting, and ribs all combine to create the most graceful setting imaginable; the vaulting in the ambulatory is extraordinarily elegant. It is particularly rewarding to sit on a bench behind the choir and comprehend how the builders achieved this result. The aisle ribs embrace the chapels, particularly the diagonal arches as they reach from the aisle pier to the pilasters on the sides of each chapel. Where these two ribs cross, the vaults change from a wide flat cell to a narrow one that seems to penetrate into the space of the chapel itself. The vaults reach down to the middle of the lancet windows, producing a lovely butterfly shape (fig. 51).

Encompassing the exterior wall of the ambulatory, the stunning stained glass forms an almost continuous wall of translucent color and images. The arrangement of the windows is actually quite simple. The five shallow chapels each have three lancet windows and are flanked on each side by two larger ones penetrating the exterior wall. The simplicity of the east end creates a powerful, radiant vision (fig. 52).

53. Bourges Cathedral, detail of Joseph Window, Joseph sleeping, early 13th century.

54. Bourges Cathedral, detail of the Last Judgment Window showing lower panels, early 13th century.

55. Bourges Cathedral, Annunciation Window, 15th century. One of the great masterpieces of Renaissance stained glass.

The stained glass at Bourges is comparable to that at Chartres, but because it is lower, it is more accessible to the viewer, and creates a spectacular effect. Probably no other church has such a brilliant array of glass that can be seen in a single glance as does the ambulatory of Bourges. Most of the windows date from the thirteenth century. The most famous are the Prodigal Son, Joseph, and Apocalypse, as well as the New Alliance and Good Samaritan windows that, like many medieval windows, combine Old and New Testament themes. Medieval theologians interpreted the Old Testament as a prefiguration of the New Testament, and Old Testament figures were seen as foreshadowing future New Testament figures. For example, Abraham's sacrifice of Isaac was seen as a prefiguration of the Crucifixion, Job's suffering foreshadows Christ's suffering during the Passion and the Crucifixion, while Jonah being disgorged from the whale parallels the Resurrection. From the inner aisle we are aware of the extraordinarily brilliant variety of

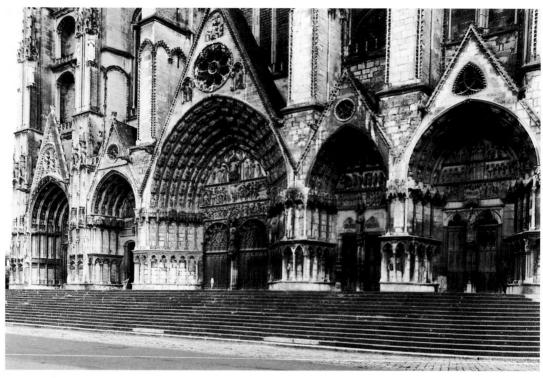

56. Bourges Cathedral, west-façade portals, 1228–1255.

57. Bourges Cathedral, west façade, central portal, Last Judgment, 13th century.

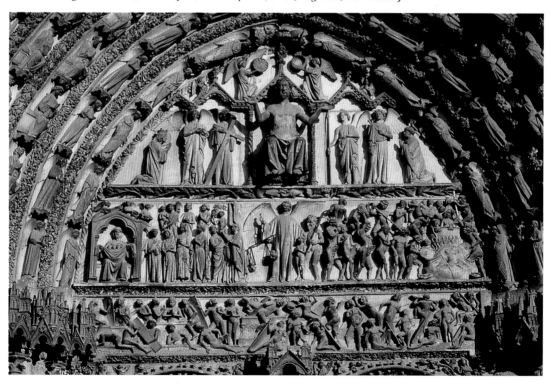

geometrical designs of the ambulatory windows. As we move forward, we delight in the superb details of the compositions. The dramatic scenes are portrayed with great freedom and finesse with the figures overlapping the geometric frames rather than being cramped within their narrative fields. For more on the Passion and New Alliance windows, see the final chapter on reading stained-glass windows (figs. 53, 54).

On the north side of the choir is one of the greatest examples of fifteenth-century stained glass, the Jacques Coeur window, a splendid, dramatic Annunciation (fig. 55). At the west end of the nave, the magnificent fifteenth-century Rayonnant window creates a huge tracery of stone and glass illuminating the entire nave.

The west façade with five portals opening onto its five aisles is one of the most unusual in France. Even with all the remarkable aspects of the interior and exterior, some people find the façade a fitting climax for a visit to this cathedral. Although the centuries have taken a toll on this end of the church, what remains is still hugely impressive and comparable to the great façades at Chartres, Paris, Reims, and Amiens (fig. 56).

The façade is flanked by two rather squat towers. The strange building to the south was constructed in the fourteenth century to serve as a huge buttress for the south tower. The north tower collapsed in 1506, and a new tower was not finished until 1542. The original rose window was replaced in the fifteenth century by the spectacular four-pointed rose window and two triple-lancet windows that crown the west end of the nave.

The two outer portals of the west façade are dedicated to local saints, Saint William on the left and Saint Ursin on the right. The inner side portals are dedicated to the Virgin on the left and Saint Stephen, for whom the cathedral is named, on the right. The central portal, by far the largest, contains one of the most dramatic and important Last Judgments in French stone. In the first lintel we see the resurrection of the dead. Pushing aside the lids of their coffins, the naked penitents gesture toward heaven in hope of salvation. Above them, in the second lintel, Saint Michael holds the scales of justice with his right hand while with his left he protects a young soul from the gleeful devil waiting to grab the child and drag him off to Hell. To Saint Michael's left various devils herd the naked damned into the waiting cauldron of Hell. Their anguish is palpable. On Saint Michael's right, the redeemed patiently, if somewhat smugly, wait in line for admission to Heaven. At the top of the tympanum Christ sits in judgment with angels and objects of the Crucifixion. On our far left, the Patriarch Abraham cradles little souls on his lap. The arch above is covered with a rainbow of small high relief religious figures representing the thirteenth-century vision of Paradise (fig. 57).

Crowning the entire city of Bourges, the Cathedral of Saint-Étienne seems to float above the sixteenth- and seventeenth-century houses on its north flank. There is something timeless and also modern in its unity and simplicity. The grand exterior invites the visitor inside where the great nave and choir wait. This most spacious of buildings has a very intellectual yet serene quality that evokes a stillness and a sense of the eternal. It is hard to imagine leaving the cathedral without a sense of contentment and fulfillment.

If the city of Bourges had only the cathedral to recommend it, a trip of many hundreds of miles would be well worth the effort. With any true masterwork there is a striking sense of both wonder and inevitability. We are simultaneously filled with both a sense of rightness and astonishment here. After seeing this daring and dazzling building, you understand how Balzac could have written, "All Paris is not worth the cathedral at Bourges."[5]

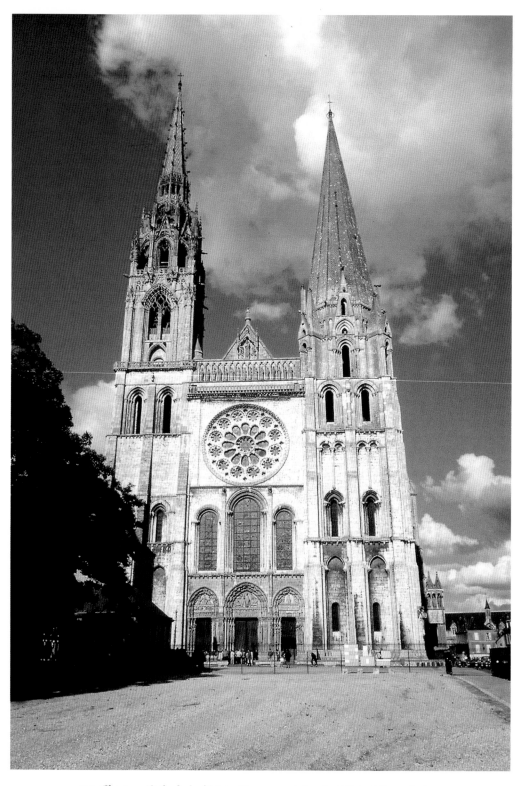

58. Chartres, Cathedral of Notre-Dame, west façade, 11th to 16th centuries.

CHARTRES

Cathedral of Notre-Dame

Whenever I talk with people about Gothic architecture, they want to know about Chartres. They may want to reminisce about their first visit to the great cathedral, and the story they often tell is not of the cathedral itself, but of their experiencing the extraordinary sight of Chartres from a distance of many miles — the dark, towering bulk of the great cathedral looming above the flat open fields of the Beauce southwest of Paris. Walking through the town from the train station, people never forget their first glimpse of the west façade with its distinctive towers. Modern travelers can identify emotionally with the pilgrims who over the centuries made this same approach by foot, horse, or wagon. Chartres brings out the mystic in all of us (fig. 58).

For the architect and the religious pilgrim, Chartres often inspires tears of devotion, tears of recognition. I have spoken with professional architects who wept when they first entered the cathedral. It is a major source of their profession, of their lives. Ordinary travelers, with only a few days to spend in France, feel they *must* see Chartres. It is interesting that many of these travelers really know very little about the cathedral. Being there and seeing it are enough. The experience is a deeply moving event.

There are many striking views of Chartres that last forever: the earlier Romanesque west front, the great south porch, and the buttresses of the chevet seen from the park on the bluff overlooking the old town below. A walk through the old town is rewarding not only for its own sake but also for the sensational views of the cathedral. If you can drive to the hill across the river to the southeast of the church, you will be repaid with a splendid panorama of church, town, and countryside (fig. 59). Even the view from the platform of the train station is remarkable.

On our first trip to Chartres we stayed at a small hotel just up the street from the train station. From our room, we could see the great western towers rising above the rooftops of the town (fig. 60). We went to sleep that night with the window open, and the towers seemed to be floating in the moonlight. For many visitors the easiest way to see Chartres is by taking the train from Paris. It only takes an hour from the Montparnasse station, and you can be back in Paris for dinner. As you walk up from the train station, and turn the corner of the first street, you see the great west façade and towers loom above the low buildings. Coming closer, being drawn on through the little lanes of the town, you finally arrive at the square in front of the cathedral and see the full façade with its wonderful portals and sculpture. The Chartres of our imagination has been waiting, and it will not disappoint us.

Chartres is often seen as the quintessential Gothic cathedral, in a class by itself, and is also revered as the foundation for the great blossoming of High Gothic architecture of the late twelfth and early thirteenth centuries. It is the parent of Soissons, Reims, Metz, Beauvais, Cologne, and Amiens—the pinnacles of High Gothic. None of the other great Gothic cathedrals of that period has escaped the ravages of time, war, or the fateful hand of the restorer as completely as has Chartres. With the exception of the screen

63

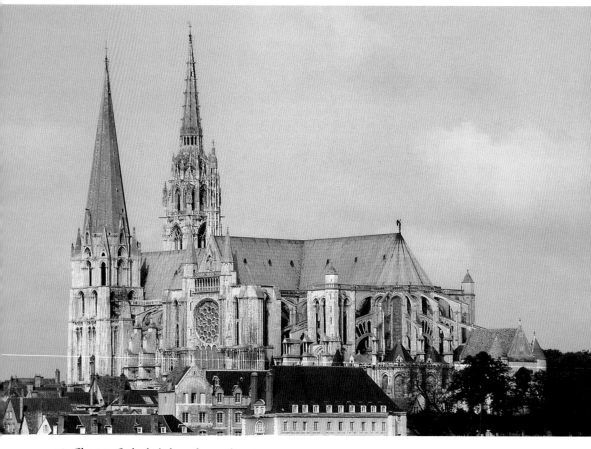

59. Chartres Cathedral, from the southeast.

that encloses the choir and the late Gothic north tower, both of the sixteenth century, the cathedral comes to us very much as it was completed during the Middle Ages.

Although the precise beginnings of the city of Chartres are lost in time, we do know that it was an important Gallo-Roman settlement, and that by the middle of the first millennium Christians had located there. At the end of the tenth century, Chartres became an important center of learning with the arrival of Fulbert of Chartres, who founded the Chartres Cathedral School, one of the pre-eminent scholastic centers in all of Europe. Fulbert, Bishop of Chartres, was an extraor-dinary scholar, churchman, and legal thinker whose teachings led to the twelfth-century

renaissance that shaped much of western thought.

The cathedral we see today is the result of two devastating fires. The first, in 1134, destroyed the front façade of the old Romanesque church. The present façade, with three portals and two towers, was begun in the 1140s. (The north tower was created in the sixteenth century.) The second fire in 1194 destroyed most of the city and the rest of the church except for the narthex and the crypt. In the crypt was the sacred relic, a gar-ment worn by the Virgin when she gave birth to the Savior. The distraught citizens of Chartres believed that they had lost not only a precious religious symbol but also an important source of divine protection.

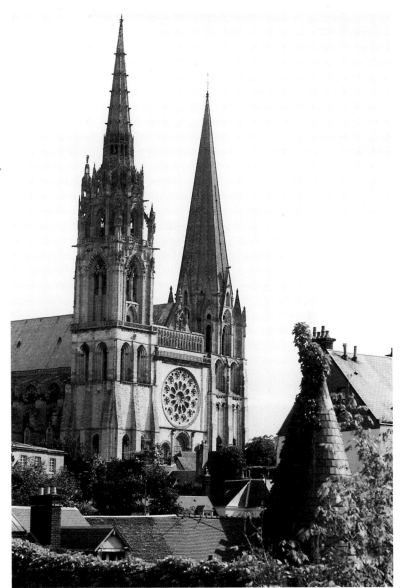

60. Chartres Cathedral, from the northwest.

Pilgrimages to worship sacred relics were an important source of income for many communities. There was great celebration when, three days after the fire, the Virgin's tunic was found in the crypt and displayed to the townspeople. The recovery of the sacred relic was seen as a sign from the Virgin to build a larger and grander church.

This led to the "Miracle of the Carts," a phenomenon of religious devotion where people of all classes, from the poorest peasant to the richest noble, came from across France to do the hard physical labor necessary for the creation of this house of God. People, not oxen, pulled the stone from the quarry to the work site. The bishops of Chartres devoted major portions of their income to the reconstruction. Royal patronage was also an important source of income throughout the construction of the cathedral in the thirteenth

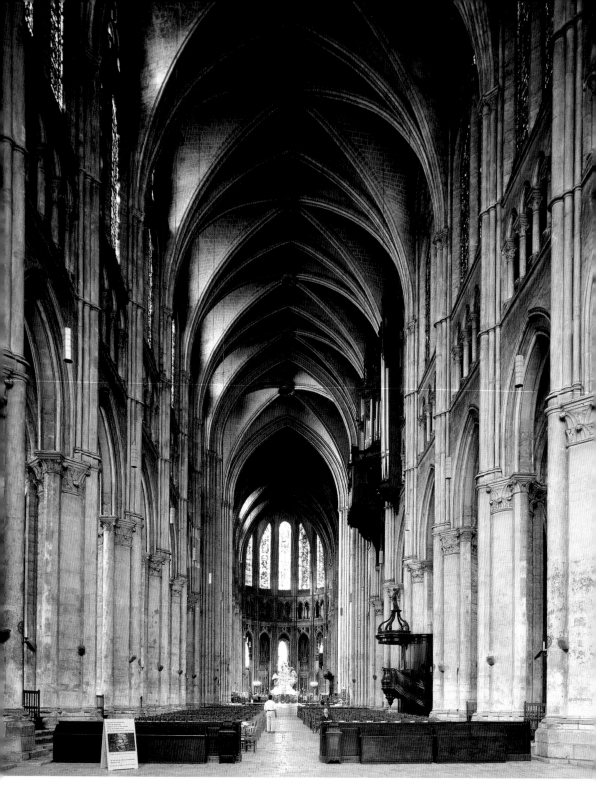

61. Chartres Cathedral, nave and choir, 1194–1220. Photograph by François Lauginie © Centre des Monuments nationaux, Paris.

century. King Philip Augustus contributed the funds for the building of the north porch and Blanche of Castile, the mother of Louis IX and Regent of France from 1226 to 1236, donated the rose and lancet windows of the north transept.

Architecturally, Chartres is a building of many parts, with magnificent stained glass and sculpture throughout the cathedral. The west façade, the north and south porches, the nave elevation, the crossing and transept arms, and finally the choir with its double ambulatory and radiating chapels are all remarkable creations to be studied and enjoyed in turn. From almost every vantage point Chartres is a revelation, in terms not only of beauty but also of architectural theory and practice. To understand these various elements is to lay the groundwork for understanding Gothic architecture (fig. 61).

The most influential feature of Chartres was the three-part elevation of nave arcade, arcaded triforium, and clerestory windows of twin lancets beneath an oculus (see fig. 15). It was the genius of the Chartres architect to take existing elements of Early Gothic architecture and employ them in a new manner for a monumental effect. To understand what the Chartres architect accomplished, we need to look back at those two great achievements of the second phase of Early Gothic architecture, Laon and Notre-Dame (see figs. 77, 101). Although flying buttresses were used at Notre-Dame, both buildings were conceived before this new technique liberated Gothic architecture. In order to gain monumentality at Notre-Dame and Laon, the architects used the second-story gallery as the basic bracing element to stiffen and support the nave wall. Perhaps because of the enormous height, the architect at Notre-Dame also put additional braces outside the building above the outer aisle. This was the birth of the flying buttress.

Medieval architects recognized that by using flying buttresses they could eliminate the second-story gallery and increase the size of the clerestory and the height of the central space of the cathedral. The flying buttress could serve in place of the gallery arch, and with the gallery gone, the architect made the ground-floor arcade and the clerestory the same size, creating an enormous but balanced elevation. In the middle of the elevation a large arcaded-wall passage, the triforium, provides a strong horizontal band throughout the interior. At Bourges, in contrast, great height was achieved by stretching the main arcade without proportionally increasing the upper elements.

Where the designers of Laon and Notre-Dame had used the round column for the main arcade, the Chartres architect utilized a new pier, the cantonné pier. Instead of a simple round or flat pier, the Chartres architect added "a pier with a circular (or octagonal) core but divided into four sections or 'cantons' by four big engaged shafts placed on the transverse and longitudinal axes."[1] He attached octagonal shafts to the round pier and round shafts to the octagonal pier, and aligned the piers so that the corners functioned in concert with the attached columns and the arches above. With this device the Chartres master gained great flexibility and strength. Now the attached colonnettes or pilasters could reach from the floor to the vaults in an uninterrupted manner instead of starting at the capital. Similarly, the attached side colonnette or pilaster flowed directly to the arch of the bay. In one stroke the whole system had been strengthened and integrated. When we take the time to walk around one of the nave columns and trace the colonnettes as they rise to their various destinations, we begin to understand the ingenuity, flexibility, and strength of this system.

The next innovation was the use of four-part vaults over the nave where six-part vaults had been traditional. The result is striking in several ways. The four-part, rectangular bay avoided the major-minor pier system of Early Gothic and allowed the architect to create a narrower bay. The leisurely rhythm of the six-bay system was replaced by narrower and more vertical bays and vaults that seem com-

pressed as they swiftly move down the nave. When we enter Chartres, because of the tall proportions of the central space, our view is drawn down the nave to the clerestory window of the Virgin at the apex of the choir.

The individual bays and vaults seem to slice through space. As Jean Bony points out, the nave piers with the attached shafts and the colonnettes rising to the vaults create strong vertical accents not only defining each bay but also reflecting "a colossal system of transverse divisions" that cut through the "whole width of the building" from the exterior buttresses on one side to the other.[2] The decorative division of the bays mirrors the basic structure of the building.

The combination of these innovations of cantonné pier, four-part vaulting, and three-part elevation transformed Gothic architecture. Thirteenth-century architects realized that the Chartres format could be modified "to suit almost any site: it could be increased or reduced in height, width, and length over varied ground plans without altering the basic features of the design; and it was capable of a development toward increased weight or, conversely, toward elegance and refinement."[3]

There is tremendous upward force in the arrangement of the piers and clerestory windows. Nevertheless, the vertical lines are broken by the horizontal massiveness of the triforium across the middle of the nave and choir elevation. There is a strong balance between the vertical and horizontal forces at play here.

While the structural scheme of Chartres became the working model for subsequent churches, Chartres itself was seen to be too heavy and overbuilt for the refined Gothic taste. The Chartres master used heavy elements throughout, although he imbued them with great energy. The columns with their large attached shafts and the triforium are not delicate. It is as if the architect did not fully trust the new technological system he had created. Nowhere is this more apparent than with the massive external buttresses of the nave, as we will see in a moment.

As with many other features of Chartres, the floor plan became the model for subsequent cathedrals. The nave with single side aisles leads to an enormous crossing and transept arms and into the choir and double aisles of the ambulatory. The choir, ambulatory, and crossing occupy two-thirds of the entire floor space; the seven-bay nave is by comparison rather short.

The crossing is a magnificent creation in terms of both engineering and aesthetics. The four majestic piers rise unobstructed to the vaulting that is 118 feet above the floor, the equivalent of twelve stories. The arms of the crossing are three bays deep, culminating in the north- and south-transept façades with their great rose windows resting on lancets.

The moments when we move from one space to another inside Chartres are spectacular. I am particularly partial to the aisles both because of their intrinsic beauty and for the manner in which our view of the rest of the building is framed. We receive an oblique view of the nave piers when we stand in the narrow aisles, and the march of the piers down the aisle is therefore compressed. Because the vaulting is lower we have a clearer sense of how the piers, arches, and ribs all work together. It is inspiring to look across the nave from inside the aisle and see the nave elevation framed within the arch of the nave arcade. Doing so gives us a keener awareness of the geometry at play. At Chartres the spectacular aisle windows tend to dominate our experience, and we may neglect these other beautiful aspects of the aisles. When we come down the nave to the crossing at Chartres, we can see the colossal piers and crossing vault from the middle of the nave. Our sense of anticipation then pulls us forward into the great crossing space when we see the lateral views of the transepts and their enormous rose windows. The approach from the aisle into the transept is strikingly different. We are in a tighter space, more intimately aware of the piers, vaulting, and walls. We see the framing arch of the entrance into the transept and the wide dou-

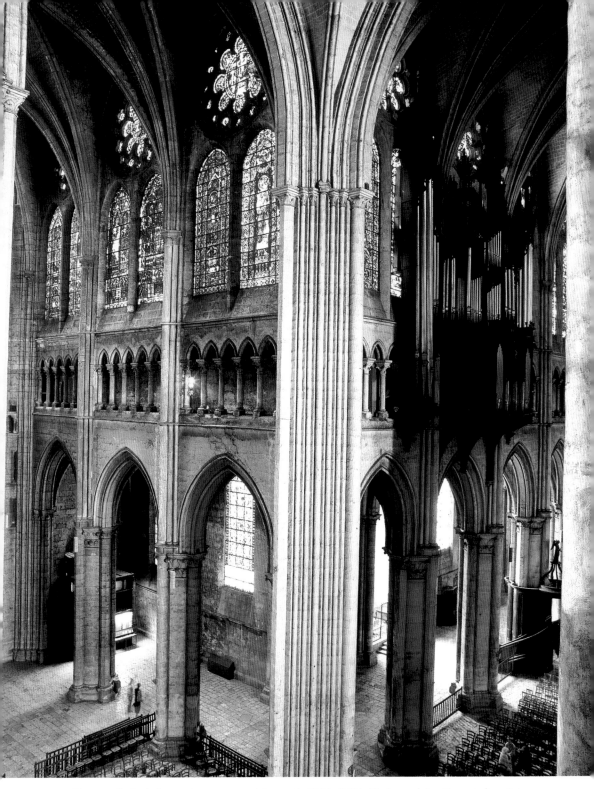

62. Chartres Cathedral, crossing, nave, and transept, 1200–1225. Photograph by François Lauginie
© Centre des Monuments nationaux, Paris.

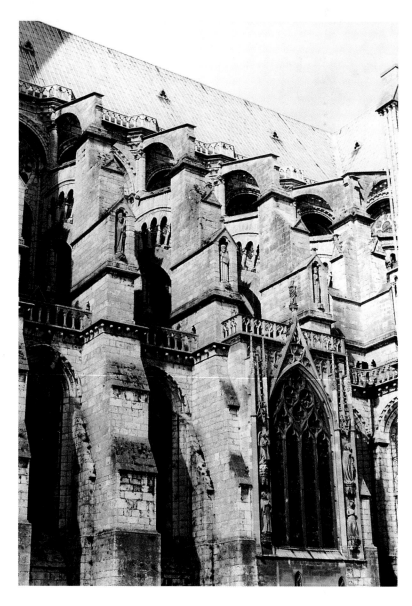

63. Chartres Cathedral, buttresses and flyers of the nave, early 13th century.

ble ambulatory of the choir across the transept. Because of these elements we may be somewhat unprepared for that moment when we actually step into the voluminous space of the crossing and transepts. We see the tremendous height of the crossing as we walk down the aisle, but are still unprepared for its profound impact. The great arms of the transepts, three bays deep with the colossal rose and lancet windows, are simply stunning (fig. 62).

As we enter the double-aisled ambulatory, we experience another change. The sweep of the two broad aisles around the end and the ambulatory chapels that reach out beyond the perimeter of the buttresses give us a sense of the expanding width of the choir. Our view of the choir is blocked by a massive

sixteenth-century choir enclosure that prevents us from seeing the great width of the eastern end of the church. Such screens or enclosures were common in the Middle Ages and Renaissance and served to preserve the sacred quality of the altar. Many were subsequently destroyed.

The Chartres chevet, with its three large radiating chapels separated by four shallow ones, was dictated by the shape of the underlying crypt. The stained glass of the choir seems endless. At no other cathedral has such a complete representation of medieval glass survived. It is discussed at the end of this chapter.

What impresses us throughout the double ambulatory is both the complexity of the space and the massiveness of the architectural and decorative features. We are acutely aware of the width of the aisles, the presence of the vaulting, and the size of the columns and piers as well as the solid wall of the profusely decorated choir screen. Although the columns and piers are widely spaced, their size is noticeable because with the two steps up into the outer aisle, we feel as if we are entering different rooms. The combination of chapels and windows inserted into the wall of the apse makes the wall a complex arrangement of large windows and large mouldings. This is a completely different experience from the ambulatory at Bourges, with its very tall inner aisle and expansive curve of windows. At Bourges we can take in the whole arrangement in a single glance; at Chartres we must proceed step by step.

The exterior of Chartres reflects the architect's tendency to combine innovative new engineering designs with conservative construction techniques. The flying buttresses echo the massive power and energy of the interior. Their design and the use of quadrant arches support a skeletal frame on the interior that reaches new heights. The buttresses are, however, massively overbuilt.[4] Robert Mark compared the buttressing of Chartres with Bourges and has demonstrated that the buttresses at Chartres are more than twice as heavy as those at Bourges. At Bourges the supporting piers are quite low and the flyers themselves are slender, reaching up at nearly a forty-five degree angle. At Chartres the buttresses reach almost to the top of the clerestory with small, almost decorative flyers just below the roofline (fig. 63).[5]

Our view of the chevet at Chartres is somewhat blocked by extension of the Saint Piat chapel, now the cathedral treasury, which was added in the early fourteenth century. We can nevertheless see how dynamic and multifaceted the exterior of the choir is. The three chapels push out beyond the buttresses that pivot like spokes on a wheel around the choir (fig. 64).

The three façades of Chartres are among the most intact and remarkable displays of sculpture in Western art. The sculpture and the stained glass of the three façades reflect the growing sophistication of late Romanesque and Gothic art. Starting with the west façade (1145–1170) and proceeding first to the north porch (1194–1220), and finally to the south porch (1210–1235), we see increased naturalism and flexibility developing, yet well within the formal, rather stiff aesthetic of the west façade. These façades deserve the greatest attention, far beyond the scope of this book. Nevertheless, it is useful to have a sense of the programmatic scheme of the portals and their stylistic changes. By comparing and contrasting them, we can see the development of a style.

The west façade is one of the last great achievements of Romanesque sculpture (fig. 65). On a fine summer or autumn evening, seeing the soft evening light giving a luminous glow to the Old Testament figures is a special vision. The west façade and the crypt were all that survived the great fire of 1194 that destroyed the cathedral and the town of Chartres. Built in the middle of the twelfth century, the west façade of Chartres is contemporary with the façade of Saint-Denis. The sculptors of Saint-Denis might well have moved on to create the west façade of Chartres. The format of the west façade is the

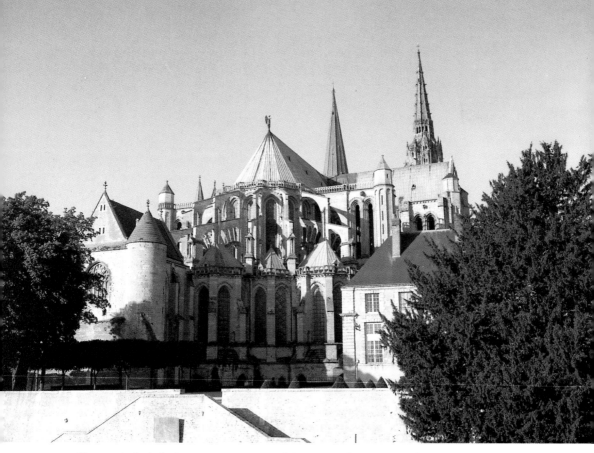

64. Chartres Cathedral, chevet, 13th century, and Saint-Piat Chapel, 14th and 15th centuries.

traditional two-tower format used at Saint-Étienne at Caen. The simple south tower of Chartres was part of the original creation, and the rose window was added above the three lancets around 1216. The Flamboyant north tower was built at the beginning of the sixteenth century.

Situated between the towers, the three portals all open directly into the central aisle of the nave. The tympanum of the central portal depicts Christ in Glory surrounded by the symbols of the Apostles and resting on a lintel containing the twelve apostles. The right portal shows the Virgin and Child in the tympanum with scenes of the infancy of Christ below. In the archivolts of the right portal are figures of the liberal arts (grammar,

rhetoric, dialectic, geometry, arithmetic, astronomy, and music). The left portal portrays the Assumption of Christ into Heaven with the signs of the zodiac and labors of the months in the archivolts. The jamb figures on each of the portals are particularly appealing. These Old Testament figures, part of the round columns framing the doors, have a slender, elegant serenity (fig. 66). There is a sweet expectation to their rather blank expressions. Above the west portal figures, the capitals run together as a frieze showing scenes from the life of Christ.

Instead of the flat façade of Romanesque churches such as Saint-Étienne at Caen, the north- and south-transept façades are covered porches with separate gables giving each por-

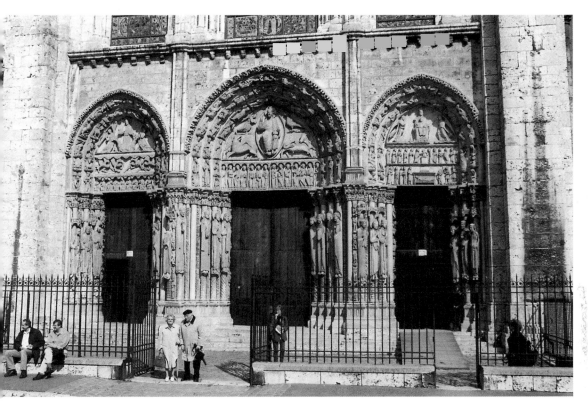

65. Chartres Cathedral, west-façade portals, 1140s.

tal the protection of a stone canopy. These deep gables provide an ample surface for the numerous figures of the archivolts. Both the north- and south-transept porches were originally designed to support twin towers and their structures are massive. With a central tower over the crossing and two flanking the choir, Chartres would have had nine towers in all.

On the north- and south-transept porches the jamb figures are still part of the columns and still face forward, but there is some slight animation in the bodies and a more natural draping of the robes. Neither the north- nor the south-porch figures are completely naturalistic in expression, yet we can see the change in that direction.

The north porch was created first, concurrent with the building of the new cathedral

from 1204 to 1220, and illustrates the role of the Virgin in relating Old Testament figures with those of the New Testament. The central portal presents a particularly dramatic program on this theme. The tympanum holds the Coronation of the Virgin along with scenes of the Death of the Virgin. The jamb figures are Old Testament figures facing their New Testament counterparts. Finally the archivolts illustrate the genealogy of Mary and Christ. This is an extremely sophisticated and complex program for a single portal.

On the right of the north porch is the Old Testament portal with its scenes of the Trials of Job in the tympanum and the Judgment of Solomon in the lintel. The stories of Tobias, Gideon, Samson, Esther, and Judith are in the archivolts. The jamb figures are still more natural, particularly the Queen of Sheba and

73

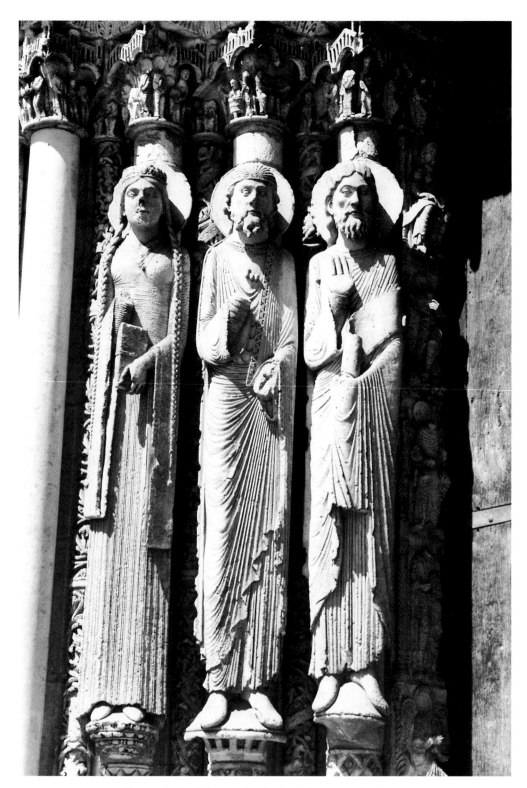

66. Chartres Cathedral, west façade, jamb figures, mid-12th century.

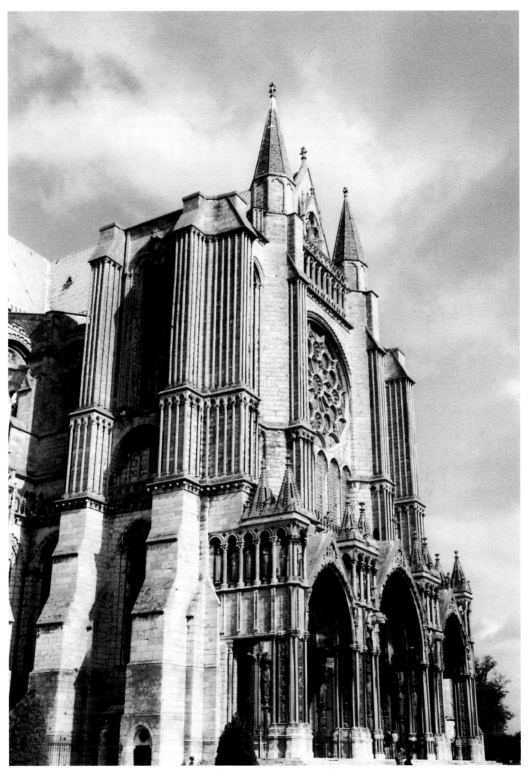

67. Chartres Cathedral, south porch, early 13ᵗʰ century.

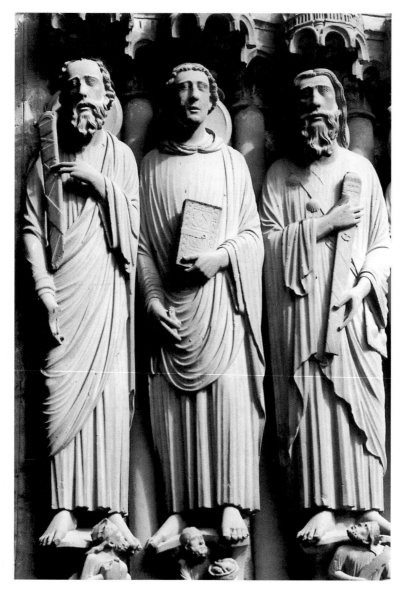

68. Chartres Cathedral, south porch, central-portal jamb figures, 13th century.

Solomon, and for the first time we have a clear, if subtle, sense of their bodies under the garments.

The south porch by itself is one of the most impressive structures in Gothic architecture. More than a simple transept façade, it dominates the entire flank. A beautiful armature of colonnettes encases the sides and central pillars, giving a refinement and tremendous vertical lift to an already soaring front. The equal of the main façade of any cathedral, the south porch rises majestically above the small plaza along the flank of the cathedral. During the Middle Ages, the south façade was the principal entrance to the cathedral and it was not until the coming of the railroad that pilgrims to Chartres began to approach the church from the west.[6] The café across the

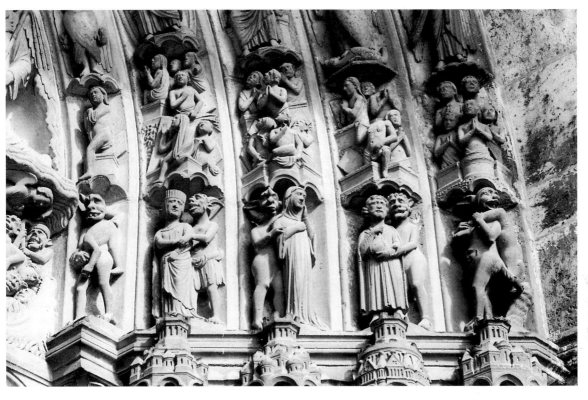

69. Chartres Cathedral, south porch, Last Judgment, the Damned Led by Demons into Hell, 13th century.

street is the ideal spot on a long summer evening to watch the sun set over the great church (fig. 67).

Carved by the artists of the north porch, saints from the Gospels embrace all three doors and even with their blank expressions, the jamb figures take on a poignant quality of people transfixed by a transcendental vision (fig. 68). The central portal presents Christ the teacher on the central pillar (the trumeau) under a fine Last Judgment. In the lower level of the lintel Saint Michael weighs the souls. To the left of Christ (the sinister side) the damned are being led into the fiery jaws of the monster. On His right the saved make an orderly procession to Paradise. Each scene is continued on the archivolts. On our right we see dramatic little scenes of devils

taking terrified sinners, including a nun, off to Hell (fig. 69). On the left an angel is bringing a soul to Abraham with angels leading nude figures to Heaven. Their nudity is a sign of their purity.

The left portal contains scenes of the martyrs with Christ as the martyr between two kneeling angels. The lintel represents the stoning of Saint Stephen. On the right portal, dedicated to the Confessors, the lintel and tympanum illustrate the stories of Saint Martin and Saint Nicholas. Saint Martin gives a beggar half his cloak, a famous medieval legend, and Saint Nicholas drops a purse into the house of a poor man whose daughters are about to turn to evil ways.

After we have recovered from the architectural splendor of Chartres, the stained glass

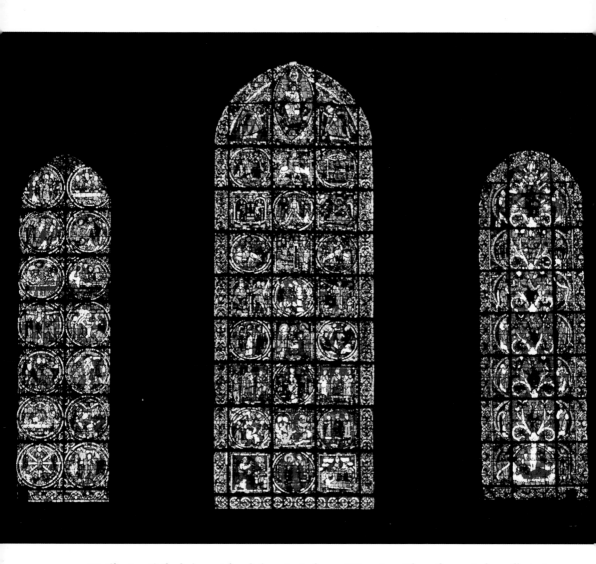

70. Chartres Cathedral, west-façade lancet windows, 12th century. These three windows illustrate the early Life of Christ in the center, the Passion on the left, and the Tree of Jesse on the right.

commands our attention. When we enter through the west portal, our eye is drawn swiftly down the nave and choir to the great lancet windows above the choir. The Virgin in Majesty at the apex of the choir is particularly striking. The 166 stained-glass windows on all levels are a virtual encyclopedia of medieval thinking, and they are the major attraction for many visitors. As Henry Adams said, Chartres has its moods,[7] but on a sunny day the glass creates a diffuse glow throughout the cathedral that is extraordinary. One of the advantages of staying in Chartres is being able to get up with the sun and stand in the choir as the sunrise bathes the eastern end with the soft morning light. Returning to the interior throughout the day to track the light as it works its way from east to west is particularly satisfying. In the autumn when the sun sets directly on the west end, the great western rose and the lancets are spectacular.

There is so much radiant glass at Chartres that it is difficult to know where to begin. It may be wise to start with the earliest glass, the twelfth-century lancets of the west end above the entrance. The window on the right, called the Tree of Jesse, depicts the genealogy of the House of David culminating with the Virgin and Christ. It was based on the first Tree of Jesse to be shown in stained glass, made just a few years earlier for Abbot Suger's ambulatory in the Abbey of Saint-Denis. The great lancet in the center tells the life of Christ from the Annunciation to His entry into Jerusalem. The left window is the story of the Passion and the Resurrection (fig. 70). The details of these windows are particularly well discussed in Malcolm Miller's guidebook, *Chartres Cathedral*,[8] which not only describes the individual scenes but also

71. Chartres Cathedral, Good Samaritan Window, south aisle, early 13th century. This famous stained-glass window illustrates the story of the Good Samaritan below, and the Creation, Temptation, and Expulsion of Adam and Eve at the top. Photograph by François Lauginie © Centre des Monuments nationaux, Paris.

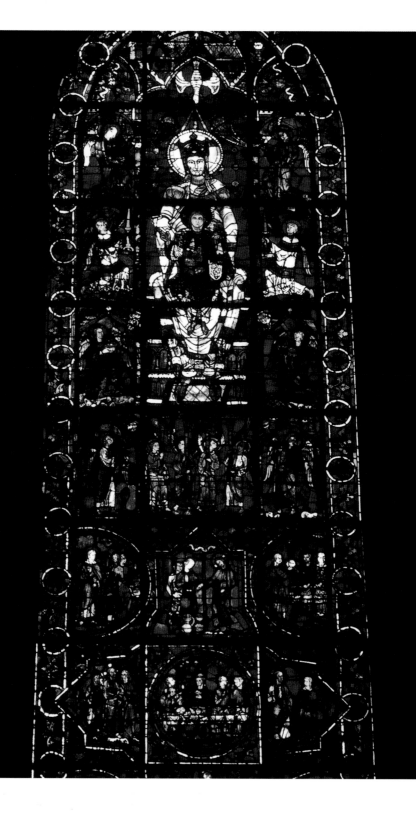

such important theological issues as Old and New Testament parallels and how medieval artists showed Old Testament figures and episodes as anticipating New Testament events.

Along the north aisle the upper windows show large figures of bishops and donors and Old and New Testament characters and saints. The lower windows display narrative scenes, such as the stories of Noah, Joseph, and the Redemption window. On the south side in the upper register are saints, with stories of John the Evangelist, Mary Magdalene, and the famous parable of the Good Samaritan in the lower level (fig. 71).

The transepts with their magnificent rose windows resting on lancet windows are simply astonishing in their beauty and architectural magnificence. On the north façade, the rose shows the Glorification of the Virgin with Old Testament figures. Small lancets with the fleur-de-lys of Saint Louis and the castles of his mother, Blanche of Castile, support the rose. The south rose displays the Apocalypse of Saint John with Christ in the center. The five lancets contain the Virgin with four prophets, Isaiah, Daniel, Ezekiel, and Jeremiah, carrying the four Evangelists on their shoulders.

On the south side of the ambulatory is the famously beautiful window of the Blue Virgin (Notre Dame de la Belle Verrière; fig. 72). The central four panels at the top showing the Virgin and Christ Child are twelfth century and have the light blue glass that is characteristic of early stained glass. These four panels are set into a larger thirteenth-century window that shows the deeper, more intense blue coloration of thirteenth-century glass. Much of the remainder of the ambulatory contains great blue windows telling the stories of a variety of saints, with the history of the Apostles in the central chapel. Particularly noteworthy is the thirteenth-century Charlemagne window to the right of the left apsidal chapel. Considered one of the best windows in the cathedral, this window tells the stories of Charlemagne's crusade to Jerusalem, his expeditions to Spain, and his conflicts with the Muslims.[9]

Chartres Cathedral occupies a place of highest honor within both Christianity and the history of Western art and architecture. Chartres has always been an exemplar, a model for all time. It can awaken a deep sense of self and connection to a greater community stretching back through time. It serves as a vital link to the Middle Ages and to the very foundations of Christianity and Western civilization. For many it is a spiritual homecoming.

72. Chartres Cathedral, Notre-Dame de la Belle Verrière, 12th and 13th centuries. The four central stained-glass panels containing the Virgin and Christ Child and the Dove of the Holy Spirit survived the fire of 1194 and were reinstalled with many 13th-century panels surrounding them.

LAON

Cathedral of Notre-Dame

Rising above the great agricultural plain of northern Champagne, the old town of Laon occupies one of the most dramatic sites in all of France. With five enormous towers, the silhouette of the cathedral is unparalleled. It lies on the eastern edge of a ridge that overlooks the flat expanse to the north. To the south, the steep hills of the Chemin des Dames (Ladies Road) hover over the Ailette River. The road along the ridge was built in the eighteenth century to enable the daughters of Louis XV to visit their governess near Vauclair. The cathedral is a striking sight from the Chemin des Dames, and the ruined abbey of Vauclair is worth a quick stop if you are coming from the south. Driving up the switchback road to the old town, you may find yourself hurrying to reach this masterpiece of French Early Gothic. The view from the cathedral of the old town and surrounding countryside is spectacular (fig. 73).

Begun in the 1150s with the building of a shallow three-bay choir, Laon's Cathedral of Notre-Dame was essentially completed by 1225. The monumental west façade was begun in the 1190s, the round portion of the choir was demolished around 1205, and seven bays and a flat eastern façade were added in the next twenty years.

As exceptional as the individual elements are at Laon, you never forget the overall coherence that holds this wonderful cathedral together. The site, the west façade, the exuberant towers, the three rose windows, the soaring lantern tower over a magnificent crossing, the second-story gallery that surrounds the interior, the long nave and deep choir, and the four soaring stories of the ele-

vation all work together in a manner that allows you to appreciate them individually but never at the expense of the whole.

A walk around the exterior reveals some of the greatest moments in French medieval stone. The west façade has two towers with oxen looking out from little porticoes that rise above the powerful and dynamic base. The towers with their oxen are a tribute to those durable animals that pulled the carts of stone from the quarries to the south up the steep flanks of the hill below the cathedral. According to legend, oxen appeared when they were needed and then disappeared when their work was done. Obviously, the builders had a profound affection for them. The deep-set rose window was the first major rose created after that at Saint-Denis. The west-façade doors are placed deep within steep gables with statuary covering every angle. Behind the gables a row of Romanesque lancet windows supports the third story containing the great rose and two large lancet windows. It is amazing how much glass there is within the support structure of this monumental façade. A staggered arcade above the windows crowns the façade, and four porticoes with pinnacles serve as bases for the two western towers (figs. 74, 75).

It is difficult to realize what a radical departure from previous towers these incredible creations really were. Although massive, they are light and airy with lancets, gables, and porticoes turning in every direction. This is a pivotal moment in Gothic architecture. Laon is a departure from the flat planes of Chartres and Saint-Denis with its multiplicity of motifs, angles, and dimensions. The Laon

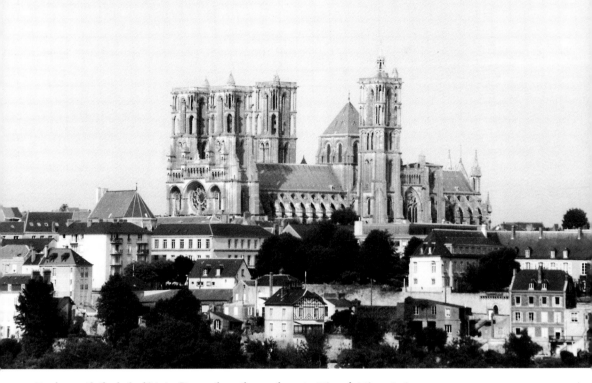

73. Laon, Cathedral of Notre-Dame, from the northwest, 12th and 13th centuries.

format would become the model for most of the great façades to follow. Notre-Dame of Paris would restate the simple classical façade of earlier Gothic, but it is at Laon that a wholly different, three-dimensional approach appears.

The towers are rather complex, although they may not seem so at first. After a close look you realize that there are two sets of small porticoes on each corner of a tower, and that they are set on the diagonal, one portico on top of the other. The lower portico is square and the upper is a hexagon. They look like cages set on top of each other. The interior of the towers has two stories but the corner porticoes have three. A delicate balcony of small arches crowns each tower.

While the essential elements of the two-tower façade are present at Laon, they have been converted into a much more dynamic and fluid arrangement. Instead of the flat surface of Saint-Étienne at Caen, Saint-Denis, and Chartres, Laon has deep spaces, gables, pinnacles, arcades, and statuary in profusion. The underlying integrity of the twin-tower formula is preserved and prevents the arrangement from being overdone. The combination of fantasy and stability is fully accomplished. Because we have become so accustomed to this format with gables and statues at every possible location, we may not give this amazing creation enough attention. Coming a century before the façades of Amiens or Reims, the façade at Laon was a stunning revelation and made a dramatic impression at the time.[1]

The interior of Laon is as rewarding as the exterior. Although I have walked into the

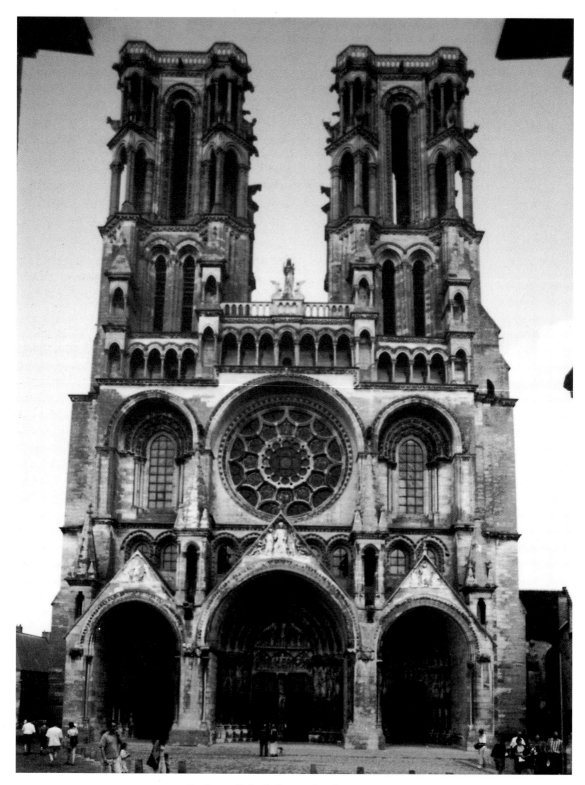

74. Laon Cathedral, west façade, 1190–1205.

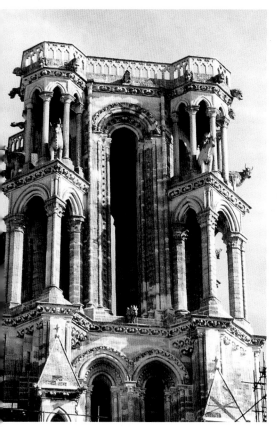

75. Laon Cathedral, upper stories of west-façade tower, 1190–1205.

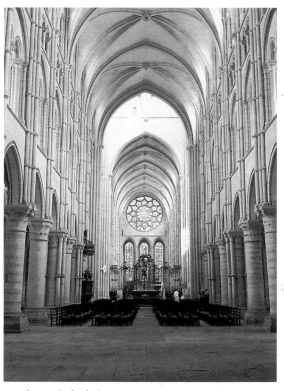

76. Laon Cathedral, nave 1150–1200 and choir, after 1205.

nave many times, I still have the same feelings of respect and delight. The interior seems more monumental than it really is (the vaults are 90 feet high compared to 115 feet at Notre-Dame in Paris). Just as the outside works in so many different dimensions, the interior dazzles and startles us without ever losing its overall coherence and integrity. This is no piecemeal church but a well-thought-out plan with vigor and energy in every direction (fig. 76).

Laon has its parts but, unlike Chartres, it is not compartmentalized. Laon appears to be an exceptionally long church; the eleven-bay nave, generous crossing, and ten-bay choir stretch out ahead of us before culminating in a flat apse. Single aisles run along each side of the nave and choir. From every vantage point you see the great interior reach out in every direction: the length, the width, the diagonals, and the verticals all spread out and at the same time converge into the great lantern tower over the crossing.

Immediately upon entering Laon you are

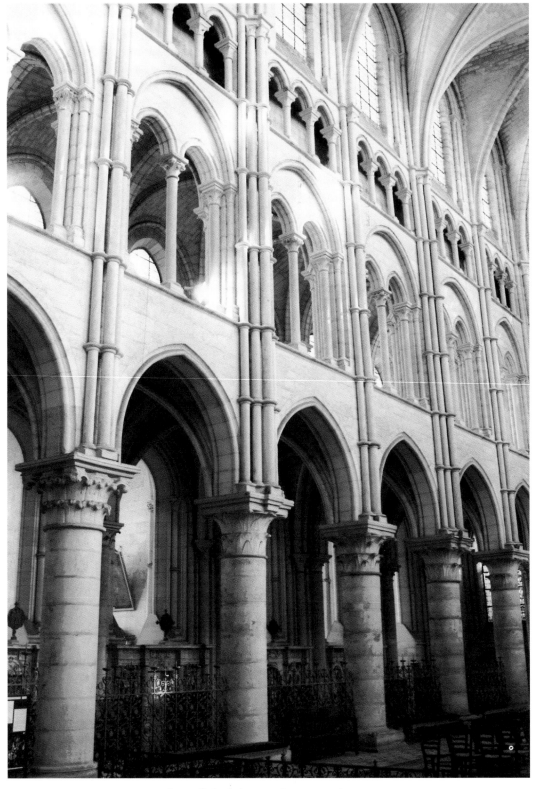

77. Laon Cathedral, nave elevation, 13th century.

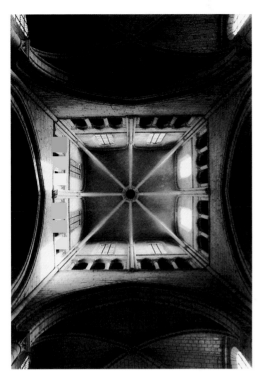

78. Laon Cathedral, crossing lantern, 13th century.

glimpses of other portions of the building are particularly intriguing.

And yet, as significant as this sense of depth is, it does not completely dominate the interior. The rising colonnettes are so strong that it is possible to experience the nave in a more two-dimensional manner. The play of this two-dimensional screen with the three-dimensional space clearly visible is quite lovely and alive.

Finally, the length exerts itself. The eleven bays of the nave and ten bays of the choir create a sense of continually receding space that ends at the glorious rose window above the large lancets. It is one of the most appealing and vibrant vistas in all of Gothic architecture.

The crossing tower at Laon is notable not only for its height and the light it provides to the center of the church, but also for the design of its own interior.[3] At Laon the manner in which the gallery and the triforium circumscribe the interior of the church is particularly impressive. It is possible to walk the entire perimeter of the interior at the second level. The crossing tower has its own elevation of triforium and clerestory that maintains the continuity of the upper stories of the church proper (fig. 78).

The transepts at Laon are remarkable elements in and of themselves that are still in complete harmony with the rest of the interior. The elevation of the transept is essentially that of the nave and choir. The eight-bay transept, with side aisles of its own, is 184 feet long. This length gives the transept the size and presence of an entire church.

The façade of the south transept has a substantial single-arched window with three double lancets supporting a large oculus on top. This fourteenth-century Rayonnant window is quite graceful in its use of tracery and even though the glass is now plain, it is worth studying. The north façade of the transept has a classic rose window supported by four lancet windows. This transept contains some of the oldest stained glass in the cathedral, dating from the 1180s. Inside the rose is a

struck by three major forces. The nave elevation, a trellis of open arches, is faced with sizable colonnettes rising off the capitals of the plain round columns. The face of the nave elevation is so strong that your first impression may be of its two-dimensional quality. Vincent Scully has noted that these colonnettes have an almost ironwork quality to them.[2] To me they have always seemed like an elegant plumbing system with the pipes flowing upward to the vaults (fig. 77).

The second force at play is the depth behind the energy of the surface. This depth is created at the first and second story by the openness of the nave arcade and the second-story gallery. As you move down the center of the nave you can see up into the second story and finally even through the corner of the tribune gallery to the transept. Powerful new diagonal vistas keep appearing. These

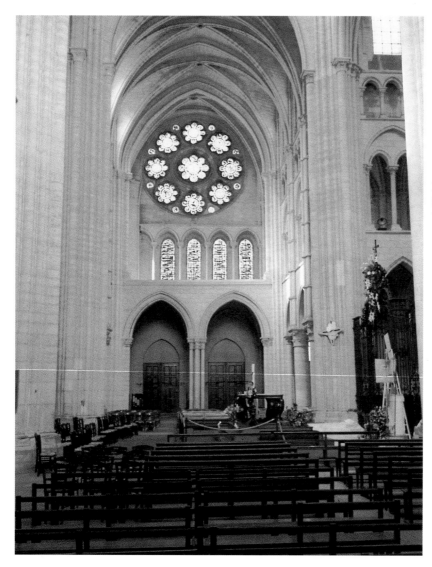

79. Laon Cathedral, north-transept interior, 1160s–1170s.

central oculus surrounded by smaller ones. The theme of the glass is the Liberal Arts of Rhetoric, Grammar, and Logic, which were the basis of medieval education. At the base of each transept end is an interior porch or narthex that supports the gallery above. They have an elegant processional quality worthy of a main entry (fig. 79).

Of particular interest are the round chapels on the eastern ends of each transept.

From the inside, on the ground floor, these chapels are not insignificant; it is not until you are outside that you realize that they are merely the first level of three stories of windows. Inside, however, there are only two levels because the upper chapel is a two-story chapel. Be certain to look at them carefully on the inside in order to understand the exterior arrangement. The second-story galleries and chapels are especially attractive. If possi-

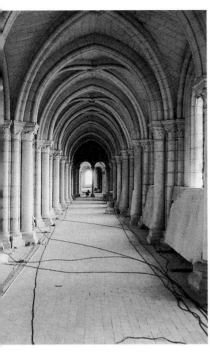

80. Laon Cathedral, second-story gallery, 12th century.

81. Laon Cathedral, choir, after 1205.

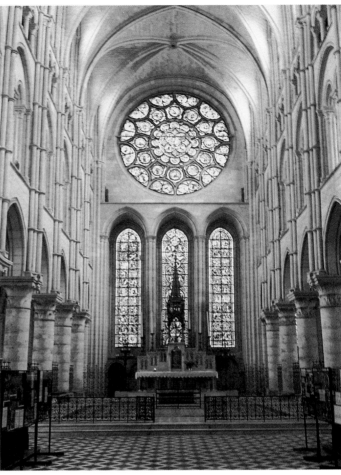

ble, try to take a tour of the second story. Arrangements can sometimes be made at the tourist office next to the cathedral (fig. 80).

The choir at Laon is unusual because of its impressive length of ten bays and its flat rather than round end. In effect, the choir appears to be a second nave and gives Laon its sense of enormous length. In actuality Laon is sixty-four feet shorter than Notre-Dame of Paris, where the crossing and choir are great stopping points and the round elevation of the choir is only three bays from the crossing. At Laon the linear reach of the bays seems to recede into the distance.

The original round choir was the first portion of the cathedral to be constructed, and was replaced shortly after it was built in the 1180s. Grodecki dates the new choir construction after 1205.[4] The choir architect kept to the original format of the nave, including the six-part vaulting, even though that would have been out of date by that time.

The flat end of the new choir provided the builders the opportunity to employ a third rose window above three very tall and large lancets. The lancets are deeply recessed behind slender framing arches that support a shelf under the rose. Even in a situation as

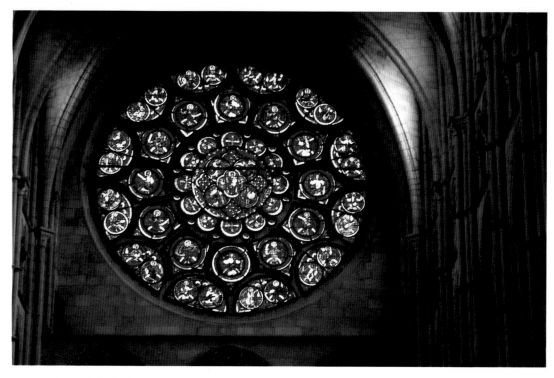

82. Laon Cathedral, choir, rose window, 13th century.

83. Laon Cathedral, choir, rose window, detail of an Elder with harp, 13th century.

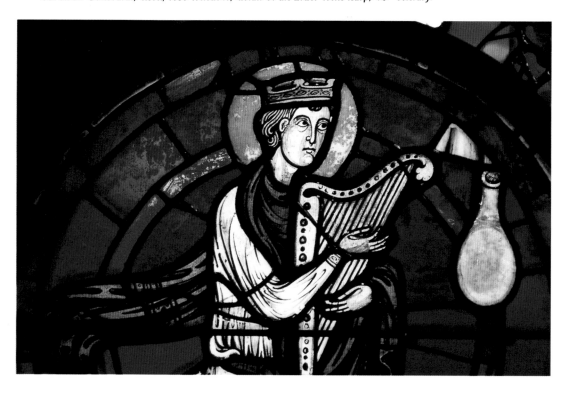

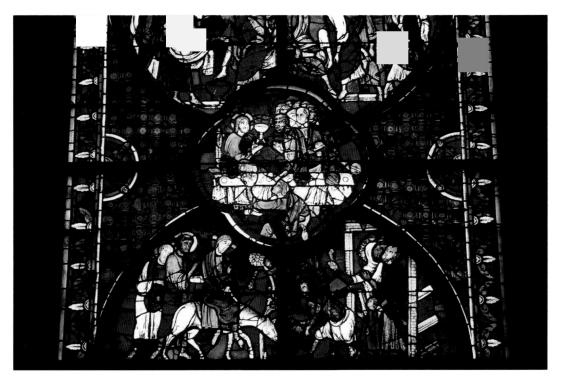

84. Laon Cathedral, choir, detail of Passion Window, Entry into Jerusalem and The Last Supper, 13th century.

85. Laon Cathedral, detail of Passion Window, Supper at Emmaus, 13th century.

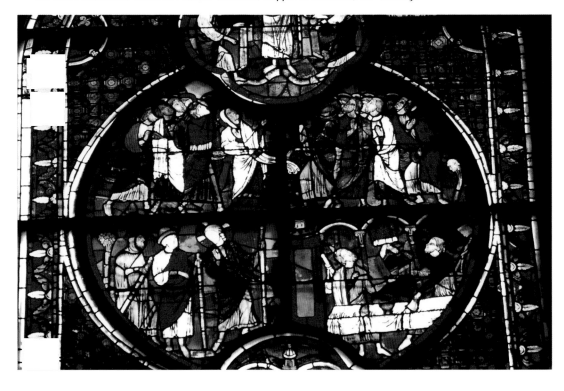

simple as this east end, the architect at Laon saw an opportunity to create a sense of depth. In this way, we have a combination of a French use of the rose with the English flat apse (figs. 81, 82, 83).

The rose window shows the Virgin and Child with John the Baptist and Apostles on the inner circle and the Elders of the Apocalypse on the outer circle. The left lancet window tells the martyrdom of Saint Stephen and the fictitious story of Saint Theophilus the Penitent who made a pact with the Devil, but was saved by the Virgin. The stoning of Saint Stephen, the first martyr, is shown in the third right roundel from the bottom. The central lancet portrays the Passion of Christ. As with most medieval windows, the scenes of the Passion are to be read from the bottom up, beginning with Christ's entrance into Jerusalem and the Last Supper (fig. 84). The story of the Passion of Christ continues upward with scenes leading to the Crucifixion, the Entombment, the Supper at Emmaus, Pentecost, where the Holy Ghost descended upon the Disciples, and finally Christ in Glory. The Supper at Emmaus is the scene in the upper roundel, lower right quadrant, that shows the pilgrims at the table with only the feet of Christ visible as he ascends through the ceiling! It is a charming scene and well worth looking for (fig. 85).

The right lancet depicts the early life of Christ from the Annunciation through the Massacre of the Innocents with two angels looking down on the events below. There are several Old Testament scenes as well, including Moses and the Burning Bush. There is also a particularly appealing scene of an angel waking the Three Magi.

Laon was conceived before the advent of the flying buttress at Notre-Dame of Paris, so the supportive structure is chiefly inside the building. The vaults of the first-story aisles and the second-story galleries provide a honeycomb of internal supports not dissimilar to the cubes of Notre-Dame. With so much internal structure it should not surprise us that the exterior is as solid and dense as it is.

Besides the remarkable façade and towers, the exterior of Laon reflects the Early Gothic period in which it was conceived. Even though flying buttresses were added to the nave and incorporated into the design of the straight choir, the bulk of the exterior and underlying construction reflects the reliance on sturdy buttressing instead of fully conceived flyers. The flying buttresses are close to the building and augment rather than replace the traditional buttresses. Because of this, the buttresses appear to be a more integrated part of the building than at later Gothic cathedrals. Chapels have been added to fill in the space between the buttresses and the projection of the three-story chapels off the east side of the transepts further crowds the flank.

On the west side of the transepts the huge towers overshadow the flank as well, diminishing the impact of the flyers. Far more dramatic is the arrangement of the transept towers, the lantern towers, and the bases for the unfinished towers. This ensemble dominates the close silhouette of the buttresses on the flank. The flank of the nave seems sandwiched in between the incredible western-façade towers and the towers of the transepts.

There are four very powerful façades at Laon: the dynamic western façade, the façade with rose and lancets on the eastern end, and the façades of each transept arm. The eastern façade can be seen by entering the courtyard of the old Bishop's Palace to the southwest. These three façades are all, to some extent, dominated by the massive piers flanking the central window and lancets. They have powerful elements but lack the almost Baroque dynamism of the gables, arcades, and porticoes of the western façade.

Laon dominated Gothic architecture in northern France for a number of decades until the creation of Reims Cathedral in the thirteenth century. For the modern visitor the combination of a great site with the beautifully conceived and executed architecture creates a noble building of great magnificence and vitality.

NOYON

Cathedral of Notre-Dame

Just off the Paris-Lille Autoroute, where the River Oise meets the Canal du Nord, the city of Noyon is situated in some of the finest agricultural land in Europe. On a gently sloping hill, surrounded by a residential neighborhood, the site of the Cathedral of Notre-Dame is pleasant, if not dramatic. The imposing western façade with classic twin towers opens onto a quiet square between the cathedral and the canons' sixteenth-century houses, and there is ample room on all sides of the cathedral to appreciate the exterior (fig. 86).

From its beginnings in Roman times as an army outpost, Noyon was an important town. It was at Noyon that Charlemagne was crowned King of the Franks in the eighth century, and Hugh Capet's coronation in 987 inaugurated the Capetian dynasty that was to rule France for nearly three hundred and fifty years. During the Middle Ages, the northern trade routes stretched nearly two hundred miles along the northern edge of the Île-de-France, from the Channel ports through Arras, Valenciennes, and Cambrai, to Reims and Troyes. Along this path north of Paris a series of remarkable twelfth-century churches came into being, including Senlis, Soissons, and Laon. Noyon, begun around 1145, was one of the first and most noteworthy.[1]

Conceived at the beginning of the Early Gothic style, and completed nearly one hundred years later at the beginning of Rayonnant, the decoration and arrangement of the transepts and nave are nevertheless consistent with the choir and ambulatory, while expanding and enhancing the original elements. The result is one of uniformity and wholeness of the central space of nave and choir. The choir and ambulatory were begun in the 1140s, and are somewhat cramped when compared to the wonderful double-aisle ambulatory and chapel windows of the nave of Saint-Denis. The climax of a visit to Noyon is not at the choir, but at that moment when you step into the central crossing and realize you are embraced by the luminosity and refinement of the rounded transepts, particularly the south one with its three levels of light. This is a beautiful moment in Early Gothic architecture, but it is not one that was followed by many later builders.

It has taken me a number of visits to appreciate the architectural ingenuity of this church, and particularly the elegance of the transepts and the slender proportions of the central space. Noyon is not a church to hurry through; if you give it time and thought, it will respond.

Architecturally, several design elements are particularly significant, reflecting the Early Gothic aesthetic, the development of the four-story elevation, the use of decoration to create the grid pattern on the surface of the interior, the intricate use of a double-wall system, and two elegant round transept arms. The major piers have attached columns that project into the nave and rise uninterrupted from the pavement to small capitals at the vault ribs. The minor piers are slender columns with their colonnettes rising from the capitals.

From the west porch you immediately enter a towering single-bay narthex that rises to the level of the nave vaulting. The narthex opens onto the nave through a large round

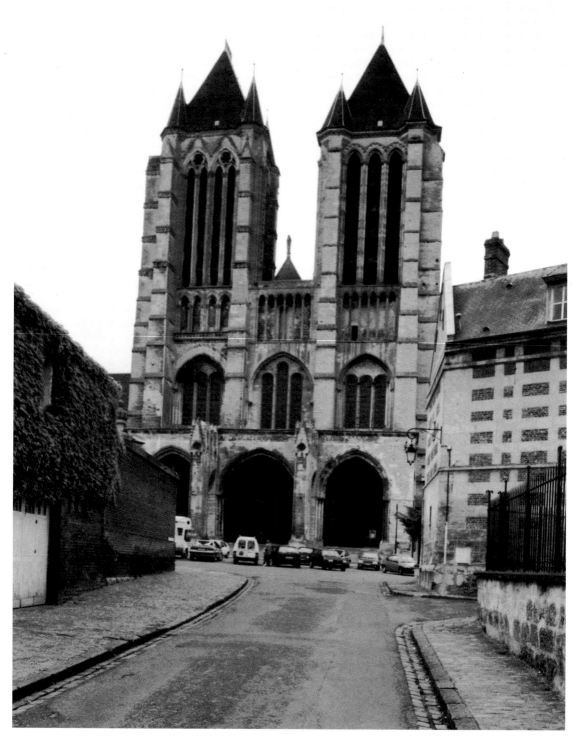

86. Noyon, Cathedral of Notre-Dame, west façade, ca. 1235.

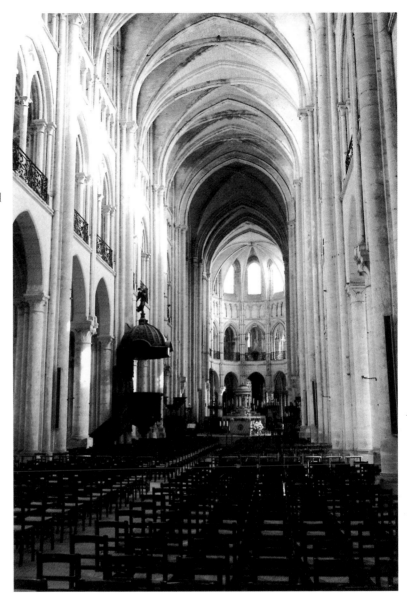

87. Noyon Cathedral, nave and choir, 12th and 13th centuries.

arch. At Saint-Denis the narthex was built in two stories and provided a viewing gallery for the king. Here there is no second story but simply a single towering space. It is easy to miss it.

The cathedral did not emulate the broad proportions and mural appearance of Sens. Whereas the nave vaults at Sens (81 feet) are taller than at Noyon (75 feet), the nave at Sens (49½ feet) is much wider than at Noyon

(29½ feet).[2] The slender proportions of Noyon's nave and choir create the illusion of great height, and the vaults seem to float above the central space. The visual sense of height is enhanced by the architectural elements and details (fig. 87).

Noyon represents a crucial step in the quest for additional height. The key innovation was the addition of a fourth story: a blind arcade was added between the gallery and

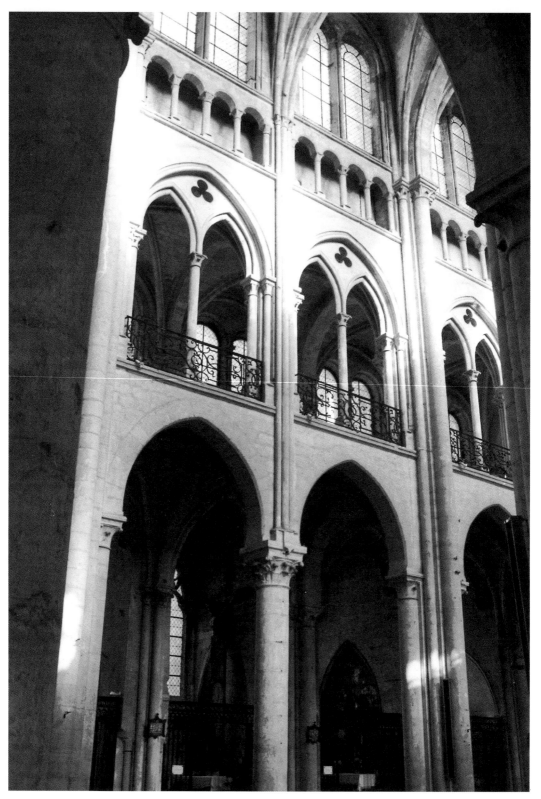

88. Noyon Cathedral, nave elevation, 1170–1205.

clerestory. This new story, called the triforium, created a forceful horizontal element that became a significant feature in French cathedrals. Medieval builders, reluctant to increase the size of the individual parts, increased the height of the nave by adding this new element.[3] Laon, the south transept at Soissons, and the original configuration of Notre-Dame of Paris were all four-story churches.

What strikes you about the four-story nave elevation at Noyon is the rigorous division of its parts. The first-story arcade is relatively modest in height, and the second-story gallery is somewhat smaller. The lower arch is very plain, almost punched out of stone, while the second-story gallery has double arches within a single arch topped with a small cut-out trefoil. The combination of these two stories appears to dominate the upper two stories of the triforium and clerestory. Simple moldings form the bases of the second-level gallery, triforium, and clerestory. The plain attached colonnettes of both the major and minor piers, which interrupt the moldings, emphasize the verticality of the elevation.

The combination of nave arcade and second-story gallery arcade opens the wall surface and provides a view of the supporting structure of the first two stories. These two arcades lift our gaze past the triforium to the crowning clerestory windows. A balanced grid has been created that helps us understand the organization and division of the elevation and the structure of the building (fig. 88).

The nave of Noyon has major piers with five attached colonnettes alternating with slender minor piers of single columns with three colonnettes rising off the capitals. This arrangement corresponds to the ribs of the traditional six-vault double-bay system where there are five ribs coming off the major pier and three ribs off the minor. The attached colonnettes of the major piers project significantly into the nave and rise uninterrupted to the vault ribs to create a strong double-bay

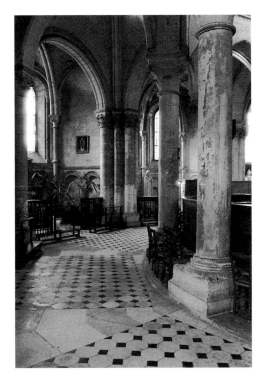

89. Noyon Cathedral, ambulatory, 1150–1185.

unit. After a fire in 1293, the six-part vaults at Noyon were replaced with four-part vaults while the original alternating piers were retained. The transverse ribs of the vaults are also treated in a major-minor pattern. The quicker pace of the four-part vaulting is countered by the slower tempo of the alternating piers and ribs, creating a contrapuntal rhythm. It is somewhat confusing to look up from the nave arcade to the vaulting and realize, after some examination, that these are four-part rather than six-part vaults.

At Noyon the choir was first begun in the 1140s, and the cathedral was built from east to west with increasing expertise in the Gothic manner. The west façade was finally completed in the 1230s. This ninety-year period in Gothic architecture saw the elimination of the gallery as a means of gaining height with the building of the monumental

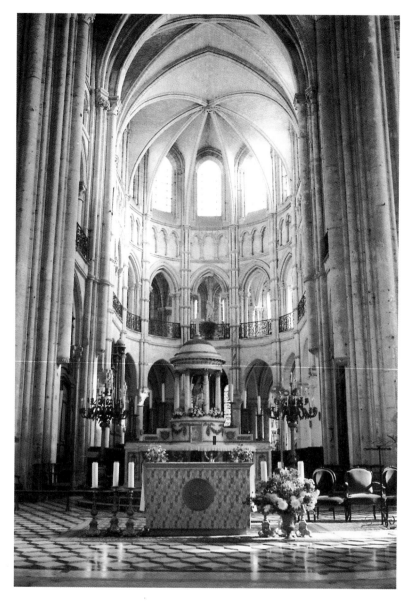

90. Noyon Cathedral, choir, 1150–1185.

High Gothic cathedrals of Chartres, Bourges, Reims, and Amiens. Nevertheless, the builders of Noyon kept the original four-story format to the end, which gives us a complete rendition of Early Gothic design.

The choir has a single ambulatory with nine chapels (fig. 89). The hemicycle's slender columns have small foliated capitals, while in the straight part of the choir the heavier round columns have single round colonnettes rising to the vault ribs. Above the first capital is a bundle of three colonnettes with frequent bands that climb to the base of the clerestory where there are small capitals. This grid of decorative elements, particularly the colonnettes and stringcourses, is one of the distinctive, innovative elements of this cathedral. The result is a very clear presentation of the logic or organization of the four stories. The open structure of the choir

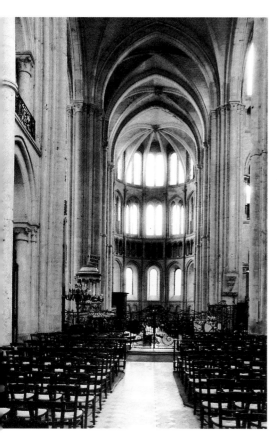

91. Noyon Cathedral, south-transept interior, 12th century.

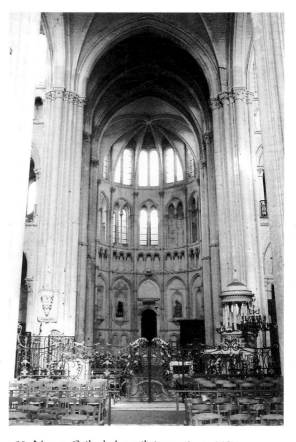

92. Noyon Cathedral, north transept, ca. 1185.

allows us to look up into the gallery and see the ribbed vaults and the gallery windows. We have the sense of a second, smaller choir on the second level. The axial chapel contains the only two medieval stained-glass windows to have survived in this cathedral.

The original master of the Noyon choir (fig. 90) placed the blind arcade or triforium above the gallery and below the clerestory. In the round transepts, the architect changed this arrangement to very good effect. Here the triforium is the second story and the

gallery with two clearly visible lancet windows per bay is the third. The south transept (fig. 91) has three levels of windows that flood the entire crossing with diffuse light. The north transept (fig. 92) has basically the same arrangement, but instead of the lower set of windows, it has a blind arcade with statuary niches and a central door to the cloister outside. While not as brilliant as the south transept at Soissons, these aisleless transepts are quite refined and attractive.

Before leaving the interior be sure to visit

93. Noyon Cathedral, cloister aisle, 12th century.

the chapter house and cloister through the door in the north aisle. The vaulting is quite dramatic (fig. 93). From the front the windows of the chapter house create an appealing addition to the west façade.

The exterior of the south flank is severe, compact, and basically unadorned. The round exterior of the south transept appears to be a single straight smooth wall, but as Bony points out, it is really a fairly elaborate system of adjoining double walls.[4] Look closely and you can see a small arcade at the clerestory level that passes behind the exterior buttresses. On the story just below, the wall passage is inside the window rather than outside. The double-wall treatment was an important technical accomplishment because the load bearing is shared on the inside and outside, giving it the strength of a thicker wall but allowing for the penetration of windows at both levels. This construction technique allowed the builders to create a skeletal structure and increase the height of Gothic architecture (fig. 94).

The exterior, particularly the eastern ensemble, is an exceptionally worthwhile illustration of the compact, Romanesque qualities of Early Gothic construction. One can readily imagine the eastern end without the flying buttresses that were added in the fifteenth and eighteenth centuries. The coni-

cal roofs of the ambulatory chapels are also later additions.[5] The result is three horizontal levels of chapels, second-story gallery, and clerestory windows in a very compact arrangement.

Give some time to the eastern end. In your mind strip away the flying buttresses and even the conical roofs over the chapels. What remains is a progression of round shapes rising up as strong curved terraces. Without the buttresses the three-tiered array of chapels, gallery, and clerestory windows is even more impressive (fig. 95).

The west façade is comprised of four levels across three bays: a covered entry porch, three sets of triple-lancet windows, a gallery of arches, and two tall towers. The front porch is a three-bay loggia with three large pointed arches and the three entrance portals. The original sculpture on the portals was vandalized during the French Revolution, and the entry has been left barren. In front of the porch there are two open piers with numerous gables. These decorated piers appear to be later than the severely plain porch and may have been added when the façade was being completed in the 1230s. Above the porch are gallery windows with three lancets; the center lancet of the central window is slightly taller. There are three sets of arcades on the third level: two

94. Noyon Cathedral, exterior of south transept, 1170s–1180s.

95. Noyon Cathedral, chevet, 1150s–1180s.

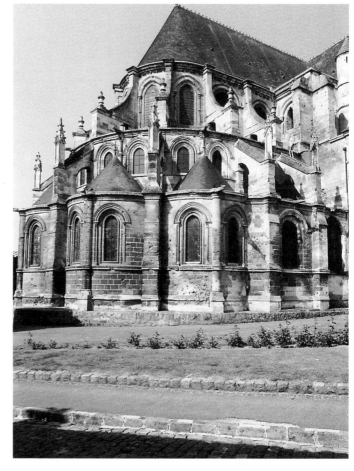

Romanesque arcades with round arches to the right and the middle and pointed Gothic arches on the left with a small balustrade. The towers are equal in size with the left tower having two double lancets with oculi under gables; the right tower has three simple lancets.

The slender piers that project from all four corners of each tower are significant design elements of the west front. Distinctive dripmolds accent every surface on four sides of each tower, creating decorative bands that give the façade a geometric, almost Art Deco appearance. The west front is a striking and

powerful structure that is one of the distinctive features of this important cathedral.

South of Noyon on the road to Compiègne are the ruins of the Cistercian abbey at Ourscamp. There is a very fine thirteenth-century infirmary that is now a chapel. All that remains of a once grand abbey church are the ruins of the choir (fig. 96) and arch and buttress of the west façade. Of particular interest are the exposed ribs of the ambulatory, left standing without the vault masonry. Ourscamp is an excellent place to gain an understanding of the nature of rib vaulting (fig. 97).

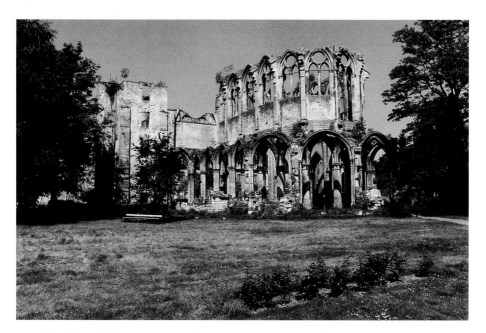

96. Abbey of Ourscamp, ruins of
the choir, 13th century.

97. Ourscamp, ribbed vaults, 13th
century.

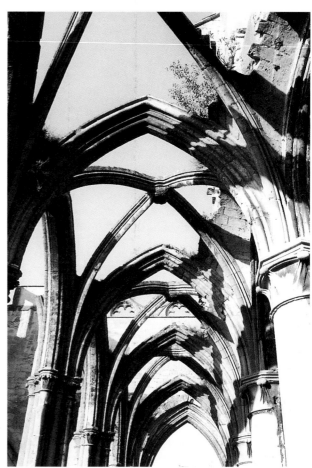

PARIS

Cathedral of Notre-Dame

The Cathedral of Notre-Dame is one of those magnificent buildings that can vividly exist in our imagination before we have actually seen it. Like the Parthenon or the Taj Mahal, the Cathedral of Our Lady is one of the most recognizable buildings in the world. Because of its remarkable site along the River Seine, we are able to comprehend it in its entirety at a single glance, and whether we first view the monumental western façade, the elegant south flank along the river, or the superb chevet with its elegant flying buttresses, we can appreciate the precision and harmony of the exterior. Once we have seen the façade with its arched portals, gallery of the kings, great rose window, and flanking towers, the memory is with us forever, not just visually but emotionally. We more than simply remember Notre-Dame; we return to its presence again and again in our imagination (fig. 98).

I prefer to approach Notre-Dame by first taking a leisurely walk around the exterior and absorbing various elements that make up this great building. I usually find myself walking along the Left Bank, crossing the river at Pont au Double, and exploring the exterior before I am ready to go inside. I save the west façade for last and start with the south side along the river where I am drawn by the gracefulness of the flying buttresses and the towering south transept (fig. 99). The body of the cathedral is a wonderful combination of elegant details and massive scale. Just behind the towers you see the sharp rows of flying buttresses rising above the delicate gables of the chapel windows. These chapels were built between the buttresses in the thirteenth

century, a change that gives the exterior the shrine-like qualities of Rayonnant Gothic. Even though the south-transept façade does not project beyond the outer perimeter, its narrow proportions give it tremendous perpendicular force commensurate with the rest of the cathedral. The square chapel-like building attached to the south flank is the nineteenth-century treasury created by Viollet-le-Duc. Here we can appreciate the remarkable flying buttresses that move around the east end. These buttresses were completely rebuilt in the nineteenth century, and there is still much debate as to when they were originally conceived and installed. I will deal with that later; for now it is enough simply to enjoy the elegance and ingenuity before our eyes (fig. 100). The exterior of the eastern end, with its steep flying buttresses and profusion of struts and pinnacles, is one of the signature moments in Gothic architecture. It is a complex but composed scene framed by the arms of the cathedral and the towering central spire, a beautiful and satisfying sight.

Our view of the north side of the cathedral along Rue du Cloître Notre-Dame is more restricted than the other sides, and it is easy to miss interesting features here. There are two very important portals: the north-transept façade and the Red Door. Finally, at the end of my stroll, the majestic west façade is one of the supreme achievements in medieval architecture and it is important to spend the time appreciating both its overall structure and the quality of its various architectural and decorative components that will be discussed later in this chapter. The west

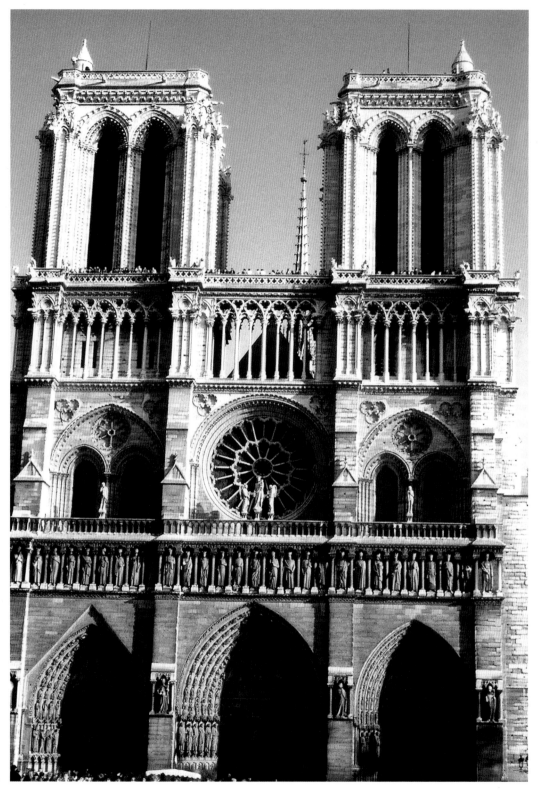

98. Paris, Cathedral of Notre-Dame, west façade, 1200–1250.

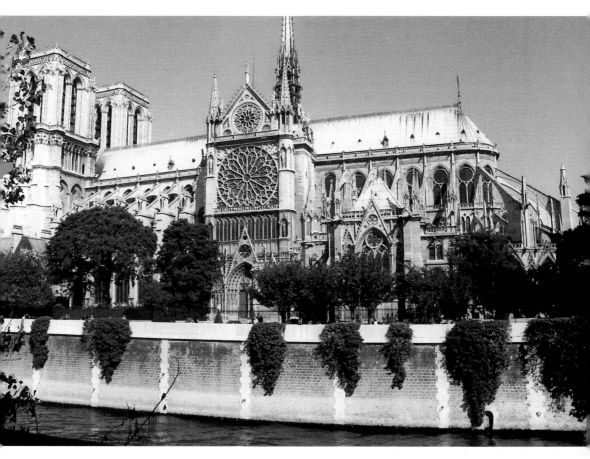

99. Paris, Notre-Dame, south flank, 12ᵗʰ and 13ᵗʰ centuries.

façade, with its three doors, the gallery of the kings, the rose window, the upper arcade, and the twin towers, has exceptional strength and composure.

The rivers that come together in and around Paris have given it a position of strategic and commercial importance. The Seine and Marne converge on the eastern edge of present-day Paris, and the Oise meets the Seine just to the west. A smaller river, the Ourcq, comes into Paris from the northeast. The Seine flows around the Île-de-la-Cité and the Île-Saint-Louis in the heart of Paris, and for many it is the heart of France. The cathedral's location on the south bank of the Île-de-la-Cité has made Notre-Dame one of the most memorable buildings in Europe. From the southwest, on the Left Bank, we have a splendid view, framed by trees and book stalls, of the majestic western façade and the flying buttresses of the south flank. From the east the island looks like the prow of a great ship with the choir of the cathedral riding the waves of the river. No cathedral has a finer home. River access was vital for the settlement and development of Paris, but it was also a curse during the Middle Ages. The Vikings came up the Seine from the sea to sack the city many times and even with the protection of the ancient Roman walls, Paris was vulnerable to attack from the west and the east.

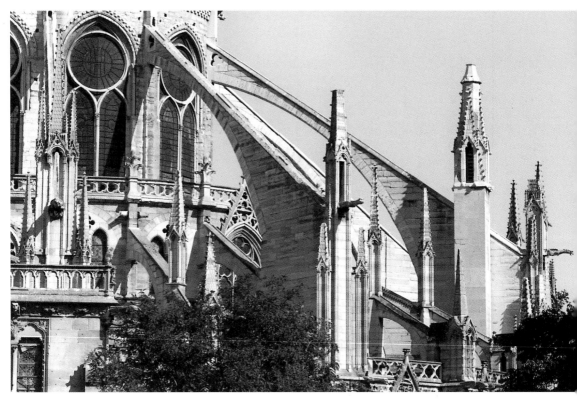

100. Paris, Notre-Dame, flying buttresses, 12th century, rebuilt in the 19th century.

When the Vikings laid siege to Paris in 985–986, the defenders were led by Eudes, the Count of Paris, who went on to lay the foundations for the Capetian dynasty with the accession of his son Hugh Capet to the throne in 987. Nonetheless, the Île-de-France, the area around Paris, was an intense area of contention for another fifty years until Louis VI brought peace by containing the warring nobles in the area. Because of the discord in the eleventh century, there was not much construction in the Paris region, particularly of religious buildings, until the early twelfth century. From then to the present time, through periods of peace and prosperity, of war, plague, and famine, Paris continued to grow and flourish.

Medieval kings traditionally moved from place to place, taking their government with them in large baggage trains. After Philip II's baggage train with his archives and treasure was captured by the English in 1194 at Fréteval, he made Paris his permanent residence and built a fortress on the western end of the Île-de-la-Cité. Even so, the presence of the monarchy was not the sole driving force in Paris's early growth. The establishment of religious schools that led to the creation of the University of Paris in the twelfth century and the commerce surrounding them were more important for urban growth than the monarchy itself. Students came from all over western Europe and the common language was Latin. The Latin Quarter survives today, and the Sorbonne occupies a place of honor just below the Pantheon. The book-

stalls along the Left Bank facing the cathedral are the heirs of many centuries of student life.

Perhaps as much as any other factor, it was the very long reigns of Louis VI, Louis VII, and Philip II from 1137 to 1223 that contributed to securing for Paris the position it continues to hold to the present day. The construction of Notre-Dame coincided with the great expansion of Paris and the French monarchy, particularly under Philip II, who drove the English out of Normandy, Brittany, and most of the land north of the Loire river. His victory at the battle of Bouvines in 1214 over an alliance of the English, Germans, and renegade French nobles was a great turning point for France. In this momentous battle fewer than two hundred men died.

Notre-Dame was the central part of a massive urban renewal project that involved the demolition and construction of many buildings. With our unobstructed view of the cathedral from the Left Bank, it may be difficult to realize that at the time the cathedral was conceived and built, it was surrounded by many other buildings. The bishop built an elaborate complex of buildings, including a hospice, refectory, dormitory, cloister, infirmary, and even a bakery. A magnificent bishop's palace was also erected along the south bank. That palace was attacked and finally demolished during the July Revolution of 1830. On the northern side, the canons' houses and gardens occupied the northeast quarter of the island. A major part of this late twelfth-century urban-renewal project was the opening of the square, or parvis, occupied by the ancient cathedral in front of the present cathedral, a project that required the purchase and demolition of numerous private buildings over several decades.[1] The colossal ambition and determination it took to accomplish this undertaking still challenge our imagination.

Work began on the choir of Notre-Dame in the 1160s and steadily progressed to the completion of the choir and nave in the 1190s. There were then two major rebuilding campaigns in the next fifty years that physically and stylistically transformed the cathedral, reflecting the aesthetic changes that took place over a hundred-year time span. We can follow the changes from the Early Gothic interior through the High Gothic and Rayonnant west façade to the dynamic complexity and elegance of the Rayonnant north and south transepts.

The initial concept of the cathedral and the steady progress of construction from the 1160s to the 1190s were principally due to the vision and energy of the new Bishop of Paris, Maurice de Sully. Although much modified, Notre-Dame essentially remains his and the first architect's church. Maurice de Sully was an unusual person to serve as bishop because he was not from the nobility and may have come from a peasant family from the Loire. A renowned preacher, he became bishop in 1160 and began construction on the chevet to the east of the old cathedral, outside the city wall, where the builders were unhindered by the existence of earlier buildings. This area was somewhat marshy and thirty-foot foundations of cut stone were required to rest the building on solid ground; it is clear that an immense building was always intended. It took about twenty years to complete the eastern end; in 1182, the choir was consecrated. Work continued on the nave and around 1200 construction began on the west façade. By the time Sully died in 1196, the better part of the cathedral was nearing completion and work was about to begin on the colossal western façade.

Although the beginning of construction for Notre-Dame is usually given as the early 1160s, there is evidence that plans were developed in the 1150s and some work may have begun on the walls of the chevet.[2] This was only twenty years after Saint-Denis and Sens launched the revolution of Gothic architecture. Even at that early date, the Parisian builders were thinking of a building on an unprecedented scale. By comparison, the Early Gothic churches of nearby Sens, Noyon, and Senlis were 30 to 35 feet less in

101. Paris, Notre-Dame, original upper stories, 12th century, restored in the 19th century. Viollet-le-Duc recreated the original four-story elevation in the first bays of the choir, nave, and in the transept.

height. Even the vaults at Laon, contemporary with Notre-Dame, are 90 feet high compared with Notre-Dame's 115 feet. The builders of those Early Gothic churches had not yet been caught up in the drive for the greatest possible height. That was to come in the next generation with the immense High Gothic masterpieces of Chartres, Bourges, Reims, Amiens, and finally Beauvais. Today the great nave of Notre-Dame with its soar-

ing six-part vaults still seems remarkable. The impact it had in the late twelfth century as the choir and then the nave neared completion must have been extraordinary.

Shortly after the nave was all but finished, and as work on the west front continued, a remarkable decision was made to remodel the nave elevation and rebuild much of the exterior. In proportion to its height, the central space is quite narrow, and the small

clerestory windows high in the vaulting did not provide adequate illumination. At the beginning of the thirteenth century, the small clerestory windows were enlarged by bringing the sills downward into the space originally occupied by the oculus. The size of the upper windows was nearly doubled (fig. 101). As a result, the exterior was rebuilt, particularly the upper stories, and new flying buttresses were constructed.

The traditional view has been that flying buttresses were invented in the 1170s or 1180s for the nave of Notre-Dame. It was almost universally accepted that the choir, begun in the 1160s, did not have flying buttresses and that they were added in the thirteenth century. Today there is a wide range of beliefs among architectural historians as to when and exactly where flying buttresses were first used.[3] The massiveness of the outer piers for the choir seems to indicate a preparation for flying buttresses to support the upper stories. Erlain-Brandenburg has proposed that the flyers that reach from the outer pier to the clerestory wall were only added in the thirteenth century as a means of allowing water to drain off the enormous roof.[4]

Whatever the final resolution of this debate, the flying buttresses of Notre-Dame were extremely influential and demonstrated their effectiveness. After Notre-Dame, and with the construction of Chartres and Bourges, flying buttresses became a normal component of the gigantic High Gothic buildings to come in the next century.

The building campaign of the 1220s saw the completion of the upper stories of the west façade, the rose window, and the towers. In the 1240s and 1250s, the transept arms were expanded, and the magnificent Rayonnant façades on the north and south sides of the cathedral were accomplished. The chapels along the perimeter of the nave and choir were also installed between the exterior buttresses. Notre-Dame was transformed from an essentially Early Gothic building into a blend of Early and High Gothic strength and Rayonnant refinement. To comprehend these changes and the new nature of the cathedral we must not only understand its overall structure but also pay close attention to the various architectural components that came together to create a fascinating edifice. By the 1270s, the church we see today was essentially complete, but it would not escape the busy hands of kings, clerics, and revolutionaries.

In 1630, Louis XIII became quite ill and made a vow to honor the Virgin if he were to recover. At the end of his reign, Louis XIV decided to respect his father's promise by demolishing the Gothic choir and replacing it with a modern ensemble at the beginning of the eighteenth century. The choir screen, altar, choir stalls, and the enclosure of the hemicycle were all removed and entirely replaced. The outer decorative panels of the straight part of the choir are all that remain of the original choir screen that once encircled the choir. This very ambitious and expensive project was undertaken in spite of a pressing need to preserve the deteriorating edifice.

By the nineteenth century, Notre-Dame was in a ruinous condition. The great spire over the crossing had been removed, and the structure of the building was in jeopardy. The French Revolution and its aftermath had been disastrous for Gothic architecture, particularly in northern France. The great cathedrals of Arras and Cambrai were totally destroyed, and the sculpture and stained glass in most churches were removed or defaced. Of all the major cathedrals, only Chartres escaped relatively unscathed. Notre-Dame suffered cruelly, with most of the sculpture removed and buried nearby, where hundreds of fragments were discovered in the 1970s.

Fifty years ago, it was fashionable to denigrate the nineteenth-century restoration efforts of Eugène-Emmanuel Viollet-le-Duc and Jean-Baptiste Lassus as being overly romanticized and misguided. The concept of restoration was to some extent different in the nineteenth century, when restorers were more inclined to recreate the original build-

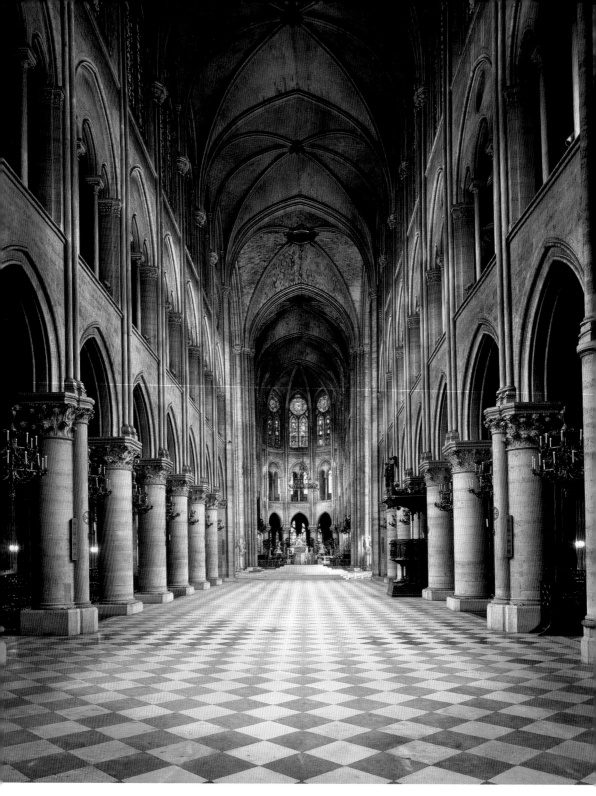

102. Paris, Notre-Dame, nave and choir, 1160s–1260s. Photograph by Caroline Rose © Centre des Monuments nationaux, Paris.

ing as they imagined it to be, than it would be today. Compared to the heavy-handed repairs by the clergy of the seventeenth and eighteenth centuries, Viollet-le-Duc and Lassus were models of caution and propriety. They not only had the task of understanding the original medieval building but they also had to rectify, to the extent possible, the earlier desecrations of well-intentioned restorers.

It is also unwarranted to blame the loss of the original medieval decorations solely on the French Revolution and nineteenth-century restorers. In fact, much of the desecration occurred earlier under the direction of zealous clerics who removed most of Notre-Dame's twelfth- and thirteenth-century stained glass, not rebels or over-eager restorers. This type of destruction occurred all over Paris. In 1700, over two hundred medieval parish churches survived. Today there are fewer than twenty. These were significant buildings, not merely small chapels that were torn down to make way for the new Paris. The drive to become modern afflicts every age. Notre-Dame is essentially a nineteenth-century building, but it is probably more faithful to the thirteenth-century original than we have any right to expect.

The overall impression of the exterior is one of peace and balance, but in the interior it is noise and confusion. In reality, the hustle and bustle of today's cathedral are probably not that different from the intense crowds of worshipers and merchants that flocked to Notre-Dame in the Middle Ages. Despite the impression of an ancient theme park, we can appreciate the architectural miracle that awaits if we have the patience to find it. The interior with its soaring vaults and the magnificent rose windows of its transepts speaks to us of the monumentality of Gothic architecture. When I sit in the rear of the nave of Notre-Dame, what strikes me is how lovely and tranquil the six-part vaults are. Floating on slightly stilted ribs with pointed crossing arches, these vaults create a great sense of height and yet have a leisurely and spacious quality as well that draws our view down the nave to the choir (fig. 102).

Once inside, we are met by a powerful combination of great height and great length. The central aisle is relatively narrow with the crowns of its six-part vaults 115 feet above the pavement. The cathedral is approximately 400 feet in length, exceeded only by the great High Gothic cathedrals of Chartres, Reims, Amiens, and a few others. Our eye is drawn upward to the vaults and lengthwise to the clerestory windows of the choir. Because of the slender proportions even the enlarged clerestory windows do not provide adequate light and the cathedral remains fairly dark. The second-story gallery windows are visible from the pavement, but are too remote to provide much direct illumination.

To understand the monumentality of the cathedral and how it was achieved we must examine the underlying structure of the church. In spite of its overall size, Notre-Dame is made up of rather small spatial units that spread laterally as well as vertically through the double aisles that brace the nave and choir. Notre-Dame is like a huge ship of honeycombed stone: the cubes of the aisle bays are topped by identical cubes of the second-story gallery, which in turn are topped by the thin wall of the upper stories braced by the flying buttresses. This system of cubes or honeycombed cells provides the lateral support for the immense vertical space of the central aisle.[5] What comes to mind, in an odd way, is the stacking of cargo containers on ocean-going freighters. The stacking of the cubes provides tremendous bracing for the thrust of the central-aisle vaults as they spread their force outward.

The main elevation, rebuilt in the early thirteenth century, is now for the most part three stories with massive round columns dominating the ground-floor arcade. Each bay of the second-story gallery is comprised of simple arches framing a three-part arcade of slender columns and delicate capitals. The original nave and choir elevation, however, was a four-story elevation quite unlike the very distinct four stories at Noyon or Laon. At Notre-Dame a thin wall topped by large roundels and small clerestory windows tow-

111

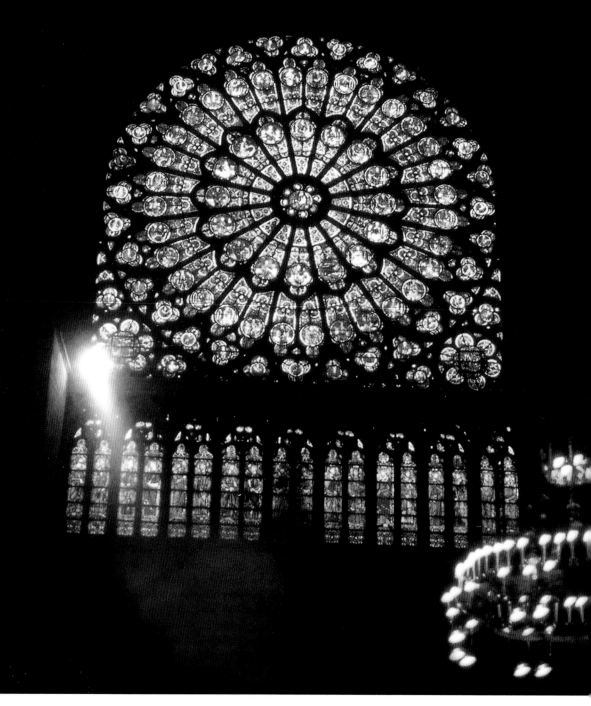

103. Paris, Notre-Dame, north rose window, 1250s.

ered above the second-story gallery. In the nineteenth century, Viollet-le-Duc discovered that the original elevation had large round openings above the gallery. Perhaps this was an initial attempt in the twelfth century to move away from the four-story elevation, but the technology was not adequately developed until the three-story elevation appeared at Braine and Chartres twenty years later. In order to demonstrate what the original elevation was like, Viollet-le-Duc recreated it in the first bay of the nave and in the transept arms. The original round openings were not glazed and provided no light, but he glazed them or allowed them to open onto gallery windows. The light they provide is minimal but striking.

The nave elevation of Notre-Dame is an intriguing combination of massive support and extreme thinness. The low arcade of huge columns and the second-story gallery support a tall and thin upper wall with clerestory windows. This combination of massiveness and thinness was made possible not only by the sturdy support of the columns but also by the lateral support provided by the cubes of the gallery. If we look closely at the restored oculus at the end of the nave, we recognize how slight the upper-wall construction really is. This thin wall rising above the gallery is further animated by the use of very slender triple colonnettes that climb uninterrupted from the column capital to small hanging capitals at the springing of the vaults. These rising colonnettes create a vertical uplift that seems to energize the wall.[6]

Notre-Dame is a five-aisle church with double aisles that envelop the nave and choir. The chapels with their altars and large windows were added in the thirteenth century. These chapels are of interest, but they radically alter the space of the aisles and ambulatory. The original aisle and ambulatory windows would have been quite large, and not only would have shed much more light into the aisles but also would have clearly defined the inner perimeter of the cathedral. It is quite easy to get swept along by the crowds circulating through the aisles and miss their spaciousness and elegance. In a curious arrangement, the second architect did not keep to the uniformity of the round columns of the nave, but created alternating columns surrounded by slender detached columns in the aisles. There has been some speculation that this was done to provide for the new flying buttresses above the gallery, but whatever the reason, the effect is quite dramatic and pleasing. The aisles are broad and low, giving us an excellent view of the four-part vaults.

The great crossing of Notre-Dame is extremely dramatic with the steep proportions of the nave and choir accentuated in the narrow, aisleless transepts and the towering piers of the central crossing, all framed by the immense rose windows of the transept façades. The rose windows and their glazed triforia entirely fill the upper reaches of the transepts. The north rose depicts the Virgin and Child surrounded by concentric rings of prophets, judges, and clerics. The south rose shows Christ on a throne encircled by apostles, martyrs, and confessors. The glazed triforia with their full-figured representations of the kings of Judah on the north and prophets on the south were created in the nineteenth century (fig. 103).

The central space of the crossing is a magnificent accomplishment, particularly for an Early Gothic cathedral. It is far taller than the beautiful crossing at Laon or the vaulting of any contemporary building with the exception of the now-destroyed cathedral at Cambrai. The eastern piers next to the choir are bundles of attached columns rising uninterrupted to the vaults, while those on the nave side are plain rectangular piers. This choice gives a somewhat dry, thin quality to the west side of the crossing. It seems to me that the proportions of these piers are too slender for the monumental scale of the crossing (fig. 104).

The side entrance into the ambulatory reveals two broad aisles separated by plain columns that pull us toward the curve of the hemicycle. The wide triple ribs spring off the

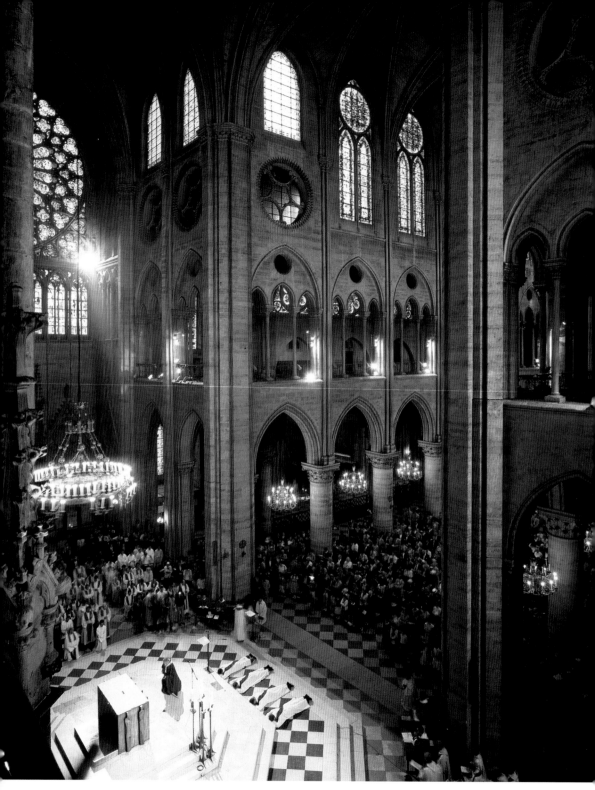

104. Paris, Notre-Dame, crossing, 1160s–1260s. Photograph by Caroline Rose © Centre des Monuments nationaux, Paris.

square shelves above the capitals to create powerful, dome-like vaults. There is a spacious, processional aspect to these aisles because the columns generate a commanding, regular rhythm.

The only surviving panels of the original choir screen are to be found in the first five straight bays of the choir. They were created at the beginning of the fourteenth century, possibly to protect the altar from the noisy crowds of worshipers. The frieze on the north side depicts the life of the Virgin and Christ from the Visitation to the Last Supper, and Christ's Agony in the Garden of Gesthsemane. The south panels illustrate scenes after the Crucifixion, when Christ revealed himself to Mary Magdalene, and his various appearances to the Disciples, the Supper at Emmaus, and the Ascension into Heaven. These two groups of sculptural panels are worthy of our closest attention, particularly the south panels. The north panels were created first and, although impressive, reveal more formal design and artistry than those showing the apparitions of Christ after the Crucifixion. These panels are extremely natural and affecting, and the relationships between the figures both intimate and respectful. The panel of Christ with the Magdalene shows two individuals who know and care for one another, and are not mere religious symbols. While we may wish to concentrate on the power of the architecture of Notre-Dame, this is one of the most beautiful and moving displays of medieval sculpture and should not be missed (fig. 105).

The ambulatory and chapels behind the choir are reserved for prayer. Originally, there were no chapels, but instead a curved screen of windows comparable to those in the ambulatory at Saint-Denis. A close look at the vaulting of the choir reveals how the builders solved the problem of creating ribbed vaults for parallel curved vaults. The ribs reach from two columns of the choir to three of the first aisle, and then the four piers of the exterior. Made up of small triangular units, the inner-aisle vault is in the shape of a W and the outer aisle in the shape of an M. This approach allowed the builders to create consistent spatial units and gives us a clear example of the flexibility and strength of ribbed vaults when combined with the pointed arch.[7]

In the choir the wooden choir stalls and panels depict the life of the Virgin. The altar represents the vow of Louis XIII, who is on the right paying homage to the Virgin in the central Pietà. On the left, Louis XIV, who commissioned the choir, looks on.

From in front of the choir we can see the rose window of the west façade. At the center the Virgin and Christ are surrounded by virtues and vices and signs of the zodiac. The scenes are a mix of medieval, sixteenth-century, and later restoration, but they create a vivid scene when the setting sun illuminates the nave. Among the lightest rose windows ever created, it became the model for those that followed.

One of the most appealing aspects of Notre-Dame is its historic site on the Île-de-la-Cité in the middle of the River Seine, and the wonderful open vista it provides of the west façade with its two crowning towers, the south side with its towering transept, and the eastern end with its dramatic flying buttresses circling the choir. Even though it is in the midst of a busy city, there is a splendid sense of isolation to the cathedral as it floats above the surrounding river and buildings. Because of its monumental size and the dramatic site it occupies, Notre-Dame seems untouched by the surrounding buildings and traffic. It is so dominant that we are almost forced to ignore the adjacent buildings. Many of the great Gothic cathedrals have this same quality of being part of the surrounding city or town but somehow separate as well.

There is a serene balance and harmony to the west façade; the ascending force of the four enormous piers and the two towers is balanced by the horizontal bands of the Gallery of Kings and the open arcade above the rose window. Even though the façade is pierced by the three portals and the rose window is flanked by double-lancets within

105. Paris, Notre-Dame, choir-screen detail, Christ and Mary Magdalen, 13th century. Photograph by Caroline Rose © Centre des Monuments nationaux, Paris.

broad arches, the west front presents itself as a great wall rising above us with a mural quality that is one of Notre-Dame's distinctive features. Unlike the designers of Laon, Reims, and Amiens who used recessed portals and elaborate compositions, the architect at Paris chose a more traditional formula based on the Romanesque fronts at Caen, Saint-Denis, and Chartres, but took it to a monumental scale. Despite the success of Notre-Dame's façade, however, it did not become the model for the future. Its great simplicity and balance were replaced by a more exuberant, intricate style. The simple lucidity of its flat style gave way to more multidimensional and complex arrangements.

The Gallery of Kings and the rose window,

the elegant openwork gallery above the rose, and the towers were begun in the 1220s and essentially completed by the 1240s. Spires for each tower were originally contemplated but were abandoned when the crossing spire was erected. The Gallery of Kings was created shortly after Philip Augustus's great victory over the Germans and English at the Battle of Bouvines in 1214, and may have been a memorial of that triumph.[8] Removed and broken into pieces during the Revolution, 143 fragments of the gallery statues were discovered in 1977 buried under a nearby Paris street. They can now be seen at the Cluny Museum on Boulevard Saint-Germain.

Created in the 1240s, the Last Judgment of the central portal is not the terrifying portrait

of the Second Coming so vividly portrayed at Bourges, with the damned being dragged into the fiery cauldron of Hell by gleeful devils. Instead of focusing on the horrors of the Apocalypse of the Book of Revelation, this Last Judgment shows a beneficent Christ presiding over a scene where salvation is given more emphasis than damnation. In many ways it is a rather sweet Last Judgment, if that is possible. In the lower lintel the raising of the dead from their graves is an orderly, somewhat leisurely experience rather than a scene of chaotic panic. Here the dead are all fully clothed as they gently push aside the coffin lids. The cauldron of Hell is not even part of the central scene, but off to the side in the first archivolt. Naturalistic renditions of two of the horsemen of the Apocalypse are found in the second and third rows. The upper lintel is equally placid. The damned being led off in a reasonably calm manner in the upper lintel appear to be sad rather than totally distraught. In the center of this lintel is the very fine modern rendition of Saint Michael and a devil, but even this scene lacks the intensity of a true struggle over the soul of an individual sinner.

The top of the tympanum shows the instruments of the Crucifixion: the cross, spear, and nails. This is another orderly scene with very strong vertical and horizontal elements. Christ sits above a small representation of the Heavenly Jerusalem with the Virgin and Saint John kneeling in prayer to His right and left, while angels in the archivolts lean over a railing to look down on the scene with a marvelous variety of expressions, almost as if they were watching a play or concert. We are drawn into the intimacy of the scene (fig. 106).

On the central doorpost is a nineteenth-century copy of Christ teaching. The jamb figures are of the apostles, with medallions representing the virtues and vices below them. The wise and foolish virgins are on the side doorposts. The central portal was mutilated in the eighteenth century when the lower central pillar, lower lintel, and the cen-

ter of the upper lintel were removed by Jacques-Germain Soufflot, the neo-classical architect of the Pantheon. During the French Revolution, all the jamb figures were destroyed. The portal was restored in the nineteenth century with excellent copies of the statuary based on eighteenth-century prints.

The right portal was originally designed for the old cathedral in the 1160s, but was not placed in its present position until the early thirteenth century. Originally dedicated to the Virgin Mary, it was moved to the right door and consecrated to Saint Anne, the mother of Mary. A new lower lintel was added that includes several wonderful scenes from the life of the Virgin: Mary embracing Elizabeth, the mother of John the Baptist, in the Visitation, the heads of cattle peeking out over the Nativity, Herod on his throne, and the three Magi.

In the tympanum the Virgin sits under a canopy holding the Christ Child with graceful angels swinging incense holders, a standing bishop, and a kneeling king with a scroll. Below on the central doorpost is a statue of Saint Marcel, a fifth-century Parisian bishop. Beneath him is a depiction of the miracle of the sinning woman being freed from a serpent that had devoured her, a popular legend from the life of Saint Marcel.

The north portal is "one of the most beautiful conceived in the Middle Ages. Consecrated to Mary and her Triumph in Paradise, it is the most magnificent hymn to the glory of the Virgin that the thirteenth century could have imagined."[9] As with the other sculpture on the west façade, the north portal emphasizes clarity and balance with each figure clearly delineated and slightly separated from the others. There is a stately, processional quality to the sculpture of this portal, beginning with the jamb figures and the seated kings and prophets. In the upper lintel the Virgin is gently attended by angels who are lovingly lifting her from her death bed. The seated apostle on the right with one hand on his cheek and his head slightly tilted,

106. Paris, Notre-Dame, west façade, central portal, Last Judgment angels, early 13th century. Photograph by Caroline Rose © Centre des Monuments nationaux, Paris.

and the apostle on the left stroking his beard, show endearing gestures of love and concern. The tympanum displays the Coronation of the Virgin.

The transept arms were begun in the 1250s by Jean de Chelles who completed the north arm and had begun the south one before his death in 1258. Pierre de Montreuil, the succeeding architect, changed the original design, making it more animated and elaborate than its counterpart.[10]

The transepts played an important part in defining both the exterior and the interior of the cathedral. The northern side of the cathe-dral, along rue du Cloître Notre-Dame, was controlled by the canons with an elaborate collection of buildings and gardens to house and support them. The south side belonged to the bishop. The images of the north and south portals reflect the rivalry for control of the cathedral between the canons and the Bishop of Paris when construction began in the 1160s. The north portal is dedicated to the Virgin, to whom the canons had become devoted. The south portal is dedicated to Saint Stephen (Saint Étienne), to whom the cathedral was originally dedicated, and thus reflects the position of the bishop. It is ironic

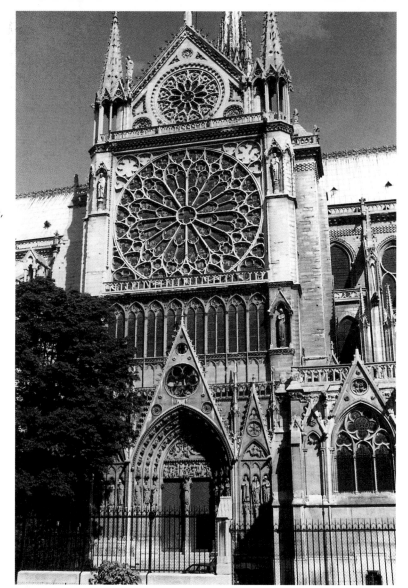

107. Paris, Notre-Dame, south-transept façade, 1260s.

that as the canons' power waned over the next fifty years, the worship of Mary gained ascendancy, not only in Paris but also throughout Christendom.

Because the crossing arms at Notre-Dame have no side aisles, the façades are quite slender and have great verticality. The façade exteriors do not project from the body of the building, and the strong piers on each side ascend with great force to the side spires that

embrace a second rose window. The forceful verticality is balanced by the delicate decorative features of the portals, the gallery windows, the rose window, and the crowning ensemble of spires and gable. Above all this rises the tall central spire built by Viollet-le-Duc in the nineteenth century.

The transept façades rise in four stages, beginning with the sharply pointed gables arranged across the base of the transept, cre-

ating an exquisite screen that lifts our gaze upward. In spite of its delicacy, the ensemble of gables gives the façades a strong base. There are three arcades at the second level comprised of a very small balcony and then a larger blind arcade, and a glazed arcade of double lancets. The great rose windows occupy a huge square at the third level of these soaring façades, giving a balance to the vertical thrust of the piers and towers. Small and refined balconies above and below further frame the rose windows with their horizontal accents. The roses dominate but do not overpower the rest of the façade, and are extremely light in construction. Except for the upper corners, they are glazed from edge to edge. At the top there is a rather solid gable with a smaller rose window of its own flanked by two pinnacles. Beneath the upper rose a delicate balcony spans the width of each transept (fig. 107).

The private entrance for the canons, the north portal has images that were important daily reminders for the clergy as they entered the cathedral to perform Mass and other duties. The lower lintel of the north portal shows scenes from the Nativity, the Presentation in the Temple, Herod Ordering the Massacre of the Innocents, and the Flight into Egypt. The second and third levels portray the legend of Saint Theophilus, a priest who made a pact with the Devil. On the right Mary intercedes and retrieves the pact from the serpent.

The Red Door, to the left of the north transept, illustrates the Coronation of the Virgin along with the story of Saint Marcel in the archivolts. Near the Red Door is an interesting though damaged set of panels depicting the Death, Assumption, and Coronation of the Virgin.

A statue of Saint Stephen on the central door post reminds us of the original dedication of the cathedral to Saint Stephen, who was the first Christian martyr; many French churches and cathedrals were originally dedicated to him. After Christ's death and resurrection, Stephen became an ardent and aggressive preacher of the faith, blaming the Jews for Christ's death. The lower lintel shows him preaching before Jewish priests and being brought to trial. In the upper lintel we see the stoning of Saint Stephen and his body being placed in a sarcophagus.

The reliefs on the base of buttresses may be scenes of student life that would reflect the growing importance of the schools of learning burgeoning on the Left Bank. These are significant because so few scenes survive of everyday life in the Middle Ages.[11]

PARIS

The Sainte-Chapelle

The Sainte-Chapelle, built by Louis IX between 1241 and 1246 in his palace on the Île-de-la-Cité, is a superb example of the simplification of space and structure and the elaboration of line. The upper chapel of the two-story building is a single unified space enclosed by enormous stained-glass windows telling stories from the Bible. The designers took the model of a gold-and-enamel reliquary and expanded it to the size of a small church (fig. 108).

One of the most politically and architecturally important buildings of its time, The Sainte-Chapelle and its relics symbolized the religious and political prestige of France and the king. In 1239, Louis IX purchased the Crown of Thorns from his cousin, the Emperor of Constantinople, who needed the money to

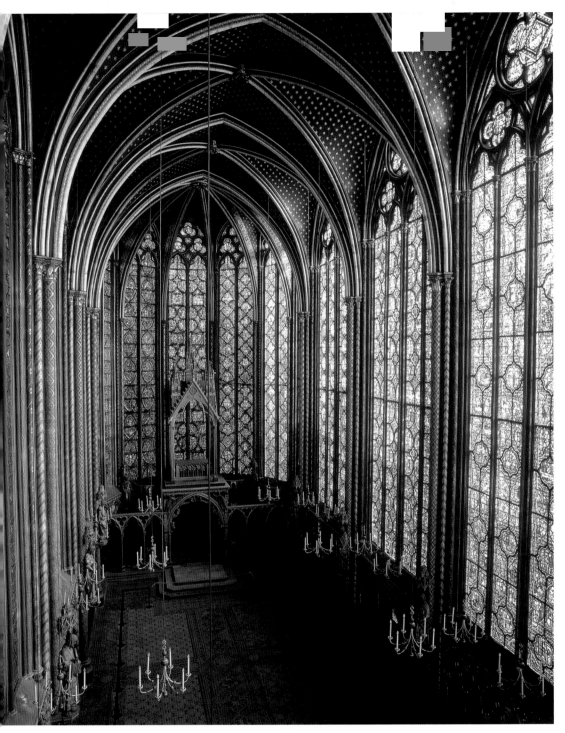

108. Paris, The Sainte-Chapelle, upper chapel, 1240s. Photograph by Bernard Acloque © Centre des Monuments nationaux, Paris.

fight the Turks threatening his kingdom. Louis bought other precious relics, including a piece of the True Cross, a nail from the Cross, and the lance used during the Crucifixion. The Crown of Thorns was the supreme relic, analogous to Louis's own crown, and elevated his image as both a political and religious leader.

In the 1230s, Rayonnant design led to a simplification of space and an elaboration of light and line. As the builders were able to move away from the massive structural piers and buttresses of High Gothic and convert the wall surface to enormous windows, bar tracery began to play a predominant role. The Rayonnant style departed from the soft three-dimensional forms of High Gothic to an emphasis on light and line at Amiens, Saint-Denis, and Troyes.[1] Line tracery in the upper windows, begun at Reims and expanded at Amiens, led to increased refinement and subdivision, particularly of the great clerestory and rose windows. At Amiens the exterior of the chevet is a profuse accumulation of arcaded flyers, decorated pinnacles, and thin gables. At the same time that architects were becoming preoccupied with the possibilities of tracery design, they were reducing the structural elements of the piers, triforia, and vaults to an absolute minimum, sometimes at the risk of collapse as at Beauvais and Troyes. Tracery became exceedingly complex and mannered, particularly with Flamboyant Gothic in the fifteenth and sixteenth centuries, but during the initial phase of Rayonnant in the 1230s and 1240s the windows still retained the restrained geometry of the lancet and the oculus format, but with more and finer subdivisions.

The lower chapel of The Sainte-Chapelle was essentially a parish church for the king's servants, while the upper chapel, reserved for the king and his court, was the repository for the sacred relics. The dual qualities of simplicity and refined design are apparent on the exterior. Built on a plain base, the slender piers framing the windows are unadorned as they rise to the roof. Delicate gables and pin-

nacles create a graceful crown for what is a simple exterior. Expecting to enter a tall building, we are surprised by the squat proportions of the lower chapel, its heavy paintwork, and lack of light. Every surface was painted or gilded and was restored by Lassus in the nineteenth century. The broad vaults are set on slender columns set off from the side wall. A sizable blind arcade surrounds the interior beneath the small clerestory and chapel windows.

A narrow circular staircase leads up to the main chapel. Nothing can prepare us for the dazzling splendor of this delicate cage of elegant vaults and towering stained-glass windows. There are four windows on each side of the chapel and seven in the apse that embraces a small screen and altar that held the sacred relics. As in the chapel below, there is a sophisticated arcade of blind lancets and niches surrounding the interior.

Medieval reliquaries usually had figures of various saints on their sides. Here at The Sainte-Chapelle statues of the Apostles (six are original) are on the inner piers beneath small canopies. As Robert Branner has written, The Sainte-Chapelle is a reliquary turned outside in.[2]

The windows, slender lancets crowned with trefoils, are 50 feet tall. They tell the biblical stories from Genesis to the Resurrection and Apocalypse. Old Testament scenes are on the side windows. Along the north wall we see the books of Genesis, Exodus, Numbers, Deuteronomy, and Judges. Along the south wall we see the story of the Relics, the Book of Kings, and the stories of Esther, Judith, Job, Tobias, and Jeremiah (fig. 109). The axial window displays Christ's Passion, and in two lancets of the window to the left is the life of John the Evangelist and the childhood of Christ. On the window to the right we see the life of Saint John the Baptist and the story of Daniel. The outer side windows of the apse illustrate the story of Isaiah and the genealogy of Christ (the Tree of Jesse) on the left and the story of Ezekiel on the right. The fifteenth-century rose window on the

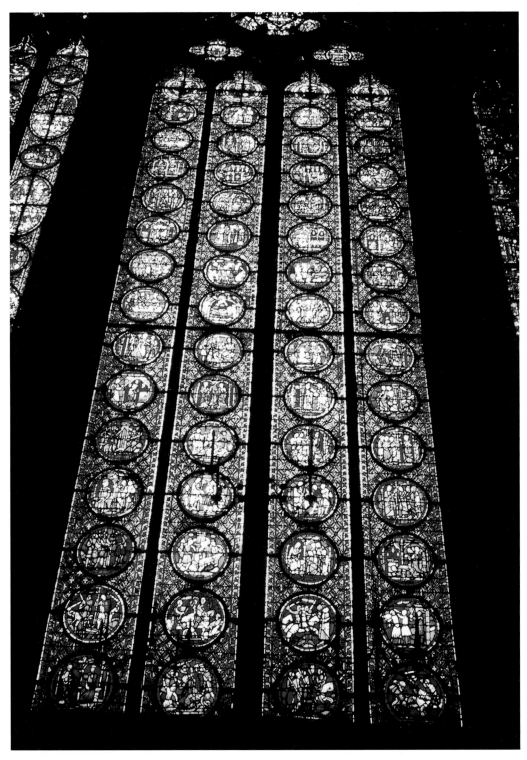

109. Paris, The Sainte-Chapelle, window, 1240s. The lancet windows are filled with scenes from the Bible.

west façade shows the story of the Apocalypse.

The windows are a mix of original, restored, and replacement panels. In some cases, as with the Genesis window, the panels are almost all modern. Others, such as the Passion, are mostly original. There are so many scenes in each window (120 in the Esther window alone), and the windows are so tall, that it is difficult to read the narratives. There are many splendid scenes, however, and the radiance of the stained glass has an impact we never forget.

PARIS

Royal Abbey of Saint-Denis

A visit to the great abbey church of Saint-Denis, on the northern outskirts of Paris, will take you back to the beginning of France: the creation of the French nation, the founding of French Christianity, and the establishment of the French monarchy. It particularly takes you back to the dawn of Gothic architecture. From the fifth century to the French Revolution and the nineteenth century, Saint-Denis played a central role in the development and preservation of the identity of France (fig. 110).

Saint Denis was an Italian who came to France in the fourth century to promote Christianity. He and his companions, Rusticus and Elutherius, created a Christian community on the Île-de-la-Cité. Imprisoned and beheaded during the repression of Christianity by the Romans, he picked up his head according to legend and walked from Montmartre to Saint-Denis where he was buried. Over time, this Denis became confused with a neo-platonic philosopher, called Pseudo-Denis the Areopagite. The latter was also confused with Dionysius, an early Christian disciple of Saint Paul's. Out of this mix of history and myth came the powerful legend of Saint Denis, the patron saint of France.

From about 500 A.D., Frankish kings recognized the importance of this sacred place. In the seventh century, Clothair II made Saint Denis the patron and protector of France, and during the following centuries the abbey played an important role in the intertwining of the Christian faith and the French monarchy. The royal regalia were kept at Saint-Denis, as was the Oriflamme, the French battle standard. Before leaving for a war or crusade, the king came to the Abbey of Saint-Denis to have his efforts blessed and to retrieve the Oriflamme.

Probably the most significant connection of the abbey with the monarchy was the practice of burying the king within the abbey church. Early French kings, Clothair II, Dagobert, Charles Martel, Pepin the Short, and Charles the Bald were entombed there. In the thirteenth century, Louis IX, later canonized as Saint Louis, made Saint-Denis the official necropolis, and from that time to the end of the monarchy in the nineteenth century almost all the kings and queens of France were entombed in the great crossing. The elaborate funerary monuments of the royal necropolis are among the main attractions of the basilica, which is now officially designated as the Cathedral of Saint-Denis.

From its beginnings in the twelfth century and throughout the entire Middle Ages, the Gothic style dominated European architecture. Throughout its incredible span of history, men of great genius, many of them unknown to us, appeared at propitious moments to further its development. Suger, abbot of the Royal Abbey of Saint-Denis from 1122 to 1151, was one of these men of vision and determination. Suger recognized

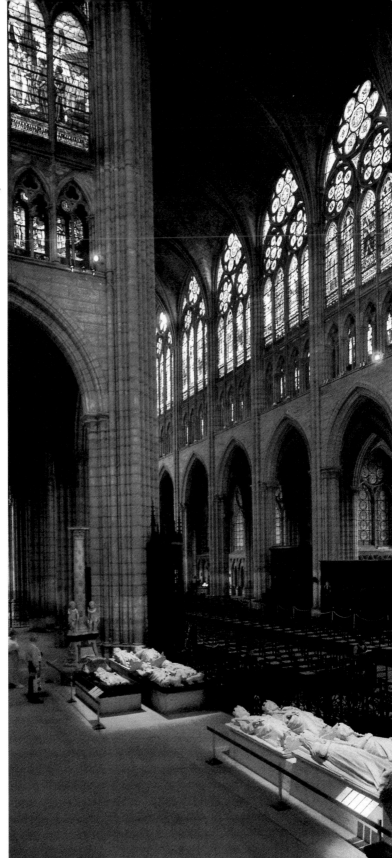

110. Paris, Royal Abbey of Saint-Denis, nave elevation, 1230s–1280s.

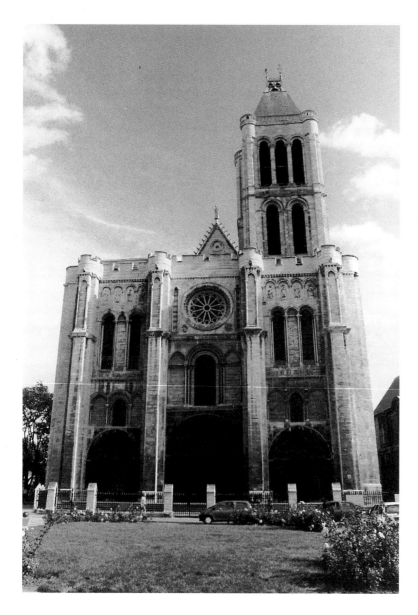

111. Paris, Saint-Denis,
west façade, 1130s.

that the abbey had allowed its economic and political base as well as the church itself to deteriorate, and he set about to restore its power, prestige, and wealth. Apparently he was both a brilliant administrator and politician. He was one of Louis VI's closest advisors during the early tumultuous years of his reign, when Louis finally brought a semblance of order to the Île-de-France by subduing a rebellious aristocracy. Suger became

Regent of France while Louis VII and Queen Eleanor were on the Second Crusade from 1147 to 1149. The vast expenses of this disastrous crusade may have prohibited Suger's successors from completing the work he began on the basilica.

Dionysus the Areopagite's writings on the divine quality of light were crucial to Abbot Suger and the design of the choir of Saint-Denis. In the hierarchy of material, from the

126

solid to the translucent, light was considered closest to God. Jesus proclaims in the Gospel of John, "I am the light of the world" (John 8:12). It was not mere symbolism, but a divine presence, a heavenly luminosity, that Suger wanted to bring into the chapels and ambulatory to shine on the sacred relics he had so assiduously assembled. How this was accomplished is one of the miracles that transformed art and architecture forever. Buildings would never be the same after Saint-Denis.

The Abbey of Saint-Denis now looks out on the city hall of Saint-Denis and attractive public housing in an industrial suburb of Paris. The recently restored northern flank and façade face an attractive park. The west front, with its military design and missing north tower, does not prepare us for the power and massiveness of the narthex just on the other side of the doors, let alone the voluminous thirteenth-century nave and choir. Like many Gothic churches, Saint-Denis is the result of separate building campaigns nearly one hundred years apart: Abbot Suger's twelfth-century western façade, narthex, and choir, and the glorious thirteenth-century basilica built during the reign of Saint Louis.

It has been convenient for writers to refer to Saint-Denis as if it had been designed and built by Suger himself. He left us a very detailed description of the achievements accomplished during his tenure as abbot, for which he took full credit. Suger was a man with a strong ego, and although he did not exclude others in his praise, he spoke as a sophisticated patron of the arts who was seeking specific results. He was a man of power who knew what he wanted. There is no question that Suger was keenly aware of the artistic and architectural developments of the day and was eager to put them to use.

Nevertheless, there was also a master mason or builder responsible for these projects. Whether it was one person or several we do not know. Suger was probably directly involved in all of the important design decisions, and was continually present during the actual construction of the façade, narthex, and choir. He must have relied on the master builder at every phase of the design and construction process. Without forgetting the crucial creative and technical contribution of such a master, it is not really inappropriate to refer to the twelfth-century church as Suger's.

The west façade is a classic twin-tower front borrowed from churches in Normandy with some very subtle differences. At Caen in Normandy the façades of the abbey churches of Saint-Étienne and Sainte-Trinité have two towers rising directly on the front with the lancet windows punctuating each story in a fixed arrangement. At Saint-Denis the two towers, one of which was removed in the nineteenth century, were recessed slightly from the façade behind a crenellated balustrade. The single rose window occupies the central position we have come to expect. The inclusion of sculpted jamb figures on the sides of the portals was not new, but at Saint-Denis these figures were fully integrated into the architectural design (fig. 111).

The narthex inside (1136–1140) rises on massive piers set on the diagonal rather than flush along the wall. Setting the piers on the diagonal allowed the builders to bring the ribs of the vaulting directly down the piers. The diagonal pier was an important and liberating technique, and Suger used the diagonal pier and the rib in a very powerful manner that was appropriate to the aspirations of the Capetian monarchy in the 1130s. We can compare the narthex piers to those at Laon or Notre-Dame, where the colonnettes spring from the top of a round column and rise along the flat wall of the nave. The colonnettes are basically surface decoration that visually binds the elevation and vaulting together. Both methods have their appeal, but the integrative power of the narthex design at Saint-Denis is apparent. Suger used the rib in a completely new manner by bringing the rib from within the supporting pier itself, not at the springing of the vaults. "With

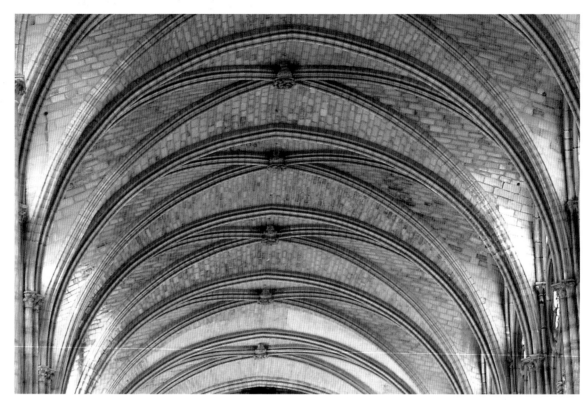

112. Paris, Saint-Denis, nave vaults, 13th century.

the new technique of the ribbed vault, in which the rib was built first, an unprecedented flexibility in vault shape becomes possible. The rib could be started from almost any elevation on the supporting piers and might take an asymmetrical route across the bay. It could be buried deep in the haunches of the supportive masonry on both sides, so giving an enormous sense of security to the builders."[1] This innovative use of the rib became an important means of integrating the elevation and vaults both visually and structurally and opening the walls to the light. At Saint-Denis the rib grows out of the pier and the decorative effect is fused with its structural purpose. The strength and flexibility of this technique were to become increasingly important as Gothic architecture progressed. One hundred years later the diagonal or compound

pier, really a cluster of colonnettes around a diagonal pier rising to the vaults, was employed with extraordinary finesse in the transept and nave of the thirteenth-century basilica.

The narthex's second-story chapel, now the organ loft, allowed the king to observe the religious ceremonies from the western end of the church. In this way the eastern end remained the province of the clergy while giving the monarch an equal position to oversee the religious ceremonies. From the steps of the narthex the great thirteenth-century nave with its amplitude of space, broad ribbed vaults, and display of stone and glass is hard to resist (fig. 112). It is difficult to turn away from such a vista, and I am ambivalent about stopping here before examining Suger's earlier ambulatory and its place in

128

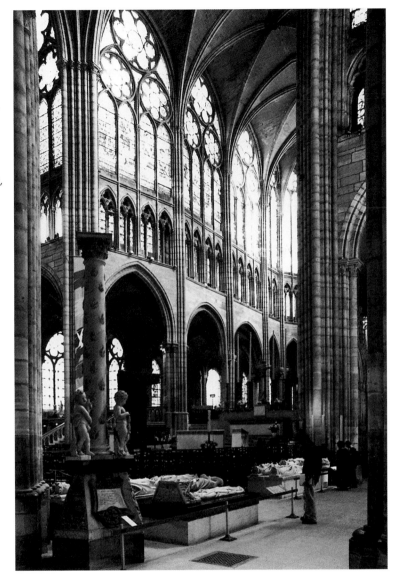

113. Paris, Saint-Denis,
nave interior,
1230s–1280s.

Gothic architecture, as well as its relationship to the thirteenth-century upper choir, nave, and transept. Perhaps it is best to pause here a moment with the clear intention of returning to absorb fully both the meaning and beauty of the panorama of the nave at the end of your visit (fig. 113).

Suger created a choir for a very different aesthetic and political purpose than he had in the narthex. In the choir he created a shrine of considerable delicacy focused on the light of reason and faith. As Vincent Scully says, "Suger's writings communicate his own feeling of excitement about the rib's nearly miraculous powers, and he used it to further his major aim: to let in the light" (fig. 114).[2]

Construction of the choir (1140–1144) began immediately after completion of the narthex with even more daring and imagination. Where the chapels of Romanesque

129

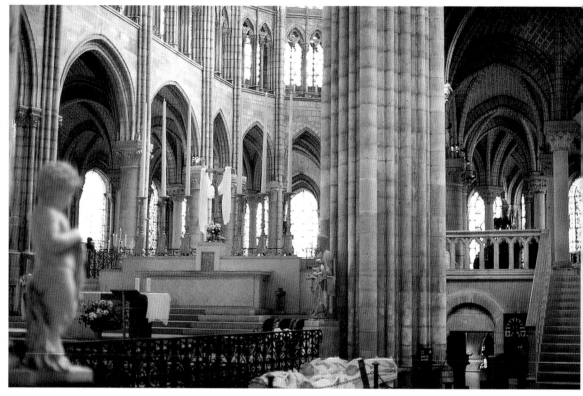

114. Paris, Saint-Denis, view of choir from nave, 12ᵗʰ and 13ᵗʰ centuries.

churches had been deep half-cylinders of solid masonry with small windows, Suger created a nearly continuous wall of glass comprised of very shallow chapels that are part of the ambulatory space. He was able to accomplish this by reducing their projection to the point where the chapels are part of the ambulatory rather than separate spaces and enlarging the windows. Even such a visionary as Abbot Suger had precedents to give him inspiration. To gain a better impression of what his new choir may have looked like before the upper stories were heightened and glazed in the thirteenth century, a visit to Saint-Martin-des-Champs in Paris (see fig. 14) is worthwhile. Saint-Martin-des-Champs, now part of the National Techniques Museum (Arts et Métiers), is still Romanesque in style, but with the impulse for expanding the choir and

creating light that was so important at Saint-Denis. The initial Gothic churches of Saint-Denis, Sens, and later Notre-Dame and Bourges all used the shallow-chapel format to create the effect of encompassing light. Deeper and more discreet chapels became the predominant Gothic style in the thirteenth century.

In the ambulatory the side walls have been removed, the exterior wall slightly flattened and there are slender columns where sturdy piers exist in the crypt below. The ambulatory and chapels share a compact arrangement of five ribs in the vaulting that unifies the two spaces. It is a historic display of design and construction logic that produces a dazzling, undulating wall of light. All of this radiates in a rigorous geometry of slender columns and colonnettes. We are still amazed by the

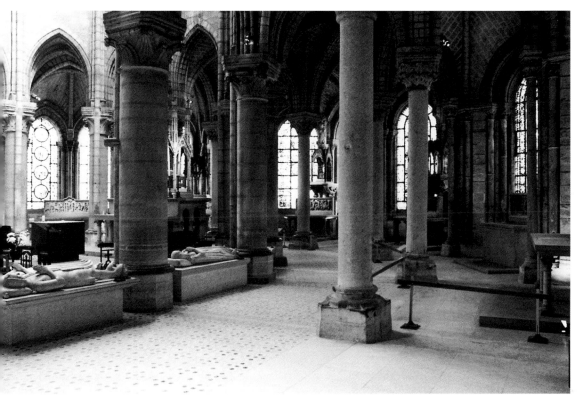

115. Paris, Saint-Denis, ambulatory, 1140–1144. The beginning of Gothic architecture.

"verve and buoyancy"[3] of the design and construction of Suger's ambulatory and chapels, coming, as they do, so soon after the invention of these techniques. Even by later standards the supporting elements and decorative details of Suger's ambulatory have a lightness and delicacy that is notable (fig. 115).

The double-aisled ambulatory at Saint-Denis was a remarkable leap forward. By concentrating the supports on the slender columns and the wall buttresses, the architect created an open semicircular space surrounded by glass. To accomplish this he used the rib vault with great refinement and sophistication. Not all the ribs are pointed; the diagonal rib is round. This technique made it possible for all three ribs to be the same height and create a segmented but uniform ceiling for the ambulatory. The vaults float above us and almost disappear as we are embraced by the chapel windows. As Stoddard writes, "What is unique about the interior of the Saint-Denis chevet is the completeness of the structural and spatial solutions at the very beginning of a new era."[4]

The original central choir must have been an amazing experience when first constructed. Because this was a much smaller building, the ambulatory and the stained glass would have been more dominant, and more of a contrast to the dark Carolingian nave. Coming around the ambulatory behind the altar must have been like entering a kaleidoscope of brilliantly colored lights (figs. 116, 117).

We must remember that in the Middle Ages light was not merely a symbolic repre-

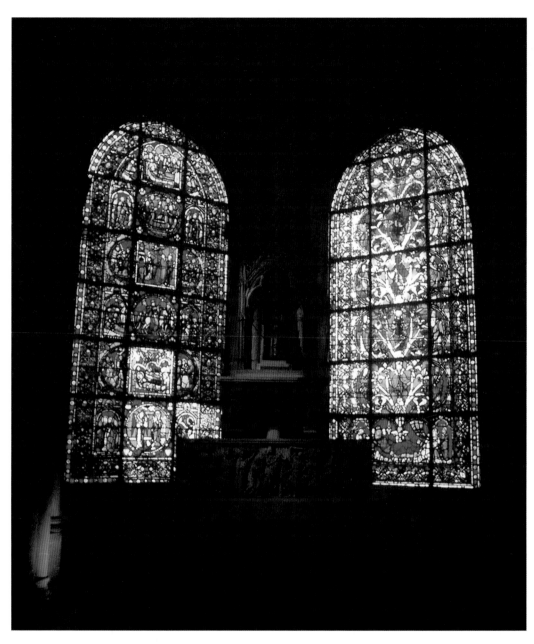

116. Paris, Saint-Denis, ambulatory windows, 1140–1144.

117. Paris, Saint-Denis, detail of the Tree of Jesse Window, 1140–1144. Abbot Suger offers a model of a stained-glass window to the Virgin.

sentation of God but a manifestation of the divine. The medieval mind did not separate the symbolic from the real in the manner we do; to the medieval way of thought, God was light and light was the embodiment of the Creator. The physical sensation of the ambulatory alone must have been overpowering. Combined with the belief in the divinity of light, it was surely an incredible emotional and spiritual experience. A close look at Suger's ambulatory should begin an appreciation of Early Gothic and ultimately all Gothic architecture that will stay with you forever. You will finally be ready to turn your attention to one of the glories of Rayonnant architecture, the thirteenth-century nave, transept, and upper choir of Saint-Denis detailed below.

The choir floats above the crossing, and from the top of the stairs leading to the ambulatory, you are able to look back and down into the great crossing, the nave, and side aisles. With the funerary monuments of the royal tombs spread out below and the upper stories full of luminous glass, the nave and transept of Saint-Denis provide one of the great interior vistas of Gothic architecture (fig. 118).

In the second quarter of the thirteenth century, the third great advance of Gothic architecture was undertaken in the Île-de-France at Saint-Denis and in the Champagne region at Troyes. As with the origins of Gothic at Saint-Denis and Sens, and with the initiation of High Gothic at Chartres and Bourges, Rayonnant Gothic, as it was to be

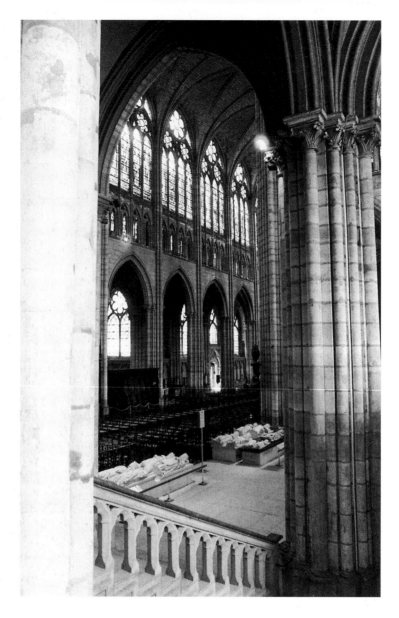

118. Paris, Saint-Denis, nave from the choir, 13th century.

called, began with great imagination and audacity as well as a sureness of style that was to serve it well in the coming decades of the thirteenth century.

Saint-Denis is unusual as a church because from the outset it has served several distinct purposes, which presented specific challenges to the builders. Suger's raised chevet was a repository for the important relics that have been a crucial part of the church's history. The crypt below was the initial burial

space for the religious community, and the small transept in front of the choir was dedicated to the necropolis of the kings. In addition, there was a separate monks' choir in the eastern part of the nave, next to the crossing.

There were also several major structural, religious, and aesthetic considerations confronting the thirteenth-century builders. Probably because of the hallowed character of the twelfth-century western façade, narthex, and chevet, they were prevented

from extending the length of the church. This decision forced the builders to expand the nave and crossing laterally rather than to create a longer building. Consistency of design appeared to be another major consideration. One of the salient features of the interior of Saint-Denis is the uniformity of the overall design of the chevet, transept, and nave. The new upper stories over the twelfth-century ambulatory were clearly designed in anticipation of the construction of the rest of the church. The width of the choir was adjusted to embrace the wider dimensions of the crossing and nave, but the result is an almost seamless continuity of design throughout the interior. By the 1220s, when the new construction was being contemplated, the ancient nave and possibly Suger's choir were in disrepair. Also, as magnificent and revered as Suger's chevet was, the aesthetics of the 1220s were very different from those of Suger's time. The accommodation of all these competing forces was an extremely difficult challenge.[5]

Because he was prevented from expanding the length, and because greater space for the royal tombs was required, the thirteenth-century architect enlarged the crossing to create one of the great central spaces in Gothic architecture. He accomplished this in basically two ways: the crossing has two aisles on each side rather than the usual single aisle, and the glazed triforium and its integration with the clerestory above by the sophisticated use of vertical accents create the impression of much greater height than really exists. The crown of the vaults at Saint-Denis is only 84 feet above the floor, compared with 115 feet at Notre-Dame. The central vaults are also broad rather than steeply pointed. The expansion of the transept had the effect of merging the nave and transept below the raised choir.[6] The result of this lateral rather than vertical expansion and the luminous panorama of the glazed triforium and clerestory is stunning. If we are being deceived by the architect into experiencing a greater height, we are happy to participate in the illusion (fig. 119).

The thirteenth-century cathedral that we see today was, of course, the culmination of one hundred years of architectural design, construction experimentation, and experience. The initial techniques of the rib vault and pointed arch allowed the builders to move from walls of stone to walls almost completely of glass, particularly in the upper stories.

The next step in this evolution of Rayonnant architecture was the merging of the triforium and clerestory. At Saint-Denis this was done with great erudition and effectiveness. Two techniques accomplished the absorption of the triforium into the clerestory: the triforium's outer wall was glazed and the vertical moldings of the clerestory, the mullions and responds, were brought directly down through the triforium. The combined triforium-clerestory now reads as one unit, although the original components are still discernible.

Viewed from the top of the stairs leading to the choir, the upper stories of nave and transept, with their full sheets of glass, are visionary. The clerestory windows at Saint-Denis are composed of a large rosette resting on twin lancets that themselves repeat the arrangement. This is a good example of the Gothic designer subdividing the basic design into repetitive elements. Every available space within this design is filled with glass. This creates a long panorama of glass that floods the building with light on all but the darkest days.

By the 1220s, the clerestory had become entirely glass and with the addition of the glazed triforium, the entire upper stories became massive screens of light. With the transept façades this treatment is truly exceptional. At each end of the transept is a gigantic rose window on top of a glazed triforium. The upper story is entirely glass with small trefoils and rosettes filling the corners. Below is a plain but refined arrangement of blind arches.

The crypt has many compartments, and the collected bones of the kings and queens of France are in a plain vault in a chapel on

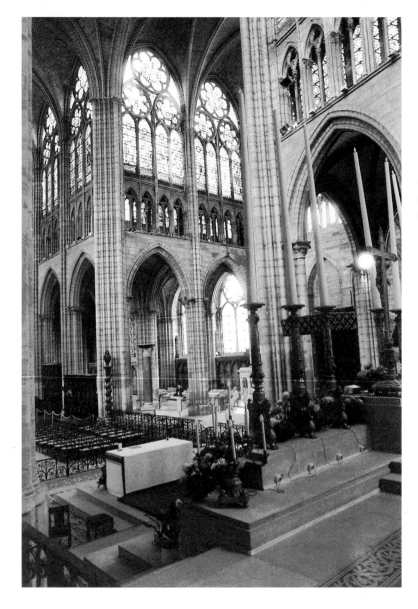

119. Paris, Saint-Denis, north transept from the choir, 13th century.

the north side of the crypt. During the Revolution the royal bones were tossed into a common pit and only later retrieved. During their lifetimes no owner of these bones was grander or more powerful, and yet for eternity they have become similar to paupers in a common grave.

I leave to the traditional guidebooks the description of the dramatic funerary monuments of the kings and queens of France. The basilica's conservator, Bratislav Brankovic, has written a fine brochure detailing the stages of construction of Saint-Denis. The architectural drawings and the comments are quite useful. It should be available at the basilica gift shop. Saint-Denis is truly a memorable experience, for within this light and buoyant building rests much of the history of French Gothic architecture and the French monarchy.

136

REIMS

Cathedral of Notre-Dame

Power—the Cathedral of Notre-Dame in Reims, the coronation cathedral of France, announces pure power: religious power, royal power, symbolic power, but especially the power of geometry and scale. The most intimidating factor is the sheer size of it all. The force of authority strikes us immediately when we enter the nave through the west façade and almost collide with the first massive pier. The bases of the piers are nearly shoulder high and quite formidable. The extraordinary size of these bases gives us the feeling of being below ground level looking up at the enormous piers and vaults above. The vastness of the nave and side aisles is arresting (fig. 120).

The city of Reims has played an important role in the Champagne region of eastern France and in the history of France from Roman times, when it was the provincial capital. The remarkable Roman gate, the Porte de Mars, is a remnant of Reims's early prominence under the Romans. The martyrdom of Saint Nicaise by the Vandals in 406 and the coronation of Clovis in 499 by Saint Remi established a religious and royal tradition that persisted until the end of the monarchy in the nineteenth century. With few exceptions, every French king from Louis VIII in 1223 until Charles X in 1825 was crowned here. The great central space of the long nave and short choir of Reims is the perfect setting for the theatrical spectacle of a coronation. It was to Reims that Joan of Arc brought Charles VII in 1429 to be crowned during the Hundred Years War.

A fire in 1210 destroyed the old cathedral, which was a collection of ninth- and twelfth-century buildings. Because it was the coronation church, it was imperative that the new cathedral be built as quickly as possible. The foundation stone of the new cathedral was laid in 1211, and both Louis VIII (r. 1223–1226) and Louis IX (r. 1226–1270) were crowned in the unfinished church.

Reims became an important textile-manufacturing center in the twelfth century, and the great trade fairs of the Champagne region created a strong merchant class eager to develop secular power. The choir was finished in 1241 after a period of conflict between the town and the clergy culminating with an attack on the Bishop's Palace in 1233 that drove the clergy from the city for three years. Ultimately, with the assistance of the king, the bishop prevailed, but the citizens of Reims did not support the building of the cathedral to any great extent. Unlike Chartres, where merchants contributed many stained-glass windows, Reims was primarily financed by the clergy and the bishop, as well as by generous royal patronage. Work continued on the nave for another forty years until its completion in the 1280s. The western façade was begun in the 1250s and mostly completed in the thirteenth century; the towers were not finished until the middle of the fifteenth century (fig. 121).

The cathedral and much of the city of Reims were almost completely destroyed during World War I. The Western Front skirted Reims to the north, and for four years the German army bombarded the cathedral and the center of town. If you look carefully, you can see remnants of the destruction, particularly on the northwest corner of the

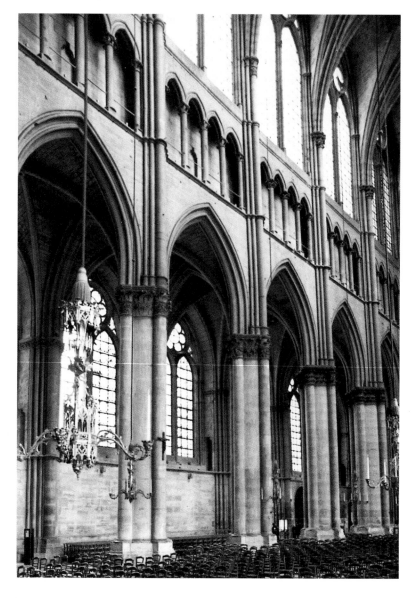

120. Reims, Cathedral of
Notre-Dame, nave
elevation, 1210s–1280s.

cathedral where the sculpture became disfig-
ured when the bombardment caused wooden
scaffolding to ignite and melt the stone (fig.
122). The destruction of the city was so dev-
astating that aerial views of Reims after the
war look very much like Berlin, Dresden, or
Tokyo after World War II. Not only was the
cathedral gutted but so also was the great
abbey church of Saint-Remi to the south.

World War II brought even further destruc-
tion to the city before the Germans surren-
dered in 1945 to the Allies in Reims.

Reims Cathedral, like its model, Chartres,
has its moods. In the thirteenth century, the
clergy removed a great deal of the stained
glass in the nave and aisles, and when light
floods the nave through the translucent glass
of the large clerestory and aisle windows, the

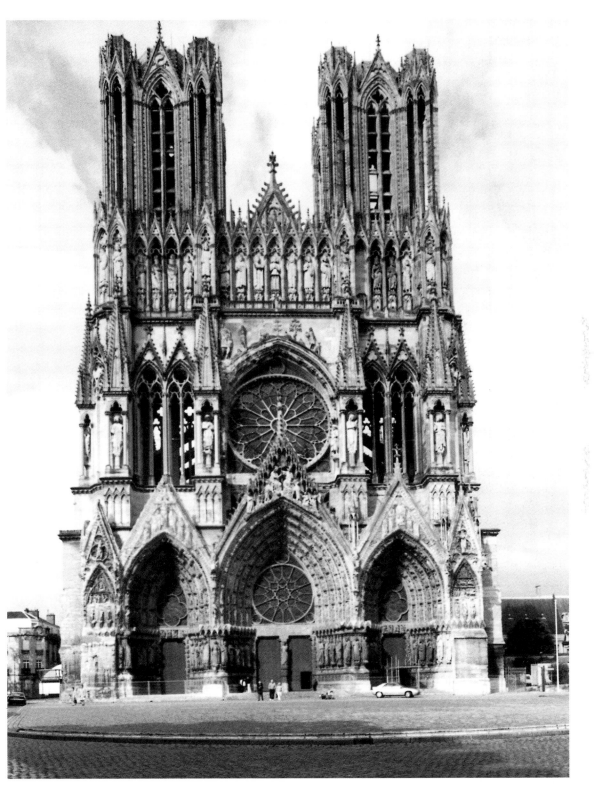

121. Reims Cathedral, west façade, 13th century.

122. Reims Cathedral, west façade, 1250s–1280s. The northwest corner of the façade shows the damage from German bombardments during World War I.

cathedral has a subdued but welcoming glow. At the end of the day in the darkness of early evening, it can be quite forbidding.

The totality of Notre-Dame of Reims is so overpowering, and there are so many superb works of art here, it can be difficult to appreciate the architectural and artistic achievement this church represents. One can get off to a slow start at Reims, and it took me some time to grasp the many attractions and architectural accomplishments brought together in this magnificent building. It was difficult to get beyond the bulk of the interior and the apparent complexity of the exterior with its spiky pinnacles and lavish decoration. Probably I was being loyal both to the simple elegance of Bourges and the openness of Amiens. Reims is not a particularly dark church like Chartres and Notre-Dame in

Paris, but the narrow proportions and the subdued tones of its stone can give you that impression.

Like many visitors, I wanted to see the great statuary on the western portals, particularly the Smiling Angel of Reims and the figures of the Annunciation and Visitation. I also wanted to see the fine Chagall windows in the ambulatory chapels. Perhaps feeling satisfied by those lovely features and somewhat overwhelmed by the gigantic dimensions of the cathedral, I was not ready to deal with the architecture itself. I have come to realize that Reims presents no real difficulty; instead it is a cathedral of great simplicity and integration, dynamism, and poise.

To appreciate the Cathedral of Reims fully the visitor needs to get beyond the sheer size of the building and to explore the architecture and decoration piece by piece to understand how its various parts and details all work together. As Stephen Murray says, we must approach each Gothic cathedral with "a broad vision to embrace the overall characteristics of the monument" and with "a microscope" to appreciate the details of structure and decoration that contribute to or detract from that whole.[1]

The ground plan is the logical place to begin our understanding of the cathedral. Because of its enormous size, it is not readily apparent that Reims is really a compact church based on a very simple plan. Although it is one of the principal descendants of Chartres and Soissons, and many features of the ground plan and elevation are familiar, the genius of Reims is the manner in which the Chartres ground plan and the architectural elements were simplified and refined.

The ground plan is quite uncomplicated. The great church really only comprises two parts: the nave and the combined space of the transept and choir. The nave has eight bays and single side aisles, while the crossing and choir have five bays with double aisles leading to a single-aisled ambulatory. The transept extends just one bay beyond the aisle, and it is not much wider than the

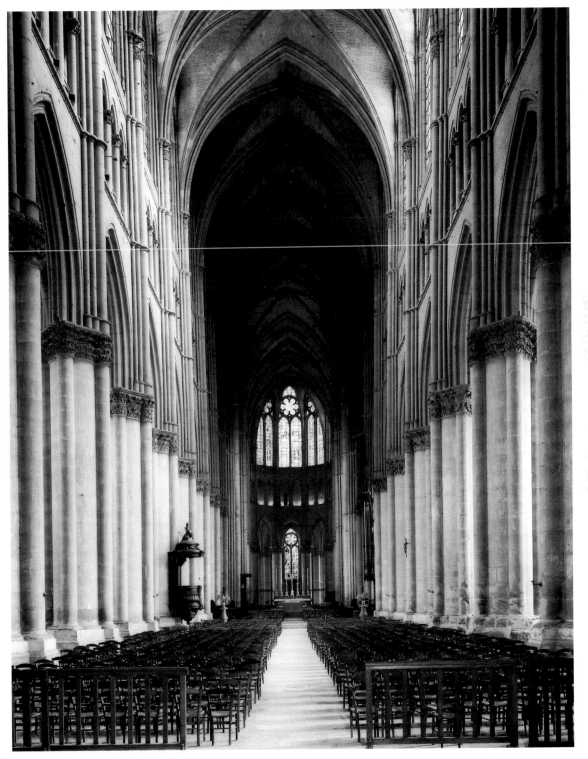

123. Reims Cathedral, nave and choir, 1210s–1280s. Photograph by Caroline Rose © Caisse Nationale des Monuments Historiques et des Sites, Paris.

straight portion of the choir; thus the choir and crossing are, in effect, fused into one space. Today, a platform for the main altar extends the choir into the transept, furthering the impression that the choir begins where the nave ends. The five chapels are tightly grouped around the ambulatory and are not particularly deep for a church of this size; the axial chapel with the Chagall windows extends only slightly more than the other chapels.

At Reims there is a fully realized balancing of height and width. As soaring as the nave and choir are on the interior, and as vertical as the pinnacles are on the exterior, height is not achieved solely for its own sake. Stability and poise are key elements in the success at Reims.[2] The 125-foot vaults are so high that when you sit at the back of the nave and look up, you really can only take in the nave arcade and the triforium. The clerestory windows and vaults are so far away that they are almost visually inaccessible (fig. 123).

You immediately recognize the Chartres format and characteristics in the nave elevation. The piers are the compound piers we have seen at Chartres, but instead of alternating their shapes and the shape of the attached columns, at Reims all the piers are round with attached round columns. "Inside, Reims is a narrower and slightly taller version of Chartres. It has the same [three-story] elevation but with more height given to the main arcade, a change of proportions which lightens the aspect of the upper story."[3]

While the decorative and architectural elements at Reims are monumental, they are much more elegant than at Chartres. The harsh qualities of Chartres—the piers, the chapels, and the decoration—have been softened. The arches of the nave arcade, triforium, and clerestory lancets are all more pointed, and the nave itself is less mural than at Chartres. The moldings of the arcade arch are lighter and blend with the colonnettes. The massive mural quality of Chartres is now skeletal and linear. The austere details of Chartres are replaced with a "lavish natural-

ism," particularly on the large floral capitals of the main arcade.[4]

The aisle and clerestory windows are in the Chartres format (two lancets and an oculus), but at Reims the windows now fill the entire wall space. It was at Reims that this complete glazing of the windows was initiated. At Chartres the three openings are separate, as if they were individually cut out of the wall. The Reims architect took the basic format, but instead of individual openings, there is just one large window divided into three sections by framing bars called tracery. The effect looks as if the designer had traced a pattern on a single sheet of glass. We know this was not the case, but the illusion is there. Seemingly, the only wall surfaces left are the piers, the triforium, and the spandrels of the nave arcade, but because the wall below the aisle windows is about 20 feet high, there is a sizable mural surface that flows around the perimeter of the interior. As we experience Reims today, we clearly see that the inspiration from Chartres has been opened up and refined.

The lavish monumentality of the nave continues through the transepts and the choir. Because much of the stained glass of the nave was replaced with clear glass, but retained in the choir, the choir is much darker than the nave. The choir has two straight bays with compound piers on the inner arcade and aisles, and the hemicycle is comprised of massive round columns with a single attached shaft on the inside. Compound piers flank the five chapels, which have blind arcades below three lancet windows. Only the first chapel on the right and the central one have stained glass. The clear windows of the other chapels lighten the interior of the ambulatory, but as you move from dark to light and back again, it can be difficult to get a coherent sense of this immense space.

As we leave the ambulatory, the side aisle stretches before us down the nave to the glazed windows above the side portal of the west façade. With the columns highlighted by the aisle windows, it is one of the most

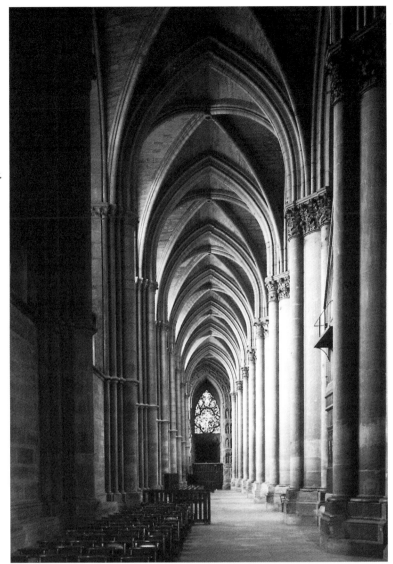

124. Reims Cathedral,
south aisle, 13th century.

appealing vistas in Gothic architecture (fig. 124).

At Reims the interior and exterior systems are fully integrated and relate perfectly to each other. Unlike Amiens or some other Gothic cathedrals, the exterior of Reims readily gives the visitor a clear understanding of what will be found inside.

The exterior, in spite of the profusion of pinnacles circumscribing the exterior, is com-

pact and economical on a grand scale. If you strip away the pinnacles and the gabled balconies over the chapels, the compact and highly geometric shapes become pronounced. Because of the prolific use of pinnacles and the complexity of the flying buttresses, the simplicity and compactness of the ground plan are not readily apparent. Inside the cathedral the sheer size and verticality of the spaces can divert us from appre-

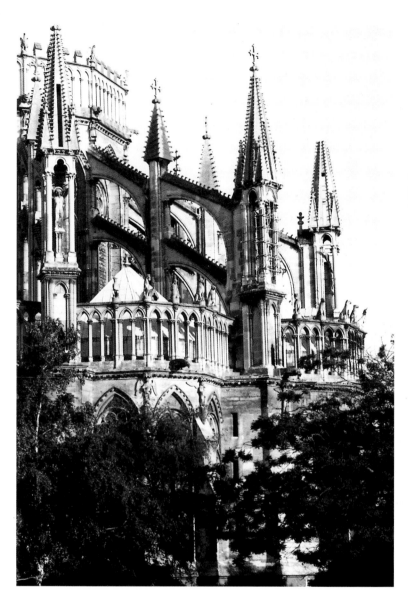

125. Reims Cathedral, flying buttresses of chevet, 1210–1240s.

ciating the elegance and refinement of the architectural details. With the exterior the reverse seems to be true. In a sense we are distracted from the exterior bulk of the cathedral by the details, particularly the march of pinnacles around the building. The buttresses create a powerful regular rhythm around the entire building on both the exterior and interior.

Due to the number of architectural elements on the chevet, it is easy to miss the fact that the chevet is comprised of only a few large-scale components. It is not as complex as it seems. Unlike Chartres, where the chapels all protrude beyond the buttresses and define the shape of the eastern end, at Reims the chapels are contained within the muscular buttresses of the chevet. Even with the verticality of the pinnacles and the great height of the cathedral, we still find a crucial

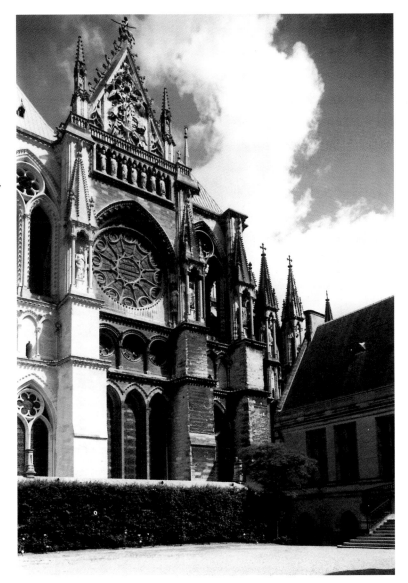

126. Reims Cathedral, exterior of south transept, ca. 1240.

balancing of height with width. The vertical elements are visually balanced by the horizontal bands of the balcony above the chapels and the blind arcade above the clerestory windows. The arches of the flying buttresses have a shallow rather than steep pitch. Nowhere is verticality there for its own sake (fig. 125).

The clear correspondence between the exterior and interior is revealed at the south façade, where for the first time the stories of a façade accurately relate to the interior elevation (fig. 126). The first story comprises three lancet windows framed by double-lancet windows and oculi for the transept aisles. These windows correspond to the first-floor arcade of the nave and transepts. The second story has three arcades reflecting the inner triforium. The central arcade contains three rounded arches framing circular win-

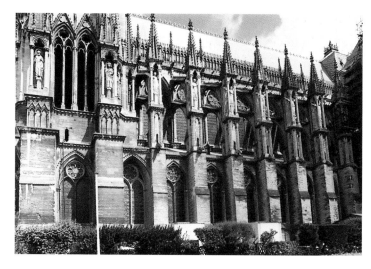

127. Reims Cathedral, south-flank buttresses, 1210s–1280s.

dows. This is a tentative glazing of the triforium. The monumental clerestory level has enormous lancet openings framing a rose window within its own arch and giant pinnacles that march around the cathedral. The entire ensemble is crowned by the gable and pinnacles illustrating the Assumption of the Virgin into heaven. At the very top is Sagittarius with his bow. The south façade was never meant to be a public entrance, for it opened onto the Bishop's Palace. Even with the presence of the pinnacles, the south façade retains much of the sober power of High Gothic. It does not have the more flamboyant dynamism of the west façade, which was changed in the late thirteenth century by Bernard de Soissons.

Recently restored, the north façade has three asymmetrical portals. On the left is a fine Last Judgment above the figure of Christ flanked by Apostles. The central portal is dedicated to local saints. The right portal, which depicts the Virgin and Child, is much smaller and not really an entrance. Above the transept rose window the gable shows the Annunciation.

The west façade of Reims Cathedral (c. 1250–1300; see fig. 120) is one of the most recognizable and most often photographed monuments of Gothic architecture. Because the size and height are so impressive and the

sculpture is so imposing, it is easy to miss the genius of the overall composition. It is definitely worth our time to take a close and detailed look at this remarkable orchestration of architectural and decorative elements. Both the interior and the exterior of the great façade have important sculptural programs. The interior is a tapestry in stone of fifty-two sculptures in niches framing the door and lower rose window that complement the life of the Virgin on the exterior of the façade.

While it retains much of the underlying structure of High Gothic, the monumental west façade moves away from the flat façades of Chartres or Notre-Dame in Paris. The Reims façade is a combination of balance and great vertical thrust decorated with pointed gables and pinnacles that build stage by stage to the fifteenth-century towers. Although spires were ultimately planned to crown the façade, it is difficult to imagine these magnificent towers reaching any farther into the sky. The move away from High Gothic was not simply with the addition of various decorative elements, but with the manner in which the gables and pinnacles overlap the various stories. The rigorous geometry of High Gothic was given a more flexible and animated interpretation at Reims.

In spite of the profusion of gables, pinnacles, and immense statuary, the west façade

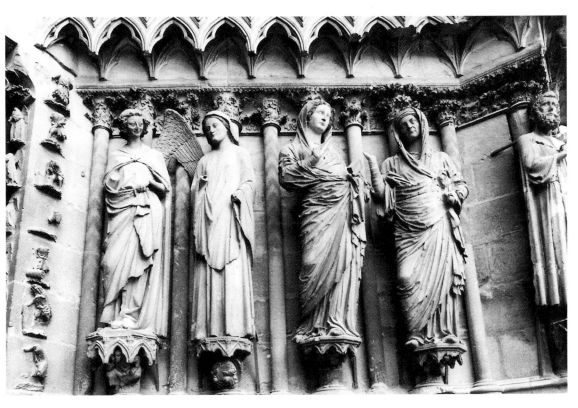

128. Reims Cathedral, west façade, the Annunciation and the Visitation, 13th century.

adheres to a logical framework that accurately reflects the interior elevation of the cathedral. Each story represents the disposition of the interior. The portals with their glazed tympanums match the nave arcade, the second story with its blind and glazed arcades corresponds to the interior triforium, and the central rose window and tower lancets coincide with the nave vaults and clerestory windows. To read the elevation of the west façade carefully is to anticipate the interior arrangements that await us. At the same time, the west façade has an exuberant force that is impossible to resist.

The center of the second-story arcade is a glazed continuation of the nave triforium. Partly hidden by the gables, this arcade acts as a base for the third-story rose window and lancet openings of the towers. At this level

the pinnacles with their niches for sculpture reach up slightly beyond the base of the Gallery of Kings. This incredible array stretches across the entire façade, and wraps around the adjoining towers, and marches down the flank and around the chevet. Some of the originals of these gigantic figures that survived World War I can be seen in the Tau Museum next door to the cathedral (fig. 127).

The central portal is dedicated to the Virgin, who welcomes us to her holy church from her position on the central pillar. On the sides we see the Presentation of Christ in the Temple and the famous scenes of the Annunciation and the Visitation. The strong influence of ancient sculpture can be seen in the powerfully robust figures of the Visitation, a beautiful contrast to the more delicate figures and drapery style of the Annuncia-

147

tion, the two figures at the left (fig. 128). In the peak of the gable is the Coronation of the Virgin (the original is in the Tau Museum), a scene repeated throughout Gothic art. The left portal gable depicts the Passion with Christ on the Cross at the top. The right portal is the Last Judgment with statues of the Apostles and Prophets below.

The shrine-like quality of Gothic architecture made its appearance during the mid-thirteenth century with the development of the Rayonnant phase. It is tempting to think that architects copied this decorative technique from the gold and enamel reliquaries created to hold sacred relics of the past. Jean Bony suggests that it may well have been the other way around. "The only major work of architectural composition that was truly treated in a shrine-like spirit in its relief and modeling was the glorious west façade of Reims Cathedral as designed most probably in the mid-1250s by Bernard de Soissons."[5]

The use of sharply pointed gables to create this shrine effect may be seen in a variety of churches stretching in an arc from Amiens through Paris and Reims to Troyes, the capital of the counts of Champagne south of Reims. This linearity and brittleness had become accented in the 1230s with the rebuilding of Saint-Denis and the building of Troyes Cathedral. The south façade of Notre-Dame in Paris with its thin pointed gables has almost an etched quality to its decoration. Lost to history is the great Abbey of Saint-Nicaise in Reims, destroyed in the Revolution. Begun in 1231, with seven gables across its west porch, it surely must have had a great impact on Bernard de Soissons as he envisioned the west façade of Reims Cathedral.

In spite of the damage done over the centuries by restorers and the bombardments of World War I, there is still a fair amount of medieval stained glass in the cathedral. The clerestory windows of the choir are dedicated to the Virgin and Christ and the Apostles. The lower sections of these windows represent the various bishops throughout northern France who met at Reims for synods. The axial window shows Christ at the very top with scenes from the Passion in the rosette. The Virgin and Child and Christ on the Cross are above representations of the Cathedral of Reims and the Bishop of Reims. In the axial chapel itself are the modern windows by Marc Chagall: in the center are the Crucifixion and the Resurrection, and at the sides are the Tree of Jesse and the Book of Kings (fig. 129).

The two rose windows of the west façade are dedicated to the Virgin. The center of the upper rose shows the death of the Virgin, surrounded by the twelve Apostles and a heavenly choir. The smaller rose window is from the 1930s.

The rose of the north transept tells the story of Adam and Eve in the Garden of Eden from the birth of Adam to Cain and Abel. These scenes are surrounded by the animals of the Creation and angels. At the top are the Virgin and Child. The south transept rose has scenes of wine making and dates from the 1930s.

The Tau Museum

The Cathedral Museum is located in the former Bishop's Palace that was built in the seventeenth century by Mansart. The fifteenth-century royal banqueting room has a remarkable vaulted-wood ceiling and a majestic fireplace. The walls are hung with tapestries that were originally in the cathedral. Off the banqueting room, the exquisite Bishop's Chapel is thirteenth century. One of the most striking attractions in the museum is the collection of colossal statues from the west façade. The statue of Goliath is nearly twenty feet tall (fig. 130). Meant to be seen from far below, these enormous sculptures have poignant expressions that are quite moving. On the ground floor near the gift shop are some gargoyle rainspouts that are choked with lead. The bombardment of 1914–1918 melted the lead roof of the cathedral, which ran like rain down the spouts (fig. 131).

148

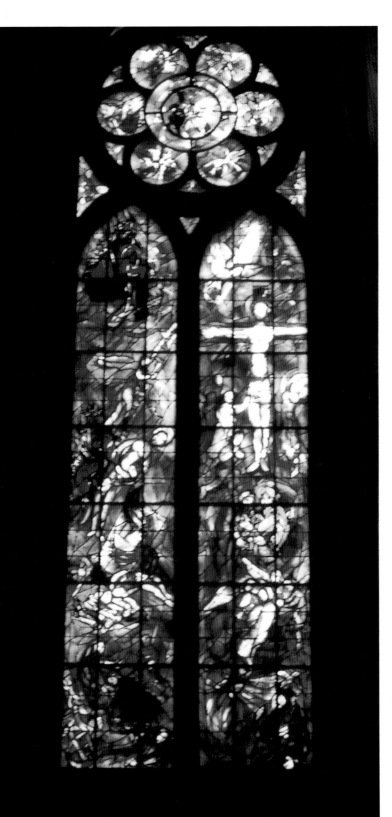

129. Reims Cathedral, axial chapel, modern stained-glass windows by Marc Chagall.

130. Reims, Tau Museum, Goliath and the author. This colossal statue originally stood above the rose window on the west façade.

131. Reims, Tau Museum, gargoyle. When the cathedral caught on fire during the bombardments of 1914–1918, the lead roof melted, and the lead ran down through the gargoyle rain spouts.

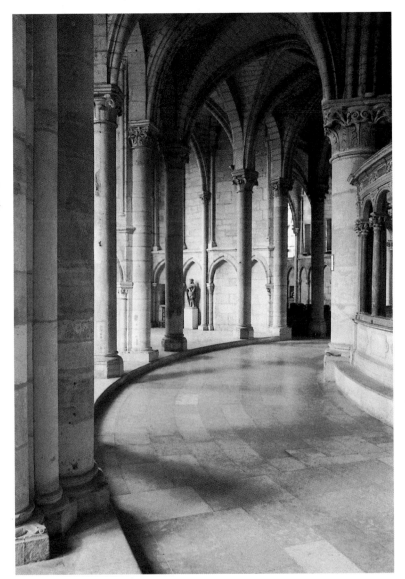

132. Reims, Basilica of Saint-Remi, ambulatory, 1170–1190.

Basilica of Saint-Remi

Located two miles south of the cathedral on the outskirts of the city, the Basilica of Saint-Remi is a treasure of Romanesque and Early Gothic architecture. Saint Remi was Bishop of Reims, who is famous for having baptized Clovis when he converted to Christianity after defeating Germanic tribes in the mid-

490s. Saint Remi is buried in a large funerary monument in the center of the choir.

Although not a tall building, the interior has a spaciousness that is remarkably appealing. The Early Gothic choir and western façade were built in the 1170s and 1180s and skillfully blend with the long Romanesque

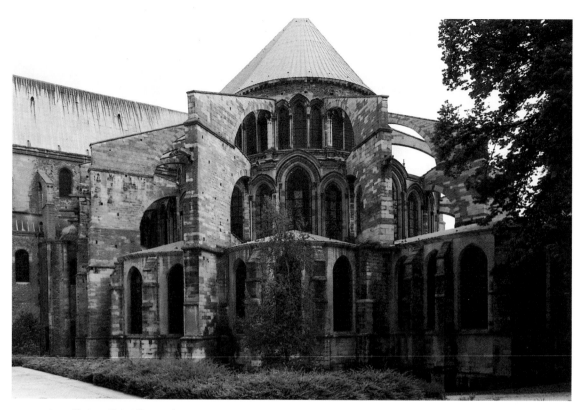

133. Reims, Saint-Remi, chevet, 1170–1190.

nave (1005–1049). The original wood roof was replaced with four-part ribbed vaulting at the end of the twelfth century.

The elegant nave arcade is comprised of beautiful piers of bundled columns supporting plain recessed round arches. The main arches and the second-story gallery form a double arcade that is crowned by a single clerestory window and small oculus installed when the roof was vaulted in the 1190s. At the time of the vaulting, attached colonnettes were added to the wall surface reaching from the nave capital to the new vaults, creating a surface rhythm that leads us down the nave. The nave is a beautiful tiered display of arches, colonnettes, and vaulting that is reminiscent of the great Roman aqueducts. Its elegant rhythm has been disrupted by the recent installation of a large modern organ with pipes projecting into the nave.

The Early Gothic choir (1170–1190) had a lasting influence on Gothic architecture and particularly Reims Cathedral. The choir is extremely wide, with a spaciousness that allows us to appreciate the entire four-story elevation. The choir vaulting is low but arched in a manner to give full access to the clerestory windows. Three levels of windows in the chapels, gallery, and clerestory bathe the choir in a harmonious light.

The clerestory and the triforium are tied together by attached colonnettes that reach from the base of the triforium to frame each clerestory-window arch. The triforium almost becomes part of the clerestory because they are not separated by the usual molding or

stringcourse. This important innovation at Saint-Remi, the fusing of these two elements, became a signature feature of Gothic architecture of the thirteenth century. In later churches the triforium was glazed and joined with the clerestory, resulting in enormous clerestory windows in churches such as Saint-Urbain in Troyes.

The ambulatory circles the choir in a simple uninterrupted curve that draws us forward around the hemicycle. Each of the five ambulatory chapels opens onto two delicate entrance columns that have the effect of creating a separate, cloistered string of chapels. From the outside we can see that they are perfectly round. The side walls of the chapel open outward into the ambulatory and are framed by slender attached columns, giving us the experience of walking along a beautifully curved loggia. Here we are in the presence of an ingenious, accomplished master builder who has elegantly brought the ambulatory and chapels together (fig. 132).

The exterior of the choir reveals the compact, tiered style of Early Gothic construction with subtle variations. The chapel, gallery, and clerestory levels all have three lancet windows, but the gallery is particularly striking. Instead of three identical lancets, the center window is larger and even pierces the roofline of the gallery. The clerestory windows echo this arrangement but in a less pronounced fashion. Sizable but slender flying buttresses constructed in the 1180s or 1190s frame these sets of triplet windows. The chevet of Saint-Remi is both composed and dynamic (fig. 133).

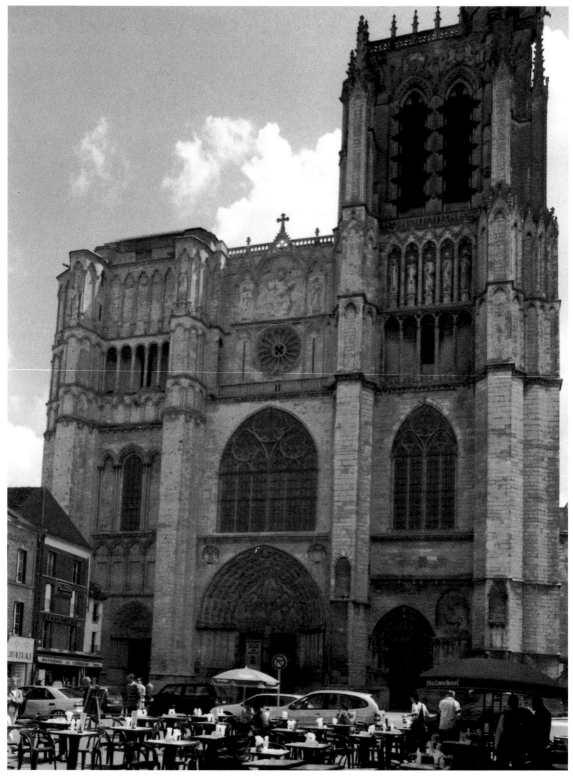

134. Sens, Cathedral of Saint-Étienne, west façade, 11ᵗʰ and 16ᵗʰ centuries.

SENS

Cathedral of Saint-Étienne

The cathedral town of Sens is in the north-western corner of Burgundy, an hour and a half southeast of Paris, where the Yonne River winds its way to meet the Seine. Although begun about the same time as Suger's choir at Saint-Denis in the late 1130s, the Cathedral of Saint-Étienne represents a completely different approach and aesthetic sensibility. Saint-Denis, with its lightness and openness, looks beyond Romanesque and even Early Gothic to the future of Gothic architecture, while Sens retains the solid, massive durability of Romanesque but clad in Gothic attire (fig. 134).

Both Sens and Saint-Denis represent the initial urge of Early Gothic to expand in a lateral fashion. The drive for verticality would come in the second generation with Notre-Dame in Paris, and at the end of the twelfth century with Chartres and Bourges. Initially, the need for lateral space predominated, a demand that these two contemporary churches would answer in very different ways. At Saint-Denis Abbot Suger's initial efforts were to expand the periphery of the choir to create an elegant panorama of stained glass. At Sens the main thrust was to emphasize the central space of the nave and choir (fig. 135). The nave is flanked by single aisles that continue around the choir. There is no double ambulatory as at Saint-Denis, and the original ambulatory had a single rectangular chapel, which was rebuilt in the thirteenth century. The Baroque ambulatory chapels on each side are sixteenth- and eighteenth-century additions.

Saint-Denis was a Royal Abbey with a number of monks who needed chapels to say

Mass on a regular basis. Abbot Suger also wanted to display important relics and for this he needed a double-aisled ambulatory for the flow of worshipers. The expansion of the choir and the addition of chapels were often prime motives for new construction in monasteries. On the road from Lyon to Paris and from the Champagne region to Orléans, Sens was, on the other hand, a cathedral in an extremely important ecclesiastical city. During the Middle Ages Sens was the archdiocese presiding over such important dioceses as Chartres, Auxerre, Orléans, Troyes, and even Paris. Synods were regularly held in the cathedral and in the great Bishop's Palace adjacent to the south tower (now a museum). Saint Bernard and Abelard debated the meaning of the Trinity in 1140, and in 1152 there was a large conclave for consideration of the divorce of Louis VII and Eleanor of Aquitaine. Louis IX (Saint Louis) and Marguerite of Provence were married in the cathedral in 1234. The need for a large hall church to handle great processions may have been a primary concern here.

The initial impression upon entering the nave of Sens is of a combination of spaciousness and substantiality. Perhaps more than anything else we are conscious of the central space of the nave. The most striking features are the strong double-bay system with major and minor piers and six-part vaults that span two bays. This creates very large spatial units in the elevation and in the vaulting. The major piers are enormous, having large attached columns that project into the nave; the minor piers are double columns that do not project. Even though the attached

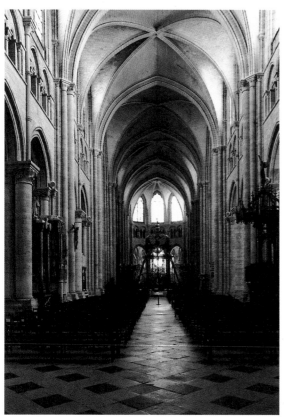

135. Sens Cathedral, nave and choir 12th and 16th centuries.

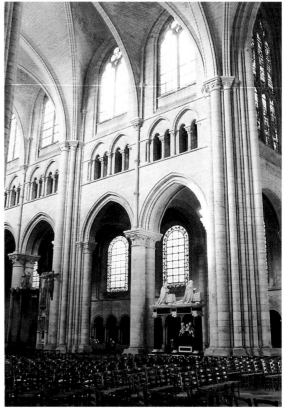

136. Sens Cathedral, nave elevation, 1140s–1160s. The windows and vaults were raised in the 16th century.

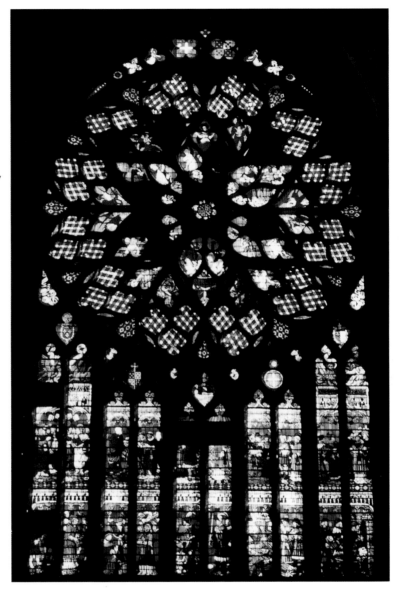

137. Sens Cathedral, south-transept rose window, early 16th century.

columns of the major piers are sizable, our eye focuses on the unusual double columns that form the minor piers. The substantial capitals of the minor piers and the thickness of the nave arches make the nave arcade seem somewhat lower than it really is (fig. 136).

The six-part vaults of the nave have very powerful ribs, particularly the crossing ribs. The nave is fairly tall (80 feet) and exceed-

ingly wide (50 feet). The broad proportions of the nave and the lack of lateral views into the side aisles make the central space the predominant feature of the cathedral. The elevation at the eastern end is shallow, and the three lancet windows above the high altar are quite prominent, creating a highly visible climax to the central aisle. The combined effect of these elements is to pull our view down slowly but firmly through the crossing into

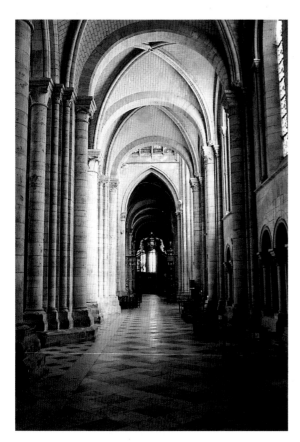

138. Sens Cathedral, aisle, 12ᵗʰ century.

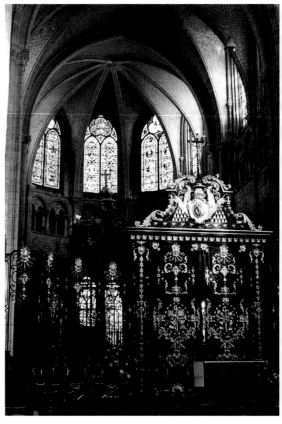

139. Sens Cathedral, choir, 1140s–1160s.

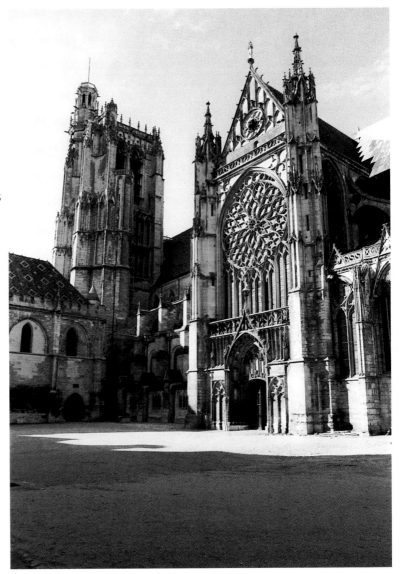

140. Sens Cathedral, south-transept exterior, 16ᵗʰ century.

the choir, where the illumination of the clerestory windows is a strong visual magnet.

The central vista of the nave and choir was probably even more striking in its original form because there was no transept. The view would have been of one uninterrupted volume with the continuous march of major and minor piers. At the end of the fifteenth century, work began on the transept façades and the crossing. What would have been the fourth double bay of the nave was altered by removing the minor piers on both sides of the nave. Designed by the brilliant architect Martin Chambiges in the 1490s, the transept clerestories and rose windows with their splendid array of sixteenth-century stained glass flood this portion of the cathedral with light and color (fig. 137). The north rose has

Christ in the center, surrounded by a heavenly orchestra. This is a charming window where binoculars are invaluable. There is an excellent Tree of Jesse in the clerestory of the south transept adjacent to the south rose with an interesting Last Judgment. Chambiges, considered the supreme architect of Late Gothic architecture in the early sixteenth century, also designed the west front at Troyes and the great transepts at Beauvais.

Although the clerestory walls and the outer sides of the nave vaults were raised in the thirteenth century to increase the size of the clerestory windows, the earlier sexpartite vaulting has been retained. This gives the nave vaults an almost dome-like appearance.

While Sens is thoroughly Gothic, its Romanesque antecedents are plainly visible, particularly in the arcades of the aisles and ambulatory (fig. 138). The arches of the nave arcade and triforium are slightly pointed, but with the change of a stone or two, the triforium arch could be round as well. The very large aisle windows have round arches, as does the lovely blind arcade of the aisle. On the north aisle, the blind arcade has been opened to create side chapels. The organization of the elevation and space, however, is much more open and less mural than in Romanesque churches. The use of ribbed vaults over the nave and the arrangement of major and minor piers are quite different from the great Romanesque nave at Vezelay with the rigorous simplicity of its barrel vaults.

The arches and the ribs of the six-part ribbed vaults of the nave are all double or triple thickness. The heavy transverse arches slow the rhythm of the nave. Even so, the overall effect has a great deal of refinement and even delicacy. Sens, as it comes to us, is not a brutal or massive church with overblown features and awkward proportions. We are aware of its very human scale and also of the monumentality achieved here. The nave and choir have a very leisurely quality because of the six-part vaults and the strong major-minor rhythm of the piers of the double-bay system.

The ambulatory is a broad single aisle that continues the Romanesque blind arcade of the nave with beautiful decorative capitals.

The high altar, canopy, and ironwork choir screen were created in the eighteenth century (fig. 139). The choir ends with a large chapel dedicated to Saint Swinien with a stone-draped altarpiece that partially blocks the thirteenth-century stained glass. The two side chapels with oval baroque domes were built in the sixteenth and eighteenth centuries.

Martin Chambiges's south façade opens onto a large court containing the Bishop's Palace and the Sens Museum. The south façade was built at the end of the fifteenth century, before the north façade, and is a very beautiful composed structure of considerable refinement in a monumental framework. With a single portal under a late Gothic gable, it utilizes slender arches and lancets, one on top of another, on the façade and side towers to create a strong sense of verticality. The rose window in the center rests on five lancets within a framing arch (fig. 140).

The north portal, based on the same format, is composed of somewhat larger elements. The north portal is much larger than the south one, filling the space between the piers. The façade as a whole includes more decorative elements, ending with a very large gable flanked by two spires and delicate arcades.

The cathedral is surrounded by other buildings and with the exception of the court-yard off the south-transept façade and the west façade, it is difficult to get a clear view of the exterior.

Sens and Saint-Denis are generally thought of as the initiating, if contrasting, examples of the Gothic style. More conservative than the great innovations of Abbot Suger at Saint-Denis, Sens is remarkable as a fully conceived Gothic building. In very different ways these two buildings represent the precocious beginnings of Gothic architecture.

SOISSONS

Cathedral of Saints Gervais and Protais

In the fall of 1914, at the beginning of World War I, the German army swept around the eastern side of Paris and overran Soissons. After the First Battle of the Marne, the trenches of the Western Front were less than a kilometer from the cathedral, on the banks of the River Aisne where it makes a loop around the city. Soissons was under siege for thirty months while the Germans bombarded the town from the hills beyond the river and was occupied for two months during the great German offensive of 1918. At the time of their final retreat of the war, the Germans turned their artillery on what was left of the town and cathedral, leaving most of the city devastated. Eighty percent of Soissons was destroyed.

The cathedral itself was so seriously damaged that the Michelin Battlefield Guide after the war stated, "The bombardments of 1918 destroyed the nave beyond hope of repair. . . . Three bays near the west front, with their large arches and the aisles, were completely destroyed. All this masonry fell inside the nave, forming across its entire breadth a heap of debris more than nineteen feet high and about thirty-three feet long."[1] You can still observe the pockmarks left by artillery fire on the north side of the cathedral and on the first nave piers.[2] To see this magnificent building today, completely and beautifully restored, it is difficult to imagine the enormity of the destruction (fig. 141).

Despite this painful moment in history, the Cathedral of Saints Gervais and Protais is the loveliest of the smaller French cathedrals, with a charm and grace that are thoroughly appealing. It really should not be missed.

Soissons was always an important part of the Royal Domaine and a vital town on the northern trade route that stretched from London and Calais to the trade fairs of Champagne and beyond to Italy. In the Middle Ages there were six monasteries inside the battlements of Soissons, as well as the cathedral and other churches. All that is left of this splendor are the cathedral, the remarkable ruins of the Abbey of Saint-Jean-des-Vignes, and the Abbey of Saint-Léger, which houses an attractive museum that chronicles the town's history from prehistoric times to the present. Saint-Jean-des-Vignes was nearly demolished at the beginning of the nineteenth century by an unenlightened bishop who wanted to use the stone to repair the cathedral. The abbey was damaged in both the Franco-Prussian War of 1870 and World War I. The spectacular façade and towers (fig. 142) give you a sense of the monumentality achieved in many of the wealthy abbeys in France. The refectory, a lovely doubled-aisled room with slender columns and exquisite vaulting, has been completely restored (fig. 143).

The setting for the cathedral itself is no longer remarkable. On the eastern end is a large public square in the center of town. The western façade faces a busy street while ordinary city streets flow along each side (fig. 144). The first impression of the exterior gives us little indication of the refined style of Gothic architecture that awaits inside. The flying buttresses are rather heavy and unadorned, with one bracing the clerestory at mid-window and the other at the springing of the vaults. It was from the mid-1190s at Soissons and the larger buildings of Chartres

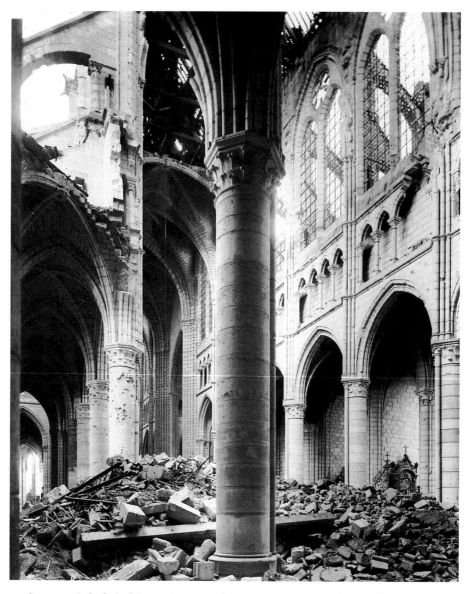

141. Soissons, Cathedral of Saints Gervais and Protais, nave interior after 1918 World War I damage. Photograph © Archives photographiques, Paris/Centre des Monuments nationaux, Paris.

and Bourges that flying buttresses began to be doubled up with two arches placed one above the other. This double bracing allowed the architects to give even more height to the buildings (fig. 145).

Soissons was conceived and built at that moment at the end of the twelfth century when Gothic architecture was moving away from the four-story elevations of Noyon and Laon to the more monumental three-story High Gothic structures of Chartres and Bourges. The south transept, one of the significant surviving treasures of Early Gothic, was begun in the 1170s and completed by the 1190s, when a new architect, probably from Chartres, began work on the choir. By the

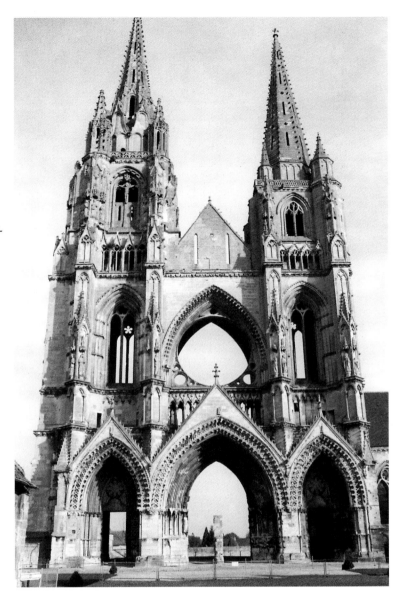

142. Soissons, ruins of Abbey of Saint-Jean-des-Vignes, 13th and 14th centuries.

1250s the cathedral was basically completed, although the north transept was rebuilt in the thirteenth century in the Rayonnant style.

A closer look at the exterior reveals the typical structure of a three-story church once we understand that the interior arches of the triforium are concealed under the slanting roof between the chapel windows and the clerestory windows, which are the classic Chartres clerestory with two lancets and an oculus. The slender chevet buttresses are positioned between the chapels and march in a regular fashion around the cathedral. Here at Soissons we do not see the exuberant twisting and turning that is so striking at Amiens or the rigid geometry of Reims (fig. 146). If you ignore the flying buttresses, you can see how solid Gothic architecture before Amiens, begun in 1220, really was. You can appreciate the connection between this construction and

163

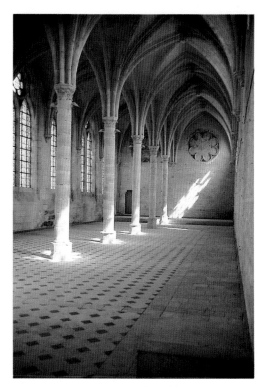

143. Soissons, Saint-Jean-des-Vignes, refectory, 13th and 14th centuries.

the weighty Romanesque buildings that preceded it. Surely, inside is a strong and sturdy church that reflects its no-nonsense exterior.

What awaits you is a delightful surprise. The nave of Soissons gives you the feeling of complete wonderment and comfort at the same time. Your mind tells you that this is a great, if not a monumental, moment in architecture with much to see and appreciate, and your heart tells you that this is what Gothic architecture should look like (fig. 147). The ground plan is that of a single-aisle church without the double ambulatory around the choir as at Chartres, Bourges, or Amiens. The view upon entering through the western portal is of a classic High Gothic interior, soaring vaulting, and a long seven-bay nave and a four-bay choir. It is one of the classic and graceful vistas in High Gothic architecture.

When thinking about the qualities of High Gothic architecture, I often use Soissons as

my inspiration. The nave is flooded with light from the large windows at the first and clerestory levels. There is a peaceful, yet lively quality to this church. The entire building reveals an unusual unity in plan and design as well as with the individual details throughout. I am often, content to sit in the nave and absorb its balance, reason, and delicacy as well as its strength and vitality. The interior is elegant, but it is not fragile. This is simplicity without austerity.

Soissons is a refined version of Chartres on a smaller scale. While the Chartres vaults are considerably taller (116 feet) than those at Soissons (97 feet), Chartres is much wider. As a result the narrower proportions at Soissons enhance our sense of verticality. The three-story elevation has the same proportions as the basic Chartres format: the arcade and the clerestory are of equal size with a moderate triforium in the middle. The windows on the first level have two plain lancets, and the clerestory windows have two lancets and an oculus. Actually, this balanced composition was in existence nearby in Laon at the now-demolished church of Saint-Vincent and can be seen at the Abbey of Saint-Yved at Braine, just east of Soissons.[3]

Begun in the 1170s, Braine was one of the models for Chartres Cathedral. A small church with a three-story elevation of arcade, triforium, and clerestory, the "Braine elevation" was adopted as the basic format for High Gothic architecture as builders sought to simplify the four-story elevation of the Early Gothic style. Braine is a lovely church that is well worth a visit.

The Soissons pillar is a simple round column with a single attached colonnette facing the nave. Space flows generously around the columns into the lovely side aisles. At the capital a bundle of five colonnettes rises to the springing of the four-part vaults in the middle of the clerestory window. There is a plain stringcourse molding at the top and bottom of the triforium (fig. 148). This is a good example of how the Soissons architect took the Chartres format and lightened it. Instead

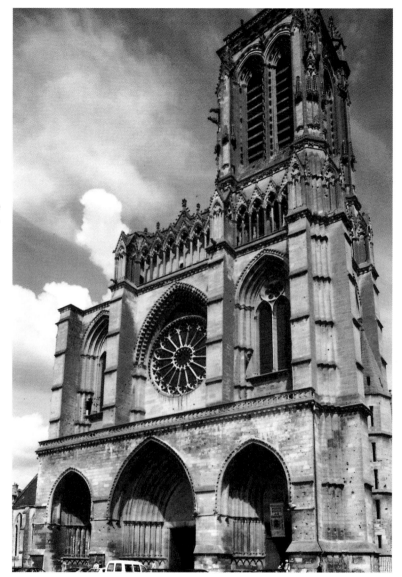

144. Soissons Cathedral, west façade, 13th century.

of the heavy compound piers of the Chartres nave, the round column with a single colonnette sufficed. As with many of the other elements of the interior, the use of the round column can be traced to the hemicycle of Chartres Cathedral.[4]

A brilliant surprise waits for you at the south transept. Even within the charm of the nave and choir, the south transept is a special moment. Built in the 1180s, it is Early

Gothic, with four stories rather than the three of High Gothic. The transept is round instead of flat and has a splendid oblique chapel on its eastern side. The whole ensemble feels like a chapel. In Early Christian times, churches often had rounded choirs at each arm and the head. The best examples, at Cambrai and Valenciennes, were demolished during the French Revolution. The only survivors of this series are the south transept at

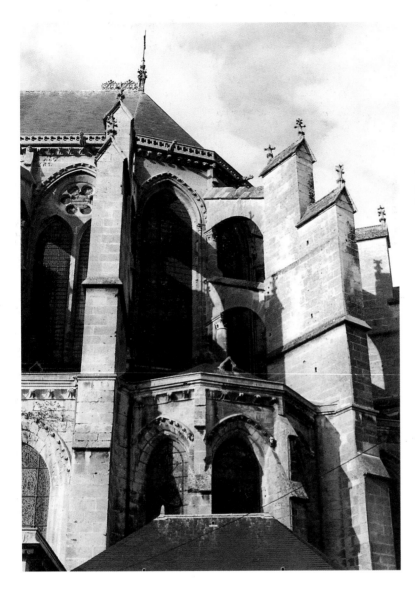

145. Soissons Cathedral, chevet buttresses, ca. 1190s–1210.

Soissons and the transepts of Noyon (fig. 149).[5]

The south transept is a pure joy. Take the time to pull up a chair and simply absorb this marvelous bequest from the past. The lightness and playfulness here have a high degree of harmony and sureness. There is a gracious symmetry to the elevation. Each bay of the ground-floor arcade has three arches, as do the second and fourth stories; the triforium

has six. The exception to this arrangement is that the outside bays only have two arches at the ground floor and gallery. Each full bay is divided by a slender attached column that rises through the stringcourse to the springing of the vaults at the base of the clerestory. There is a beautiful foliated stringcourse at the bottom of the triforium and a charming gallery going completely around the transept. Each clerestory panel of three lancets is

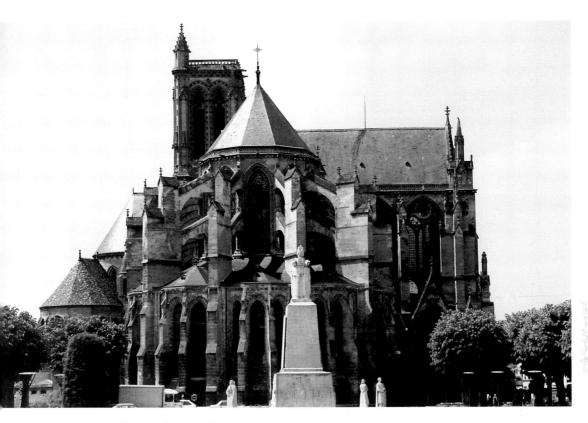

146. Soissons Cathedral, chevet, 13ᵗʰ century.

embraced by the ribs of the vaulting and placed within its own framing arch. This simple and elegant organization is more complicated to describe than to experience. The three levels of windows create a luminescent space even on a cloudy day (fig. 150).

You enter the exquisite side chapel through an arcade of three bays that is enchanting. A lovely pair of bundled columns is preceded and followed by slender columns, an arrangement that gives the entrance to this small chapel an almost processional quality (fig. 151). There is also an upper chapel on the second story and from below you can see a smaller version of the ground floor columns and the second-story vaulting.

Throughout the church the original details of the south transept have been respected,

although on a larger scale and with heavier elements. There is a sense of a logical but not obsessive mind working out the details and relationships, particularly between the south transept and the rest of the building.

The single-aisle ambulatory is both regular and graceful. Certainly not as light and spacious as the south transept, the generous ambulatory is, nevertheless, pleasingly and precisely composed. The aisle curves smoothly around the choir as we are led from one chapel to another with a sense of anticipation. The shallow chapels have five bays and each chapel and adjoining ambulatory bay share radiating vaults, a stylish solution that unifies the chapels and the ambulatory.

The cathedral's stained glass has suffered under the Huguenots, the Revolution, and

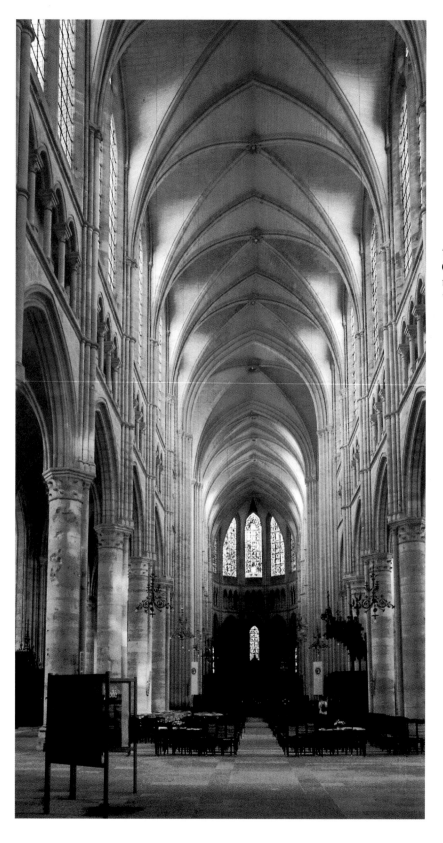

147. Soissons
Cathedral,
nave interior,
1190s–1250s.

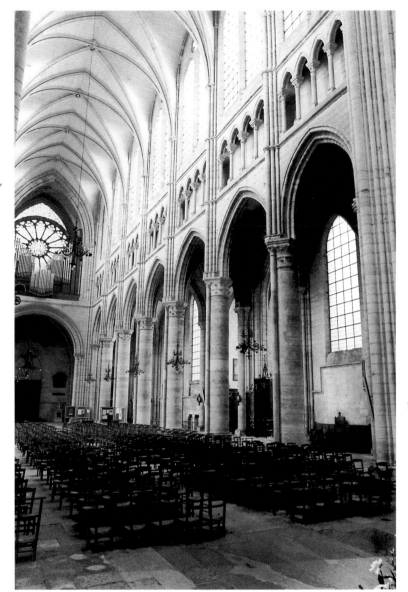

148. Soissons Cathedral,
nave elevation,
1190s–1220s.

even early twentieth-century restorers who sold some pieces to private collectors. As a result, very little medieval glass exists in the choir and elsewhere in the cathedral. There is some fine medieval glass in the axial and other chapels of the choir but it is mixed with nineteenth- and twentieth-century windows, most of which are well done and do not resemble the cartoon-like scenes prevalent in

so many churches. The glass in the north-transept rose window is appealing even though it has been greatly restored. The four supporting lancets have a lovely two-part design with stylized Art Deco windows from the 1920s showing the life of the Virgin (fig. 152).

The beauty of Soissons exists at several levels: the overall plan and elevation are bal-

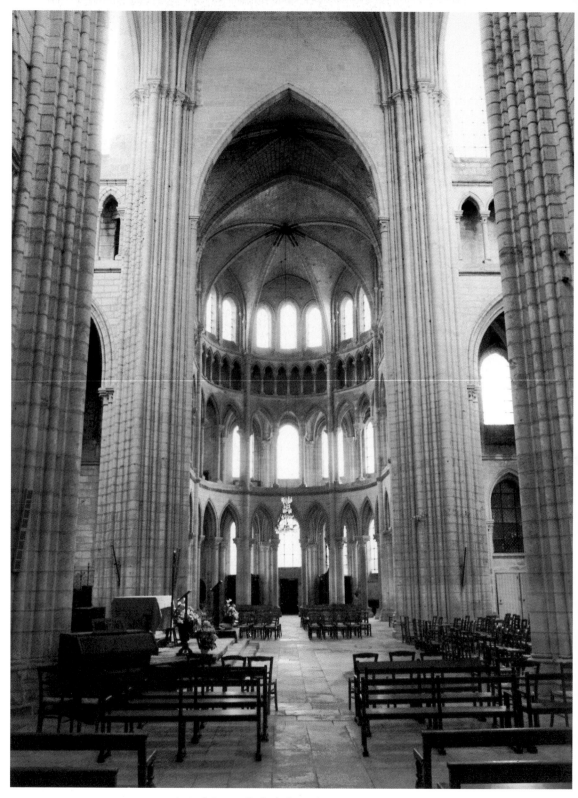

149. Soissons Cathedral, south transept, 1180s.

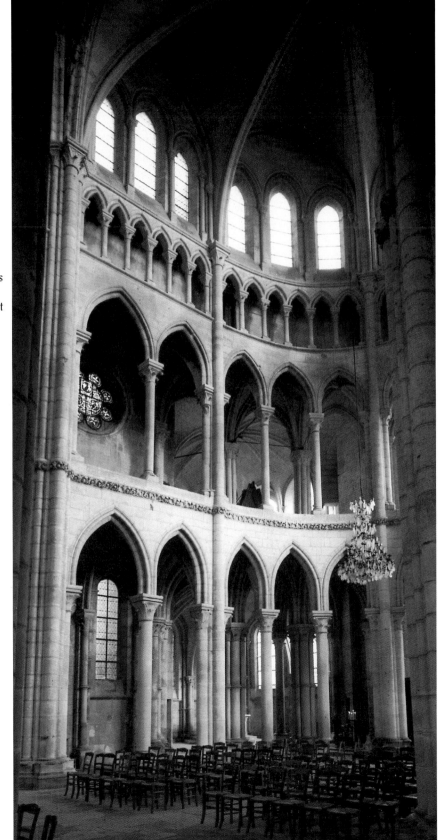

150. Soissons Cathedral, south-transept elevation, 1180s.

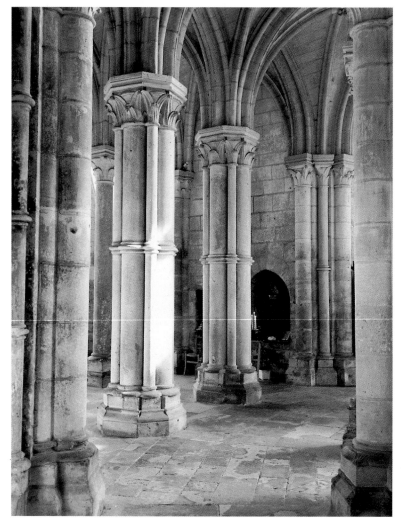

151. Soissons Cathedral, south-transept chapel piers, 1180s.

anced, moderate, and splendidly executed. Every detail corresponds gracefully with the others and with the features of the south transept. Part of what makes Soissons so restful and yet so alive is the unity throughout. The lovely south transept, a remnant from the Early Gothic phase, is like a precious gem that complements and illuminates its setting. Soissons is a wonderful blending of the intimacy and delicacy of Early Gothic and the powerful monumentality of High Gothic architecture. Nowhere else in Gothic architecture is this transition from one style to another so exquisitely captured.

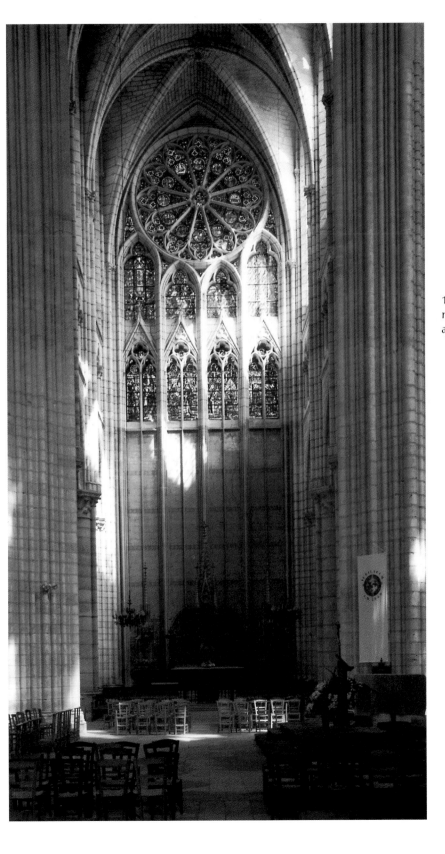

152. Soissons Cathedral, north-transept interior, 13th and 20th centuries.

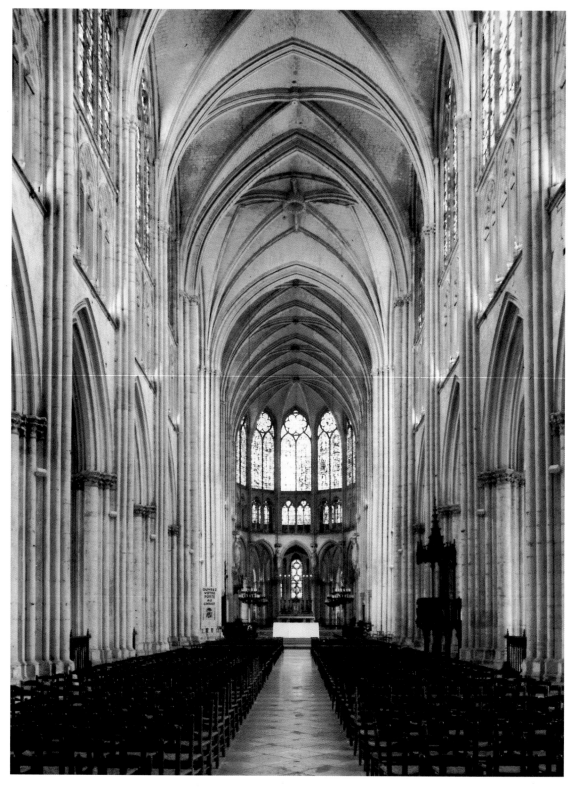

153. Troyes, Cathedral of Saints Peter and Paul, nave and choir, 1200–1500.

TROYES

Cathedral of Saints Peter and Paul

Surrounded by forests on the upper Seine in southern Champagne, Troyes is an attractive small city with outstanding churches, museums, and civic buildings. The capital of the counts of Champagne, it is being carefully restored and retains many of its medieval qualities. The old city center is particularly charming with half-timbered houses and medieval façades situated along cobbled streets. Troyes has a number of fine museums that reveal its artistic, political, and working past. The cathedral and the churches of Saint-Urbain and Sainte-Madeleine are all exceptional, each in its own alluring way, as are several other churches. In the Middle Ages, Troyes, known for its textiles and leather goods, was the site of major trade fairs. Today, in the early twenty-first century, it is also noted for its factory outlets on the outskirts of the town. Instead of pilgrims making their way on foot, we see enormous tour buses in the shopping-center parking lots.

The Cathedral of Saints Peter and Paul is an expansive church. The broad proportions of the central vessel (90 feet long by 45 feet wide), as well as the generous vaulting and two equally tall side aisles with chapels, create a very spacious interior with fine lateral and diagonal views. The nave is nearly as wide as the nave of Sens, but ten feet taller (fig. 153). On each side the width of the two aisles and the chapels is greater than the width of the nave itself. One of the pleasantest aspects of Troyes Cathedral is the way in which every part of the interior is infused with harmonious light. This is not a cathedral of dark recesses. The nave, aisles, generous transept, and the choir are all perfectly visible from almost any place in the cathedral. This consistent illumination gives a sense of wholeness and integration wherever we are. Abundant light in the nave, transept, and choir comes in through the clerestory windows as well as the glazed triforia, the windows of the aisle and ambulatory chapels, and the two enormous rose windows of the wide transept. The light throughout the interior is further enhanced by the light beige limestone.

Troyes was one of the first cathedrals in which the triforium was glazed and integrated into the clerestory, thus beginning the transformation to the glass cages of Rayonnant Gothic, and much of its magnificent original glass remains. The choir has thirteenth-century glass throughout, and the nave contains extraordinary sixteenth-century stained glass at the triforium and clerestory levels that bathes the interior with light.

The glazing of the triforium is one of the initial achievements of the Rayonnant style that was begun and developed in the Paris region in the 1220s, with complementary experiments at Amiens in the north and Reims and Troyes in the east. The architect of the upper choir and nave at Saint-Denis may have also been the architect of the choir at Troyes Cathedral, and the two churches can be seen as companions at the beginning of a new era of Gothic architecture. After 1250, Rayonnant became the dominant style in Gothic architecture throughout Europe.[1] Both The Sainte-Chapelle in Paris and the

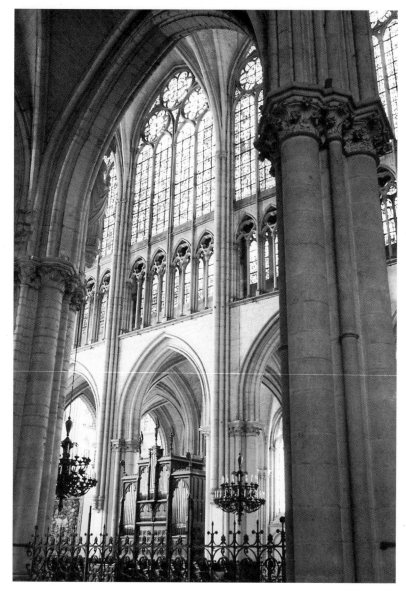

154. Troyes Cathedral, choir elevation, 1200–1250.

church of Saint-Urbain in Troyes, several blocks from the cathedral, are significant examples of the Rayonnant style.

Although Troyes Cathedral displays a consistency of style throughout the entire interior, construction continued over three-and-one-half centuries and required the services of as many as eighteen different master masons. Work spanned approximately seven building campaigns, beginning in the first

part of the thirteenth century and not ending until the completion of the west façade in the mid-sixteenth century.[2]

The pre-Gothic cathedral at Troyes was destroyed in the fire of 1188 that consumed part of the city. Construction on the new cathedral did not start until after 1200, when work began on the choir. Just as the choir was approaching completion in 1228, it was damaged during a severe storm. Rebuilding of the

176

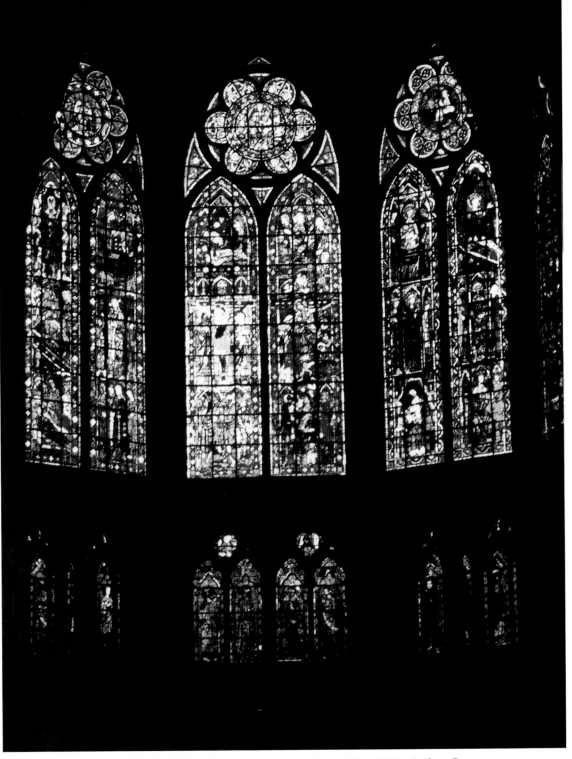

155. Troyes Cathedral, choir clerestory, central windows, 1230s–1240s. In these Rayonnant
windows, the window frame fills the entire window in contrast to the High Gothic chapel
windows below.

upper choir began shortly thereafter, and it is for these great clerestory windows and glazed triforia that Troyes is justly famous (fig. 154).

A new architect built the upper stories of the choir in the 1230s and 1240s and created a beautiful ensemble of thirteenth-century stained glass with lovely reds and blues. The three central clerestory windows are particularly impressive. The central window shows the Passion of Christ with the Flagellation, the Crowning of Christ with thorns, and the Crucifixion. The window on the left illustrates the Death, the Assumption, and the Coronation of the Virgin in heaven. The window on the right shows Saint John the Apostle in a vat of boiling oil, from which he escaped, and his ascendancy to heaven (fig. 155).

The choir chapel and clerestory windows are of particular interest because they show the difference between High Gothic construction at the beginning of the thirteenth century and early Rayonnant construction thirty years later. Here we witness the progressive dematerialization of wall structure in Gothic architecture. On the lower level the single-lancet windows in the radiating chapels of the ambulatory are refined versions of the basic Early and High Gothic technique where the window is part of the wall between the piers. There are three basic components here: the side piers, the wall surface with large sloping sills and angled frame, and the window itself more or less cut or punched out of the wall. This is essentially the same window seen at any number of Early and High Gothic churches (fig. 156).

When we look above to the clerestory windows of the choir built in the 1230s and 1240s, we see that the wall component has disappeared and the window frame occupies the entire space between the piers. The window has become a separate element fully built and placed between the piers, the wall component has been discarded, and the skeletonization of the structure is nearly complete. Combined with the glazing of the rear wall of the triforium, the results are stunning

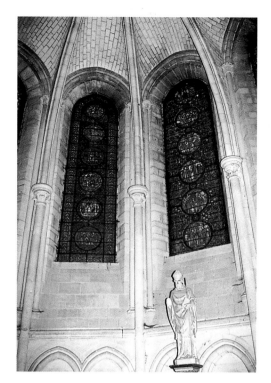

156. Troyes Cathedral, choir-chapel window, 1200–1210.

sheets of glass that encompass the choir, transept arms, and nave of the cathedral.

Although the ambulatory has been greatly praised,[3] I personally find it lacks a certain dynamic quality; it is much narrower than the nave and straight part of the choir, which is four bays deep. As a result you do not see the curve of the ambulatory until you are almost upon it. You are funneled into a single aisle between the treasury and the hemicycle. That moment of transition from the crossing to the hemicycle is missing, and you are not pulled forward into the space as you are at Chartres or Amiens. The turn of the hemicycle seems angled and choppy and the two aisles are relatively narrow in their proportions and not well arranged as you look back down the aisle to the nave. This is, however, a minor complaint in what is truly a very spacious and graceful cathedral.

The glazed triforium and clerestory win-

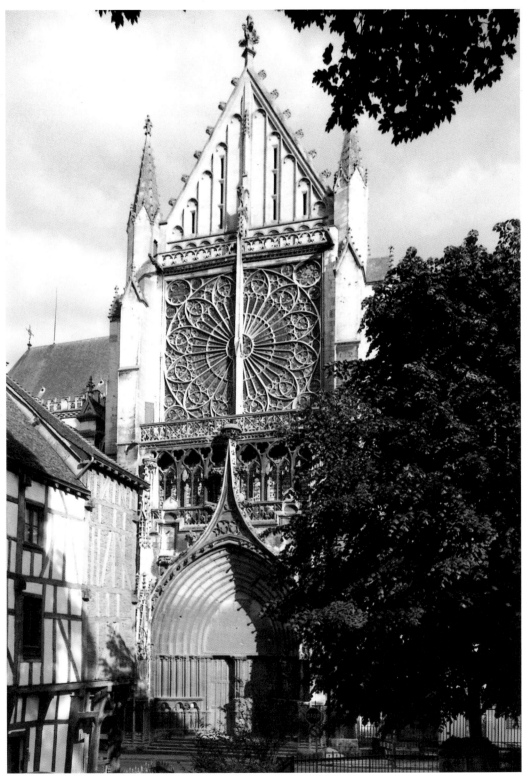

157. Troyes Cathedral, north-transept façade, 14th century.

158. Troyes Cathedral, glazed triforium, the Joseph Window, late 15th century. These panels show Pharaoh dreaming of seven years of feast and famine and Joseph interpreting the dream for Pharaoh.

dows on each side of the three-bay transept arm create a superb display of stained glass embracing two enormous rose windows. Both transept façades, however, were dangerously unstable. The north rose fell from its place in 1390 and was rebuilt by 1408. Two side buttresses and an elegant vertical brace dividing the rose window were added to increase stability.[4] Today, the north façade, facing a small park, is the most aesthetically pleasing of the three façades at Troyes (fig. 157). The south façade and its rose are nineteenth-century restorations with overly brilliant glass that is somewhat disconcerting with its almost fluorescent effect.

While some construction was done on the eastern end of the nave after 1270, it was not until the 1290s that further work was begun on the nave, a task that took two hundred years until the completion of the upper nave in 1500. During that time there were more collapses, including part of the upper nave in 1389 and the north rose in 1390.

In spite of continuous interruptions and a series of collapses in every part of the building, the cathedral exhibits a remarkable consistency of form and design. The original choir elevation of arcade, glazed triforium, and large clerestory window was respected in both the transept and the nave, with some

180

stylistic differences reflecting their different periods of construction. The choir, even with the significant innovation of the glazed triforium, utilized the familiar geometric arrangements seen at Reims. The clerestory windows in the hemicycle have double lancets crowned by a single oculus. In the straight part of the choir there are two large lancets, each containing two smaller lancets and an oculus, all crowned by a third oculus. The vertical posts or mullions dividing the lancets continue down to the base of the triforium. This technique integrates the triforium and the clerestory into one component, although we still see their separate features. The completely separate triforium of High Gothic is gone. This same arrangement was used in the transept. While there are many subtle differences in design, the overall uniformity of this cathedral is remarkable.

It is in the fourteenth- and fifteenth-century nave that we can see design changes reflecting the stylistic developments that had evolved since the creation of the choir in the thirteenth century. While the clerestory windows and the triforium in the choir employ the Chartres format of two lancets beneath a crowning rosette with considerable wall surface at the top of the triforium, in the nave the flame motif of the Flamboyant style is exploited in both the triforium and clerestory to create a lace-like screen of color. The nave lancets are much narrower than those in the choir and each bay has three sets of double lancets within a single arch. The upper portion of the triforium is completely pierced and the arch is closer to the clerestory sill

than in the choir. Similarly, the nave-arcade arches, with more refined moldings, are sharper than in the choir and reach to the very base of the triforium. The full effect of the tightening and refining of the original design is dazzling.

On the south side of the nave, the windows tell the stories of Daniel, Joseph, and the Prodigal Son; there is also a fine Tree of Jesse. The stories read from bottom to top beginning in the triforium and continuing in the clerestory. In the triforium of the Joseph windows is a particularly charming scene of Pharaoh dreaming of seven fat and seven lean years that Joseph interprets for him (fig. 158). On the north side the middle window tells the story of Job and includes a remarkable Satan.

The west façade was designed in the sixteenth century by the great architect Martin Chambiges. The city of Troyes experienced an economic resurgence at the end of the fifteenth century, which enabled the builders to undertake the immense project of the portals, rose window, and twin towers. Even though the west front with its three gabled portals does not correspond to the five aisles of the interior, the west façade has a beautiful Flamboyant rose window and a great deal of elaborate stonework. The south tower was never begun, and the statuary was destroyed during the French Revolution. It is best to stand across the cathedral square and examine the overall composition of the façade. Up close one becomes more aware of the missing tympanums and lost sculpture.

Basilica of Saint-Urbain and Church of Sainte-Madeleine

Saint-Urbain

When I first saw Saint-Urbain in 1987, it was in sad shape. The choir windows were boarded up because the foundation of the church

was unstable, its exterior was grimy, and it was open only on Sundays for services and brief visits. Today, the choir has been restored, the stained glass is back in its prop-

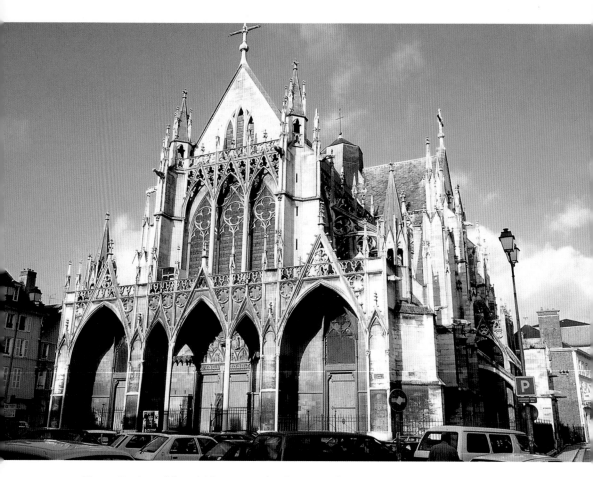

159. Troyes, Basilica of Saint-Urbain, west façade, 13ᵗʰ and 14ᵗʰ centuries.

er place, the exterior is being cleaned, the parking lot in front has been converted into a lovely square, and the church is open daily throughout the year.

Begun in 1262, Saint-Urbain had a violent birth. Jacques Pantaléon, a native of Troyes and the Patriarch of Jerusalem, became Pope Urban IV in 1261, and immediately planned to build a church on the site of his father's cobbler shop in Troyes. The land was owned by the Abbess of Notre-Dame-aux-Nonnains, and she was not pleased with this invasion of her little realm. When Urban died, Pope Clement IV continued the project; the partially finished church was to be consecrated

in 1266. Then the Abbess struck back, sending in thugs to ransack the building not once but twice, breaking down the doors and demolishing the high altar. The choir and transept were probably finished by 1270, but fires and more vandalism plagued the church, and it was not consecrated until 1389. The nave was not completed until the early twentieth century.

Saint-Urbain and The Sainte-Chapelle in Paris are often paired together as the great examples of early Rayonnant architecture as a reliquary or shrine. Stylistically they have much in common, but they are also very different churches, and the differences are

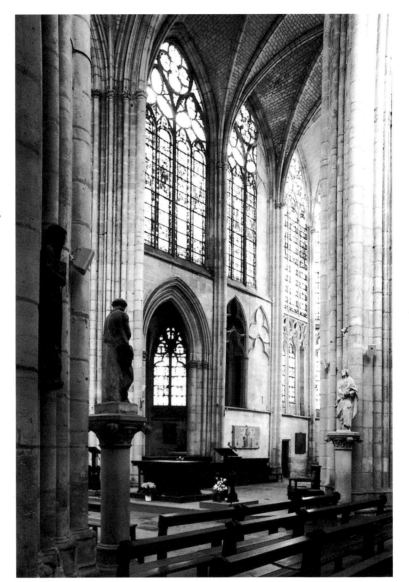

160. Troyes, Saint-Urbain, choir interior, 1260s.

illuminating. The Sainte-Chapelle is a single-aisle two-story church with a relatively plain exterior without flying buttresses. Saint-Urbain's exterior is almost fantasy-like in its complexity and exuberance. Although the choir has no flying buttresses and is reminiscent of The Sainte-Chapelle, the rest of the building is surrounded by a spiky, intricate web of buttresses, flyers, gables, and pinnacles. The small north and south porches are independent structures with freestanding piers and flying buttresses in front of them. The west façade is a broad arcade of gabled arches that creates a screen-like front to the building. The exterior is full of little pockets of space among the abundance of thin piers and arches. Saint-Urbain has the appearance of a monumental crustacean with its skeleton

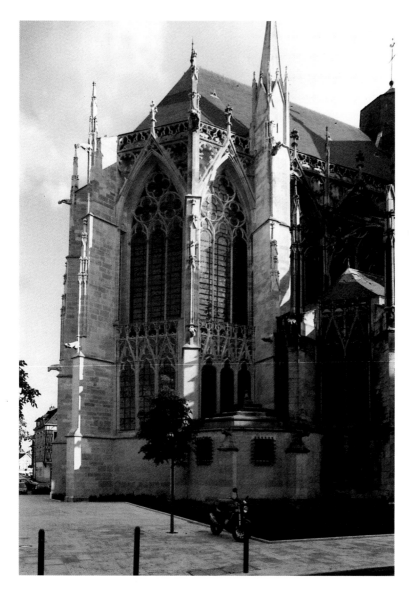

161. Troyes, Saint-Urbain, chevet, 1260s.

on the outside and a thin membrane of glass on the inside (fig. 159).

Unlike The Sainte-Chapelle with its narrow single aisle, Saint-Urbain is a spacious three-aisle church with broad arches and vaults. It is a two-story church without the traditional triforium, which had not been structurally necessary for some time. It is in the choir, flanked by two large chapels, that

we see Rayonnant design at its finest (fig. 160). The choir is comprised of two straight bays, one of which is blocked, and a five-bay apse. The apse windows rise in two stages, the first a three-lancet gallery with a glazed outer wall like the triforia of the early Rayonnant Cathedral of Troyes. The second level also has three lancets topped by three quatrefoils, a seamless and beautiful arrange-

162. Troyes, Church of Saint-Madeleine, Genesis Window, God Creating the Sun and Stars, early 16th century.

163. Troyes, Sainte-Madeleine, Tree of Jesse Window, Jesse sleeping, early 16th century.

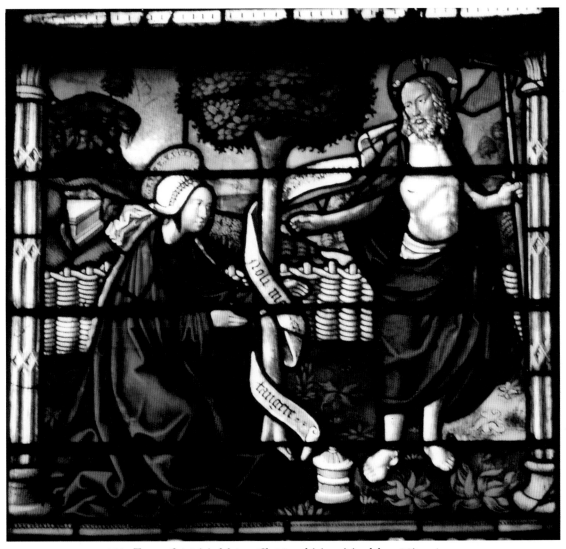

164. Troyes, Saint-Madeleine, Christ and Mary Magdalen, 16th century.

ment. Saint-Urbain is a fine combination of composure and exuberance and a fitting climax to early Rayonnant architecture (fig. 161).

Sainte-Madeleine

Mary Magdalen was one of the most respected saints of the Middle Ages. It was believed that she came to France after Christ's death and became a hermit in Provence, where she is said to have been buried in the church of Saint-Maximin near Aix-en-Provence. Her relics were supposedly moved to Vezelay in Burgundy in the ninth or tenth century, and veneration of her shrine began there in the eleventh century.

The Church of Sainte-Madeleine in Troyes was begun in 1200 but the choir was not built until the end of the fifteenth century. It is a lovely three-aisled church principally renowned for its Flamboyant choir screen and magnificent sixteenth-century stained-glass windows, among the most accessible and dramatic windows in France. The Genesis window vividly portrays scenes of the Creation (fig. 162), the formation of Adam from dust, Eve being created from Adam's rib, Cain and Abel, the Sacrifice of Isaac, and other scenes from Genesis. The Tree of Jesse (Genealogy of Christ) window (fig. 163) is a stunningly elaborate illustration of the tree growing out of Jesse with many twisting branches spread across its surface. It is one of the most memorable renditions of this subject. The Passion of Christ and the life of Mary Magdalen (fig. 164) are also remarkable displays of sixteenth-century artistry.

Jean Gailde's stone screen spans the entrance to the choir like an intricately carved bridge or balcony that continues around the flanking piers. As we walk through the entrance under the three floating arches, we realize that we are beneath three beautifully carved hanging vaults. This balcony screen is an ingenious tour de force. The church of the Sainte-Madeleine is a beautiful, hidden treasure in the heart of the medieval section of Troyes.

READING STAINED-GLASS WINDOWS

This chapter on stained-glass windows is the result of a conversation I had with another traveler in Troyes Cathedral. In his late seventies, Arthur was traveling alone across France visiting cathedrals and churches from Paris to Bordeaux with stops in Burgundy, Champagne, and Provence. We started talking about the stained-glass windows in the choir of Troyes Cathedral—how they had been made, and how old and beautiful they were. I mentioned that he should take a look at the Joseph window in the nave, and we walked over there to look at Pharaoh sleeping and dreaming of the seven fat and seven lean cattle. I began to explain how you "read" the story displayed in a stained-glass window, in this case starting with Pharaoh's dream in the lower-left corner of the glazed triforium and proceeding upward to the clerestory window. Arthur, a highly educated man, said that he had never really understood that you could read the stories illustrated in the windows, but had received immense enjoyment from just looking at them (see fig. 158).

Stained-glass windows dazzle us with their beauty, but are not easily understood. Even professional art historians, familiar with the various religious symbols and stories depicted, can find it difficult to read these amazing windows. Familiar scenes or details can still be misleading, for a scene showing Christ at a dining table may illustrate the Last Supper, the Supper at Emmaus, Christ in the House of Mary and Martha, or the Wedding at Cana.

In the thirteenth century, the Chancellor of the School of Chartres wrote that the windows were to teach those who were illiterate. "The paintings in the Church are writings for the instruction of those who cannot read. . . . The paintings on the windows are Divine writings, for they direct the light of the true sun, that is to say God, into the interior of the Church, that is to say the hearts of the faithful, thus illuminating them."[1] Today, most of us have lost the ability to read fully the symbols and the stories displayed in the stained glass of the cathedrals. In a sense, it is we who are now illiterate.

The beauty and meaning of medieval and Renaissance stained-glass windows are revealed to us in many ways. The dazzling colors, the intricate geometric shapes and patterns, and the individual scenes all compete for our attention. We can certainly appreciate the color or the composition independently of the subject matter. Unfamiliar as we often are with the various legends that would have been second nature to the medieval viewer, their narrative thread can easily be lost as we rely on a scene here or there to give us some sense of the story. Following the narrative can also be difficult because medieval designers did not always arrange the story in a strict sequence of events. Many windows start at the bottom and work their way through the narrative to the top; others may begin at the top. The bottom frames are often reserved for scenes depicting the donors. Some windows may present the major scenes in the central medallions and provide commentary along the sides. Sometimes panels have been scrambled during restoration and put back out of chronological sequence, as we see to a small degree in the Incarnation window on the west front of Chartres, or to a greater

degree in the Joseph window at Bourges. The gift shops in many of the cathedrals have guidebooks about the stained glass that outline the various windows, at least in summary fashion.

The use of stained glass had religious significance because it gave the clergy the opportunity to bring divine light into the house of God. "Light demonstrated the principle of continuity in nature in that it was transmitted from the firmament through each of the heavenly spheres down to the lowest element, earth. Just as light, created by God before all else, was the factor in unifying the physical universe, so divine illumination was the means by which the soul, having its origins in both material and physical aspects of being, could, through imagination and intellect, ultimately ascend to God."[2] Abbot Suger compared the radiance of stained glass to precious jewels bringing sacred images into his church.

For centuries, Christian churches were adorned with mosaics, frescoes, and sculpture telling the stories of the Bible and the myths and legends of Christianity. It was not until the Gothic period that stained glass came into its own as a story-telling medium. Gothic architects sought to open up the churches and provide more light by replacing solid wall surface with windows, and as a result stained or painted windows began to replace Byzantine and early Christian mosaics and Romanesque frescoes as decoration. The earliest stained-glass window that we have today was created in the late seventh or eighth century in England, but the first program of stained glass in France did not appear until the eleventh century in Abbot Suger's ambulatory and choir at Saint-Denis.[3] This program included what was probably the first Tree of Jesse, the depiction of Christ's ancestors, that gained immediate popularity (fig. 165).

Twelfth-century window designers were restricted to squares and rectangles to frame individual scenes. In the three large lancet windows of the west façade at Chartres, cre-

ated about 1150, the circles are in the glass and are not part of the iron framework. The windows, particularly the central Incarnation window with the life of Christ from the Annunciation to His Entry into Jerusalem displayed in thirty panels, are quite difficult to read because of their great distance from the viewer (fig. 166). In the 1190s, at the Basilica of Saint-Remi in Reims, stained-glass designers addressed the issue of scale by putting larger figures in the upper windows and smaller narrative scenes at a lower level in the ambulatory chapels.[4] The development of bar tracery at Reims gave designers much greater flexibility in designing windows, and at the same time new techniques in bending the metalwork frames allowed for a more complex, interrelated composition of scenes. In the thirteenth century, circles, quatrefoils, trefoils, and other shapes could be woven together in more elaborate patterns, giving greater clarity to individual scenes. At Bourges Cathedral the designers often allowed scenes to overlap and individual figures to step outside the surrounding frame, which gives these windows a marvelous sense of energy and spontaneity (fig. 167). The aisle windows at Chartres and the ambulatory windows of Bourges have a wide variety of geometric patterns that clearly frame the scenes. It is a remarkable experience to stand at one end of the ambulatory at Bourges and look at the complex array of compositional fields in this curving space that glows with radiant color. Renaissance windows such as the beautiful Annunciation at Bourges were modeled on Flemish paintings and were often designed by painters rather than craftsmen (see fig. 55).

Medieval stained glass was made from sand and potash with the colors added with metallic oxides. The glass was usually blown in a cylindrical or bottle shape and then cut lengthwise and flattened into a sheet or blown and spun into a flat circle with a radiating pattern.[5] The design was drawn full scale on a whitewashed table, and the glass was placed on the table and cut into desired

165. Paris, Cathedral of Saint-Denis, Tree of Jesse Window (Genealogy of Christ) in the ambulatory, 1140s.

166. Chartres Cathedral, west façade, Incarnation Window (the Life of Christ from the Annunciation through the Entry into Jerusalem), 12th century.

shapes with a hot iron. Cold water was then poured on the glass, which caused it to crack along the lines. Details were painted on with a dark pigment, and the pieces were fired to fuse the paint with the glass.

Colors changed over time as designers learned new techniques, and larger windows allowed them to use more opaque glass. The blue used in the twelfth century at Chartres, the sky blue (bleu de ciel) of Chartres, had more soda in it than the darker, more saturated blues of the thirteenth century.[6] The most famous surviving example of the Chartres blue is the window at Chartres called Notre Dame de la Belle Verrière, where the four central panels, which survived the fire of 1194, were reinstalled in a new window placed in the south-choir aisle of the new cathedral. We can see the contrast between the medium blues of the Virgin's robes and

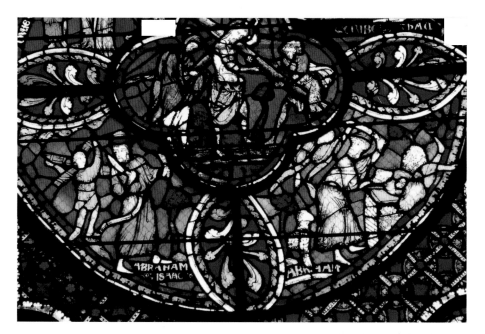

167. Bourges Cathedral, New
Alliance Window, detail showing
the Sacrifice of Isaac, early 13th
century.

168. Chartres Cathedral, detail of
the Notre-Dame de la Belle Verrière
Window showing the Virgin and
Christ Child, south choir aisle, 12th
and 13th centuries.

the much darker blues of the thirteenth-century borders (fig. 168).

Only a very small portion of medieval stained glass survives. Various wars and conflicts have taken an enormous toll, from the Wars of Religion in the seventeenth century to the French Revolution in the late eighteenth century and the two World Wars of the twentieth century. Changing taste and neglect have been equally damaging as clergy and others wished to become more modern. The Industrial Revolution and the automobile have brought the ravages of pollution that still threaten the finest windows.

How then, do we read a stained-glass window?

The Passion Window at Bourges

Passion cycles show the events in Jesus's life from His Triumphal Entry into Jerusalem (now celebrated as Palm Sunday) through His Arrest, Flagellation, Crucifixion, Resurrection, and events beyond the grave such as His Appearance to Mary Magdalen (the Noli Me Tangere—Do Not Touch Me—scene), and the Supper at Emmaus. At Bourges the story of the Passion ends with the Resurrection and the Descent into Limbo.

The Bourges Passion Window is laid out in a clear composition of two vertical rows, each with six large circles hanging like medallions on a multicolored ribbon. Between each horizontal row of two circles we find a row with a small quatrefoil in the center and a half-quatrefoil at each edge of the frame. The entire window is surrounded by a thin decorative border of flowering vines. The scenes are easily read, generally from left to right and bottom to top (figs. 169, 170).

The window was given to the cathedral by the furriers, who are shown in the two truncated bottom circles displaying and selling a beautiful blue cloak trimmed with white fur. The first row of small quatrefoil shapes shows details of their workshops.

The story begins with the Entry into Jerusalem in the second row of large circles. On the left Christ, accompanied by His

disciples, rides on a donkey that seems to be dangerously close to a small white dog. The right-hand circle, which is to be read as part of the same scene, shows the welcoming crowd, including the traditional depiction of boys climbing the trees just outside the gates of the splendid city. The Gospels tell us that after His arrival in Jerusalem, Christ debated with groups of elders, priests, lawyers, Pharisees, and Sadducees, the scenes that fill the next row of small quatrefoil frames (Mark 11:27-33, 12:1-44; also in Matthew and Luke).

The third row of large circles shows the Last Supper on the left. Christ's beloved apostle John has fallen asleep and is bent over the table next to Jesus; Judas is a small figure sitting on our side of the table and reaching for the object Christ is holding (Luke 22:21—"But behold the hand of him who betrays me is with me on the table."). In the circle to the right, Jesus dries Peter's knee with a towel, a quite fastidious version of Christ Washing the Feet of His Disciples.

The third row of small quatrefoils depicts the Agony in the Garden in the central panel with the Apostles sleeping as Christ kneels in prayer. The partial quatrefoil to the left shows the Raising of Lazarus, an event that occurred before the entry into Jerusalem (John 11:1-44), and at the right it shows Christ Driving the Moneylenders from the Temple, which took place just after His triumphal arrival in the city (Luke 19:45-6).

At the fourth row of circles the logical order of the previous scenes reading from left to right and bottom to top row breaks down and becomes somewhat confused.

Row four of the large circles must be read in conjunction with the row of small quatrefoils just above it. Begin in the large circle at the left with the Kiss of Judas and the Taking of Christ. Move next to the next small central quatrefoil above showing Christ before Pilate, then to the half-quatrefoil at the left with the Flagellation of Christ, and then to the right half-quatrefoil with a very rare depiction of Judas returning the thirty pieces

169. Bourges Cathedral, Passion Window, early 13th century. Depicts the last week of Christ's Life from the Entry into Jerusalem on Palm Sunday to the Resurrection and Descent into Limbo.

THE PASSION WINDOW—Bourges Cathedral
1-5 Furriers
6 Entry into Jerusalem
7 Christ Debating
8 The Last Supper
9 Christ Washing the Disciples Feet
10 Raising of Lazarus
11 Agony in the Garden
12 Christ Chasing the Moneylenders from the Temple
13 Kiss of Judas and the Taking of Christ
14 Christ before Pilate
15 Flagellation
16 Judas Returning the Silver
17 Christ Awaiting Crucifixion
18 Crucifixion
19 Descent from the Cross
20 Entombment
21 Resurrection
22 Descent into Limbo

170. Bourges Cathedral, diagram of the Passion Window.

of silver to the chief priests and elders in an act of remorse before he committed suicide (Matthew 27:3-5). Continue the story by coming back down to the large right-hand circle of the fourth row. This also shows an extremely unusual scene of the Cross being put into place by various workers while Christ stands next to the centurion Longinus.

The fifth row of large circles begins at the right and moves left instead of the traditional left-to-right sequence. Here on the right we see the Crucifixion with Mary and John observing Longinus pierce Jesus's side with his lance. (This action prompted Longinus to recognize Christ's divinity and become the first post-Crucifixion Christian convert.) To the left we find the Deposition or Descent from the Cross, with the slumping body of the dead Jesus being lowered into the arms of Joseph of Arimathaea, while Mary and John watch. The small quatrefoil above shows the Entombment, with angels filling the outer quatrefoil fragments.

The top row of slightly cropped large circles shows the Resurrection on the left and the Descent into Limbo on the right, where Christ, holding the banner of the Resurrection, retrieves figures of Adam and Eve and other unbaptized Old Testament figures being restrained by the huge jaws of the demonic green guardian of Limbo.

New Alliance Window at Bourges

The New Alliance Window at Bourges is a wonderful example of the parallelism between the Old Testament and New Testament in a single window. From the days of the Early Christian Church, writers and commentators were keenly interested in treating Old Testament figures and stories as prefigurations of New Testament events. The flood from which Noah escaped was a kind of Last Judgment, and Noah was the Christ-like figure who saved mankind (and the animal world as well) with his ark, a symbol of the Christian Church (fig. 171). Christ was seen as the new Adam and Mary the new Eve. The medieval mind loved to play with Eve's name

in Latin, "Eva," and its reversal, "Ave," the opening salutation from the angel Gabriel to Mary at the Annunciation, the event (the Incarnation) that redeemed mankind from Eve's fateful action in the Garden of Eden. Typology, the notion that Old Testament characters and episodes foretold or foreshadowed Christ and the events of His life, was very popular during the Middle Ages. Old Testament scenes were often included in windows of New Testament subjects as commentary.

The New Alliance Window at Bourges is composed of two large circles and two smaller circles along the vertical axis, with sections of quatrefoils along the frame and a semicircle at the bottom. The two large circles have a quatrefoil at the center and four quadrants separated by decorative almond-shaped petals. The outer frame of the window is a narrow band of flowers (figs. 172, 173).

The window was given to the cathedral by the butchers' guild whose members are seen at the bottom of the window, with a butcher's shop in the central semicircle and the slaughtering of a pig and a cow at the lower left and right corners. The window reads from bottom to top.

The quatrefoil of the first large circle shows Christ carrying a green cross, accompanied by Simon of Cyrene and a woman who represents the women to whom Jesus says, "Daughters of Jerusalem, do not weep for me" (Luke 23:26-8). In the lower-left quadrant of the circle we see Abraham and Isaac going off to make a sacrifice to the Lord. Isaac, carrying green sticks of wood arranged like Christ's cross in the center, asks his father where they will find the lamb they need for the sacrifice. In the lower-right quadrant Isaac is being held on the altar (his legs tumbling over the frame), as the angel stops his father from killing him with a knife. Isaac is an Old Testament prototype for Christ (made very clear by the juxtaposition of the two green crosses), whose role as a sacrificial lamb was stopped in this case because of God's earlier promise to Abraham

171. Chartres Cathedral, detail of the Noah Window, north aisle, 13th century.

to protect Isaac. The story of the Sacrifice of Isaac was seen in the Middle Ages as an important prefiguration of the Passion of Christ (see fig. 167).

The upper-left quadrant of this first large circle shows the Old Testament prophet Elijah with the widow of Zarephath, who holds two sticks of wood in the form of a cross. During a great famine, she was gathering wood to make one final meal for herself and her son (in the blue robe) with the last of her flour and oil. Elijah told her to feed him first, and said that her flour and oil would then be replenished every day and that they would continue to eat (1Kings 17:8-16). This Old Testament story, speaking about the nature of the widow's sacrifice and faith, parallels the sacrifice of Christ on the cross, and the faith required by the Christian community for salvation.

196

THE NEW ALLIANCE WINDOW—
Bourges Cathedral
1-3 Donors
4 Christ Carrying the Cross
5-6 Sacrifice of Isaac
7 Elijah and the Widow of Zarephath
8 Story of Passover
9 Christ with Ecclesia and Synagoga
10 Moses Striking Water from the Rock
11 Moses and the Brazen Serpent
12 Resurrection
13 King David with Pelicans
14 Family of Lions
15 Elijah Revives the Widow's Son
16 Jonah and the Whale
17 Jacob Blessing the Sons of Joseph

173. Bourges Cathedral, diagram of the New
Alliance Window.

172. Bourges Cathedral, New Alliance
Window, early 13th century. Illustrates New
Testament scenes that parallel Old Testament
events.

The upper-right quadrant of the circle depicts the preparations for Passover according to God's instructions to Moses (Exodus 12:1-13). To gain the Jews' release from Egypt, God rained havoc on Pharaoh's people, but "passed over" the houses marked with the blood of lambs that the Jews were to sacrifice, cook, and eat. We see here two figures, one kneeling over a lamb at the right, and the other standing with a bowl and brush painting the signs on the door posts and lintels that God required as markers on the houses he would avoid during His night of destruction. A small red "T" may be seen on the white lintel or roof and also at the top of the yellow column. This is another story about the nature of faith and sacrifice in which the cross-shaped markings in lamb's blood remind us of the sacrifice of Jesus, the "Lamb of God who takest away the sins of the world."

In the center of the third row is a small circle with Christ on the Cross flanked by female figures representing Ecclesia (the Church) and Synagoga (the Temple). The crowned figure of Ecclesia holds a chalice that catches the blood pouring from Jesus's pierced side; the blindfolded figure of Synagoga is losing her crown. These two figures, often shown together in places like Reims or Strasbourg Cathedral, display a favorite medieval theme of the triumph of the Church over the Synagogue, the New Testament over the Old.

The demi-quatrefoils on each side show Moses Striking Water from the Rock (Exodus 17:5-6) on the left, and Moses and the Brazen Serpent (Numbers 21:8) on the right. In describing Moses leading the Jews out of Egypt, Paul says in 1 Corinthians 10:4 that they "all drank from the supernatural rock which followed them, and the Rock was Christ." Moses and the Brazen Serpent tells the story of God sending serpents to kill the Jews who complained to Moses during their long trip out of Egypt, and then instructing Moses to make a serpent and put it on a stick

so that whoever was bitten could look at it and be cured. The Gospel of John makes the Old Testament–New Testament analogy in saying that "as Moses lifted up the serpent in the wilderness, so must the Son of God be lifted up, that whoever believeth in him may have eternal life" (John 3:14-6).

The second large circle displays the Resurrection of Christ in the central quatrefoil; the tiny figure of a sleeping soldier, yellow shield against his stomach, fits into the bottom lobe of the quatrefoil. King David, a major Old Testament prophet whose triumphant return to Jerusalem with the Ark of God was considered to be the Old Testament parallel of Christ's Entry into Jerusalem, is in the lower-left quadrant of the circle. With David is a group of pelicans, which were considered symbols of Christ, for it was believed that pelicans fed their young with blood that they plucked from their own breast, this being an analogue for Christ's sacrifice for mankind. At the lower right is a pair of lions watching and bending over a lion cub. It was thought in the Middle Ages that lions were born dead and did not come to life for three days, a clear reference to Christ's Resurrection on the third day after the Crucifixion.

In the upper-left quadrant we see Elijah reviving the dead son of the widow of Zarephath (1 Kings 17:17-24). The upper right shows one of the most charming details of this window, the figure of Jonah climbing out of the whale's mouth after three long days and nights in its belly. Even Jesus compared Himself to Jonah when He prophesied His Resurrection three days after His death (Matthew 12:40).

In the small circle at the top of the window, Jacob blesses his two grandsons, Manassah and Ephraim, but knowingly crosses his arms and gives the important blessing with his right hand to the younger grandson, Ephraim (Genesis 48:13-20). This is the only panel in this window that does not have a typological significance.

TRAVEL SUGGESTIONS

Over the years I have thoroughly enjoyed driving and traveling by train in France. The French road system is superbly maintained at all levels, and travel signs are usually clear and timely. The rail system is extraordinary, from the frequent commuter trains to outlying cities around Paris to the fabulous TGV and Eurostar. The traffic in the larger cities can be difficult and confusing, especially without very careful planning. But in the countryside traffic subsides. Away from the congestion of the cities, the French are generally good drivers. I have noticed a tendency to tailgate, and I have been told that it is because many French speedometers are broken, and they want to read yours in order to see how fast they are going. But they may just be lost and trying to read your map.

Maps and Books

The latest Michelin Red Guide to hotels and restaurants and good Michelin maps are indispensable. The Red Guide is a good practical guide, and its city maps are invaluable. The location of the cathedrals, parking, and other sites are clearly marked and directions are coordinated with Michelin maps. Towns and cities underlined in red on the Michelin maps have restaurants and hotels listed in the Red Guide. The Michelin Green tourist guides are also excellent sources of information on regional and local sites.

Taking the Train

Most of the towns and cities in this book are within easy reach from Paris by train in an hour or two. The French rail system (SNCF) is extremely comprehensive and efficient. The commuter trains are not the most luxurious, but the Eurostar and TGV cannot be beat. The SNCF website (http://www.sncf.fr) provides up-to-date timetables for any trip you would want to plan.

Driving in France

The Autoroutes may be the fastest and most direct way to get from place to place in France, but they are expensive and a little boring. Tolls are paid in French francs or with your credit card. The **N** routes (marked in red) are the major highways, while the **D** routes (yellow and plain) are less traveled and may be more interesting. A green border along the route on a Michelin map means that it is a scenic route.

Priority (right of way) is to the right in most cases unless you see the sign, "Vous n'avez le priorité" (You do not have the priority). You will see this sign at the roundabouts (traffic circles).

Parking

Parking is available on the street or in parking lots, but much of it is "payant." You need to buy a parking ticket at the nearest ticket dispenser and place it on your dashboard. In a parking structure you usually redeem your ticket at the ticket booth or dispenser before retrieving your car, not when exiting, as in the United States. Parking on the streets is usually free from noon to 2:00 pm and on Sundays. Park your car where it can be easily seen and do not leave luggage or other items visible. The only time I have had a problem in fifteen years of driving in France was at a château parking lot, where I parked out of sight of the gift shop.

French Tourist Office (Maison de La France)

The French Tourist Office has an enor-

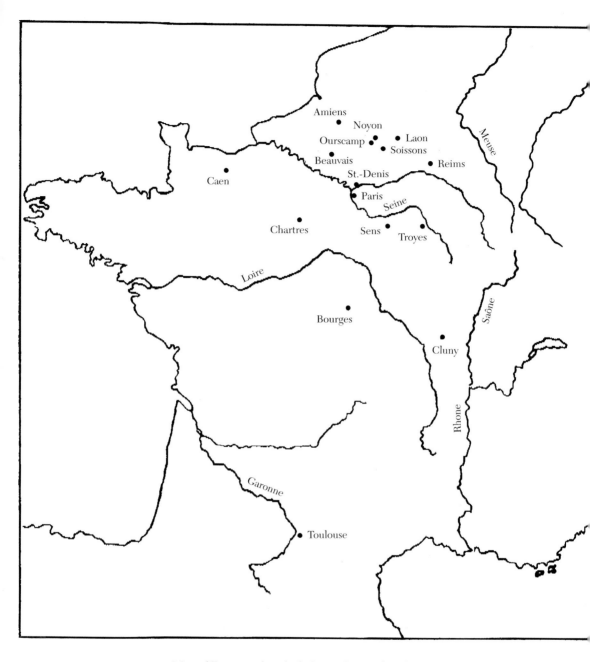

Map of France with cathedral sites discussed in the text.

mous amount of information on traveling in France, and it can be very helpful before you depart. Every city has a tourist office clearly marked on city maps. The website (http://www.francetourism.com) is very useful.

PARIS

The city of lights is also the city of great churches. What can one say about Paris? It is wonderful, and the best ice cream is near Notre-Dame on the Île-St.-Louis at Bertillion, and the best pastry is in the sixth arrondissement at Gerard Mulot's on rue de Seine near the old barn of a church called Saint-Sulpice.

Location

Cathedral of Notre-Dame—The cathedral is the zero-kilometer mark for all of France. The road signs that say "Paris 350 km" really mean it is 350 kilometers to the cathedral. The cathedral is on the No. 4 Metro line (Porte d'Orleans—Porte de Clignancourt, Metro station: Cité) or on the No. 1 line (Vincennes—La Défense, Metro station: Châtelet), which runs along the Right Bank past the Louvre. The Metro stops are a short walk from the cathedral and the No. 1 line will take you to Château de Vincennes, which has a lovely park and a beautiful sainte-chapelle of its own.

Parking

In Paris? Good luck! Take the Metro or a bus.

Other Churches, Museums, and Other Points of Interest

The Sainte-Chapelle—In the Ministry of Justice complex just to the west of Notre-Dame. There is an admission fee.

Abbey (Basilica) of Saint-Denis—Now designated as a cathedral, it is on the Châtillon–Montrouge–Saint-Denis line (No. 13). The Saint-Denis station is a few blocks from the abbey (follow signs for Basilique). There are some restaurants around the abbey, but nothing fancy. If you drive, there is

a parking lot under the shopping mall just west of the abbey and one to the southeast. There are numerous ways to get to Saint-Denis; it is just off the A1 Autoroute where it meets the N186. Plan your approach carefully and have a good navigator. The Metro is much easier. Be careful with camera equipment. There is an entrance fee for the tombs, transept, choir, and crypt. A nice park faces the north side of the abbey.

Saint-Martin-des-Champs—This pre-Gothic church is near the Arts et Métiers Metro stop, which is what you would expect, for it is in the old Arts et Métiers Museum, now called the Musée Nationale des Techniques on rue Saint Martin in the third arrondissement. About seven blocks north of the Pompidou center, the museum is a recently renovated technological museum with a lot of interesting displays, including Foucault's pendulum. Saint-Martin-des-Champs is important because it pioneered some of the building concepts and techniques later used at Saint-Denis by Abbot Suger.

Cluny Museum (the Musée Nationale du Moyen Age et des Thermes de Cluny)—(Metro: Cluny Sorbonne Metro on the Gare d'Austerlitz—Boulogne line No. 10 that runs through the sixth arrondissement). In the old Paris mansion of the Abbots of Cluny, this museum has an important collection of medieval art and antiquities, including the magnificent series of the Virgin with the Unicorn tapestries. It was built on top of old Roman baths, and part of those baths have been incorporated into the museum. The Louvre also has an outstanding collection of medieval art.

Musée des Monuments Historiques—In the Trocadéro across the river from the Eiffel Tower (Metro: Trocadéro on the No. 9 line). This museum is at the other end of the spectrum for authenticity, for it is full of life-size replicas of important French architecture, including the portals and façades of many medieval churches. It is a fascinating place.

Tourist Office

127 Avenue des Champs Élysées, phone 01 49 52 52 53 54; there are other offices at the Gare du Nord and the Gare de Lyon.

Website

http://www.francetourism.com

AMIENS

Amiens is a busy city that has renovated several areas to make the city more congenial and accessible. The city center south of the cathedral has pleasant pedestrian areas with cafés and restaurants, the old St.-Leu quarter has been restored, and the square in front of the cathedral has been renovated. The cathedral's west façade was restored in 1999 with a pioneering use of lasers.

Location

Automobile: 138 km north of Paris on the A16 Autoroute.

Train: 1 hour 8 minutes by train from the Gare du Nord. It is a relatively short walk from the station to the cathedral.

Parking

Paid parking at several locations near the cathedral. There is an underground parking lot one block south of the cathedral's south façade.

Museums and Other Points of Interest

Museum of Picardy (Musée de Picardie)—A nice provincial museum with a good collection of European and Old Master paintings in a pleasant nineteenth-century mansion.

The Hortillonnages—A network of little islands dating from Roman times, these market gardens cover over 400 acres and can be visited by boat or on foot. On market days gardeners sell their produce along the quays beneath the cathedral.

St.-Leu Quarter—The Little Venice of the North—Nine branches of the Somme flow through this inviting area to the north of the cathedral with canals, parks, restaurants, shops, and residences.

World War I Battlefields and Monuments—East of Amiens are numerous monuments, cemeteries, and memorials commemorating the Battle of the Somme. There is an oustanding military museum in Peronne.

Tourist Office

Several blocks southeast of the cathedral at 6 rue Dusevel. Phone 03 22 71 60 50.

Website

http://w2.amiens.com

BEAUVAIS

Location

Automobile: 83 km north/northwest of Paris on the N1.

Train: 1 hour 13 minutes from the Gare du Nord. A relatively long walk to the cathedral.

Parking

Paid parking next to the cathedral and in an underground parking lot in Place G. Clemenceau, two blocks south of the cathedral.

Museums and Other Points of Interest

Church of Saint-Étienne—Romanesque nave and transept with Flamboyant choir (begun 1500). Renaissance stained glass in choir by Engrand Le Prince (Tree of Jesse, Last Judgment with remarkable demons). A must see.

Museum of the Department of the Oise (Musée Départemental)—In the Bishop's Palace next to the cathedral. Medieval sculpture, French paintings, Art Nouveau furniture.

National Gallery of Tapestry (Gallerie Nationale de Tapisserie)—Close to the chevet of the cathedral. A survey of French tapestry from the fifteenth century to modern times.

Saint-Germer-de-Fly—25 km west of Beauvais on the N31 and D104. Outstanding thirteenth-century sainte-chapelle and plain Early Gothic nave. Worth a stop.

Rue Beauregard (one block east of the cathedral). Phone 03 44 45 08 18.

BOURGES

Bourges is a lively university town built on a sloping hill overlooking the Auron and Yèvre rivers with fine regional museums and many medieval and Renaissance houses. Renowned for the cathedral and the Palace of Jacques Coeur, Bourges is the site of important music and art festivals.

Location

Automobile: 245 km south of Paris on the A71.

Train: 1 hour 50 minutes from the Gare d'Austerlitz. A long walk or a bus ride to the cathedral.

Parking

Paid parking in the parking lot under the Hôtel de Ville on rue Moyenne south of the cathedral.

Museums and Other Points of Interest

Palace of Jacques Coeur—Fifteenth-century mansion of France's most influential merchant and financier. One of the most beautiful early Renaissance civil buildings in France. Contains a reconstruction of the tomb of Jean, Duc de Berry.

Musée de Berry (Hôtel Cujas)—Collection of Gallo-Roman artifacts.

The Museum of Decorative Arts (Hôtel Lallemant)—Collections of French and Dutch furniture, 16th- and 17th-century tapestries, faïence, enamels, ivories, glasswork, and clocks.

Archbishop's Garden—On the southeast flank of the cathedral. A lovely formal garden with an outstanding view of the cathedral.

Cathedral Crypt—Guided tours of the beautiful crypt with interesting sculpture. Admission fee. Inquire at the book stand inside cathedral.

Cathedral Tower—The south tower provides a spectacular view of the city and the roof and buttresses of the cathedral.

Noirlac—46 km south of Bourges on the N144. Cistercian abbey founded in the 1130s. Restored in the mid-twentieth century. Beautiful buildings and interesting site.

Bourges Music Festival (Printemps de Bourges)—A major European festival of experimental jazz and rock music held every spring.

Cathedral Light Show—Held every evening during the summer and on weekends throughout the rest of the year.

Tourist Office

21 rue Victor Hugo on southwest side of the cathedral. Interesting display of the history of Bourges. Phone 02 48 23 02 60.

Websites

Bourges city website: http://www.ville-bourges.fr

Music Festival (Printemps de Bourges) http://www.printemps-bourges.com

CHARTRES

Chartres is a charming small city with a beautiful old quarter below the cathedral along the Eure river. The churches of Saint-Pierre and Saint-Aignan have interesting stained-glass windows and architectural features.

Location

Automobile: 88 km southwest of Paris on the A10/A11.

Train: 56 minutes from the Gare Montparnasse on a frequent schedule. A short walk to the cathedral from the train station.

Parking

Paid parking in an underground parking lot west of the cathedral on Blvd. de la Résistance.

Museums and Other Points of Interest

Cathedral Crypt—Regular tours. Obtain tickets at the bookstore on the south side of the cathedral.

Church of Saint-Pierre—An interesting medieval church with thirteenth- and fourteenth-century stained glass. Nave is thirteenth century, choir is fourteenth century, with a twelfth-century apse. There is a

charming stained-glass window on the north side of the nave of the Feast of Herod, with Salomé doing a somersault during her dance.

Tourist Office
Place Cathedral, west of the cathedral. Phone 02 37 21 50 00.

Website
www.chartres.com

LAON

The old town of Laon, situated on a curved ridge above the plains of northern Champagne, is one of the most dramatic cities in France, with medieval streets and impressive vistas.

Location
Automobile: 142 km northeast of Paris on the N2.

Train: 1 hour 30 minutes to 1 hour 50 minutes from the Gare du Nord. Then city bus or funicular to Old Town (Ville Haute) at top of the hill. The funicular does not run on Sundays.

Parking
Paid parking along the flank of the cathedral.

Museums and Other Points of Interest
Chemin des Dames—16 km south of Laon on the N2. The Caverne du Dragon on the Chemin des Dames is a fascinating museum of an underground World War I battle site located in the quarries that provided the stone for the cathedral.

Abbey of Vauclair—Ruins of an ancient abbey near Craonne on the D886.

Tourist Office
Place du Parvis de la Cathédrale. The tourist office arranges occasional tours of the cathedral that sometimes include a climb up the towers as well as an exploration of the second-story gallery. Phone 03 23 20 28 62.

Website
http://www.ville-laon.fr

204

NOYON

Noyon is a quiet small city with pleasant streets and shops in a rich farming region.

Location
Automobile: 104 km northeast of Paris on the N32.

Train: 1 hour 11 minutes by train from the Gard du Nord.

Parking
Free parking in front of the cathedral and in a parking lot to the northeast.

Museums and Other Points of Interest
Abbey of Ourscamp—5 km south of Noyon on the N32. Cistercian abbey begun in 1129; very powerful in the 17th and 18th centuries. Still a working abbey. There are ruins of a 13th-century Gothic church with just the rib structure of the ambulatory vaults still in place. Trees are planted in the grass to indicate where the piers of the nave would have stood.

Château Blérancourt—14 km southeast of Noyon on the D934. Contains the Museum of Franco-American Cooperation.

Tourist Office
Place Hôtel de Ville. Phone 03 44 44 21 88.

Website
http://www.noyon.com

REIMS

Reims is a historic city, the most important in the Champagne region. Famous for its food and champagne cellars, Reims is also lively and modern, with a wide variety of excellent restaurants, bistros, and cafés.

Location
Automobile: 144 km east of Paris on the A4.

Train: 1 hour 31 minutes direct train from the Gare de l'Est. Fifteen-minute walk to cathedral.

Parking

Paid parking very close to the cathedral.

Museums and Other Points of Interest

Basilica of Saint-Remi—See chapter on Reims for discussion of this beautiful Romanesque and Gothic church.

Museum of Saint-Remi—Next door to the basilica. Good collection of Roman and medieval objects from the city and surrounding area.

Cathedral Museum (Palais du Tau)—In the Bishop's Palace next to the cathedral. Contains some of the original sculpture from the exterior of the cathedral, including the Coronation of the Virgin, tapestries, and coronation robes. Do not miss the low row of gargoyles with black material along their backs and pouring through their mouths; this is the lead that melted off the roof during the bombardments of World War I.

Museum of Fine Arts (Musée des Beaux Arts)—Near the Cathedral. A nice provincial museum with a good survey of French painting and a very good collection of Flemish drawings by Cranach.

Tourist Office

2 rue G.-de-Machault, across from the southwest corner of the cathedral. Phone 03 26 77 45 25.

Website

http://www.tourisme.fr/reims

SENS

Dating back to Roman times, Sens is now a busy town with some lovely old houses and Gallo-Roman ramparts. The museum next to the cathedral is outstanding.

Location

Automobile: 117 km southeast of Paris on the A5 or N6.

Train: 53 minutes to 1 hour 22 minutes from the Gare de Lyon. Fifteen-minute walk to cathedral.

Parking

Paid parking near the cathedral.

Museums and Other Points of Interest

Musée et Palais Synodal—In Archbishop's Palace next to the cathedral. Wonderful museum with excellent collection of Gallo-Roman antiquities (mosaics, sculpture, tools, jewelry). Don't miss the bowl filled with ancient nails; it looks like a modern sculpture.

Tourist Office

Place J.-Jaurès. Phone 03 86 65 19 49.

Website

http://www.mairie-sens.fr

SOISSONS

Soissons suffered terrible devastation during the wars of 1870, 1914–1918 and 1939–1945. In addition to the cathedral many interesting monuments have been restored. The ruins of Saint-Jean-des-Vignes and the museum in the old Abbey of Saint-Léger are interesting, and there are several important abbeys in the nearby area.

Location

Automobile: 104 km northeast of Paris on the N2. ˋ

Train: 1 hour 5 minutes to 1 hour 24 minutes from the Gare du Nord. Twenty-minute walk to cathedral.

Parking

Free parking in front of the cathedral and nearby parking lot.

Museums and Other Points of Interest

Abbey of Saint-Jean-des-Vignes—Important medieval and Renaissance abbey built between 1076 and 1506. Largely destroyed in 1804. Impressive ruins and minor buildings including a refectory.

Museum of Saint-Léger (Musée de l'ancienne abbaye de Saint-Léger)—Lovely museum in ancient abbey that covers the history of Soissons from prehistoric times; painting and sculpture.

Church of Saint-Yved, Braine—About 18 km east of Soissons on the N31. A beautiful small abbey church that was very impor-

tant in the development of Gothic architecture. It is generally open only on Sundays.

Abbey of Longpont—About 16 km southwest of Soissons on the N2. The ruins of a very simple, beautiful Cistercian abbey (12th century) destroyed during the French Revolution. It is generally open only on Sundays.

Church of Notre-Dame, Morienval—About 40 km southwest of Soissons on the N2 (then the D32 and the D335). An 11th-century Romanesque church whose ambulatory was rebuilt 1130–1135. Possibly the earliest surviving use of ribbed vaults in French architecture. Get key to the church from a resident down the street, a charming woman who sells postcards and guidebooks to the church from her living-room window. (House number is posted on the church door.)

Tourist Office
16 Place Fernand-Marquigny. Phone 03 23 53 17 37.

Website
http://www.ville-soissons.fr

TROYES

Troyes was once the capital of the counts of Champagne and is one of the best preserved medieval cities in northern France. There are a number of fine churches, museums, and monuments in this city of narrow streets and timbered houses. On the outskirts of town are numerous factory outlets that attract shoppers from all over western Europe.

Location
Automobile: 171 km southeast of Paris on the A5.

Train: 1 hour 25 minutes to 1 hour 39 minutes from the Gare de l'Est. Twenty-minute walk to the cathedral.

Parking
Paid parking in front of the cathedral.

Museums and Other Points of Interest
Basilica of Saint-Urbain—One of the most important examples of Late Gothic Rayonnant style in France.

Church of Sainte-Madeleine—A spectacular collection of Renaissance stained-glass windows in the ambulatory with the Creation of the World and Adam and Eve, the Temptation and Expulsion, the Tree of Jesse, the Life of the Virgin, and the Legend of the Magdalen. Medieval choir screen (rood screen) still in place.

Museum of Modern Art (Musée d'Art Moderne)—An important private collection of 19th- and 20th-century paintings in the Bishop's Palace next to the cathedral. Noted especially for its group of Fauve works.

Tool Museum (Maison de l'Outil)—A large and fascinating display of woodworking tools and models for carpentry, the wine trade, etc. in a beautifully designed museum built in a 16th-century mansion.

Bonnet Museum (Musée de la Bonneterie)—Museum with a huge range of knitting and sewing machines from the important textile industry in Troyes.

Tourist Office
16 Blvd. Carnot near the train station. Phone 03 25 82 62 70. The postcard/book sellers in the various churches are also small outposts of the local tourist board.

A SUGGESTED ITINERARY

The following itinerary basically follows a chronological plan, although it is really not practical to be entirely consistent in this matter.

I suggest beginning a tour northeast of Paris in the Aisne River region. This has the benefit of seeing smaller, quieter, and more accessible Early Gothic cathedrals before tackling the great High Gothic masterworks of Reims, Bourges, Chartres, and Amiens. It also has the advantage of being close to Charles de Gaulle airport, where you can rent a car and be in a cathedral within an hour. This overall itinerary can be started at several places along the circuit.

Laon, Noyon, and Soissons

We begin our trip with the Early Gothic cathedral of Laon, one of the most lively and dramatic of all cathedrals. Here we see the four-story elevation typical of Early Gothic churches and one of the boldest façades in all Gothic architecture. Noyon is a quieter, smaller four-story church, and actually earlier than Laon. I start with Laon because its transparent beauty makes it easier to understand the ingenuity and elegance of early Gothic architecture. Noyon is more subdued and may not dazzle us the way that Laon and Soissons do. I save Soissons for the last of this portion of the trip because it is primarily a three-story High Gothic structure and gives us a chance to appreciate directly the step from Early Gothic to High Gothic. Of course, the four-story south transept is one of the true delights of all Gothic architecture, and we can compare it to the rounded transepts of Noyon. When in Soissons you should not fail to visit the ruins of the Abbey of Saint-Jean-des-Vignes, a short distance from the cathedral.

Reims, Troyes, and Sens

Reims is a lively city with many champagne cellars and fine restaurants. Before seeing the cathedral, you should visit the Basilica of Saint-Remi, which continues the Early Gothic part of the tour and gives you a chance to experience a wonderful Romanesque nave. Saint-Remi was an important predecessor to Reims Cathedral, and you can see the similarities in the treatment of the chapels and the windows. The adjacent museum is superb.

The Cathedral of Notre-Dame at Reims takes us into the monumental realm of High Gothic architecture, and while we may see some similarities with Soissons Cathedral, the scale and lavishness of decoration are of another order of magnitude. Reims is not an easy church to comprehend in a single visit, and I suggest you visit it at least twice. The Tau Museum next door with its sumptuous banquet hall and tapestries gives one a feeling for the great wealth and power associated with the coronation church of France.

Troyes, about an hour's drive directly south of Reims, is one of the most appealing cities in eastern France with many timbered buildings and interesting museums. Troyes Cathedral and the Basilica of Saint-Urbain give us a chance to appreciate the delicate linear Rayonnant style that began in Troyes and around Paris in the 1220s. The small

Church of Sainte-Madeleine has a wonderful choir screen and some of the finest Renaissance stained glass in France.

You can leave Troyes in the morning, visit the cathedral at Sens, have lunch, and be in Bourges by late afternoon. Begun in the 1140s, Sens is the first completely Gothic church and was an important model for later cathedrals.

Bourges, Chartres, Beauvais, and Amiens

Bourges is one of the great masterworks of Western architecture, and I recommend you spend at least two nights in Bourges to give yourself time to appreciate fully both the spectacular architecture and the stained glass. Begun within a year of Chartres and on the same monumental scale, Bourges is completely different from its more famous rival. As with no other cathedral, we are able to appreciate the whole of the great church in a single glance, whether on the interior or exterior. The city of Bourges is an active university town with numerous other medieval monuments worth visiting.

Chartres Cathedral holds a special place in Western civilization. Its stained glass and sculpture come down to us much as they were during the Middle Ages. For pilgrims all over the world Chartres Cathedral is the pre-eminent Gothic cathedral, and its beauty and meaning stay in our memory for a lifetime.

It is possible to drive from Chartres to Beauvais for lunch, see the cathedral and Saint-Étienne, and be in Amiens for dinner. The tallest of all of the cathedrals, Beauvais is a remarkable sight, and the small church of Saint-Étienne has magnificent Renaissance stained glass comparable to that in Troyes at the Church of Sainte-Madeleine.

Amiens is a spectacular High Gothic conclusion to our clockwise tour around Paris. Its great verticality is combined with an overall balance and refinement of detail that make it one of the supreme achievements in world architecture. It is a fitting place to see all the elements of Gothic architecture brought together.

Paris — Notre-Dame, Saint-Denis, and The Sainte-Chapelle

I have left the churches of Paris at the end of the tour for practical as well as aesthetic reasons. In Paris we see both the very beginning and the culmination of the story of Gothic architecture. At Saint-Denis, we see the precocious beginning of the new Gothic style with Abbot Suger's ambulatory as well as the great Rayonnant nave and choir built one hundred years later. At Notre-Dame we see the first great leap into Gothic monumentality. The exquisite Sainte-Chapelle brings us to the Rayonnant style, where we can appreciate how diaphanous this initially sturdy architecture has become.

GLOSSARY

Abacus – A flat slab or shelf at the top of a capital.

Ambulatory – An aisle around the curved part of the choir. The aisle along the straight part of the choir is referred to as an aisle, not an ambulatory. Don't ask me why.

Apse – The round end of a church beyond the choir, sometimes called the **chevet**.

Arcade – A series of arches. A blind arcade is a row of arches set against the wall as decoration. Often used as the decorative base of a wall. Also called a dado. Sometimes, as at Notre-Dame in Paris, it is a row of open lancets forming a balcony.

Archivolt – A decorative band around an arch made up of individual blocks called voussoirs. Often decorated with figures in the arch of an entry portal.

Attached or Engaged – An attached column, colonnette, or shaft is one that is or appears to be embedded in a wall or on another column or pier.

Bar Tracery – See **Tracery**.

Barrel Vault – A continuous vault of semi-circular sections; also called a tunnel vault. Romanesque churches used the barrel vault.

Basilica – A large rectangular building with a central aisle and two side aisles, often with an apse on the eastern end. Originally a Roman assembly hall; now the term is used more flexibly. Saint-Denis is called a basilica even though it has the traditional cruciform shape of a Christian church.

Bay – In Gothic architecture usually a single opening of an arcade and the upper stories. In Early Gothic architecture a bay consisted of arch, gallery, triforium, and clerestory. See frontispiece. A bay is usually defined by one vaulting unit, so that a six-part vault would have two arches on the ground-floor arcade.

Buttress – Usually a rectangular support against a wall to provide support and counteract the thrust of the vaults. In Gothic architecture the external buttress rose above the lower aisle wall to support the upper stories by means of an exposed arch or **flying buttress** that reached across from the buttressing pier to the external clerestory wall. See frontispiece. Sometimes referred to as a **flyer**, it is essentially an exposed or external supportive arch.

Capital – The top of a column or pier, usually designed to support the arches and ribs supported by the column.

Chevet – From the French word for pillow. The head of the church. Also called the **apse**. If a Latin-cross church is the shape of a cross, the chevet is where Christ would have rested His head.

Choir – Reserved for the clergy and choir, usually the central space of the eastern end of the church.

Compound Pier – A pier or column with attached shafts usually arranged to support arches and ribs.

Crossing – The space at the intersection of the nave and choir and the two transept

arms. Sometimes the entire transept is referred to as the crossing. In this book it is used to describe only the central space, while the term transept or transept arm is used to describe the aisle or aisles at right angles to the nave and choir.

Crypt – A space beneath the church for relics and tombs, usually vaulted.

Elevation – The face of a building or a drawing of any one face, exterior or interior. The nave elevation at Laon consists of the stories of the wall: nave arcade, gallery, triforium, and clerestory. See frontispiece.

Flamboyant – Also called Late Gothic style. Flamboyant takes its name from the flame-like patterns of design, particularly in windows.

Flying Buttress or Flyer – see **Buttress.**

Foliated – A leaf-like pattern or design. The stringcourse at Amiens is a famous example of foliated decoration.

Frieze – A decorative band of painting or sculpture.

Gable – The triangular area at the top of a portal, façade, or wall. The chevet at Amiens and the north and south façades at Notre-Dame in Paris are crowned with gables.

Gallery – A series of openings in an upper wall, creating an arcade. At Notre-Dame in Paris and Noyon the gallery is above the nave arcade. The term is sometimes used to describe a row of figures, such as the Gallery of Kings on the façade of Notre-Dame in Paris.

Groin Vault – When two barrel vaults are joined at right angles, the result is a groin vault. The groin is the diagonal seam formed at the intersection of the two barrel vaults. In Gothic architecture the groin vault was replaced by the ribbed vault.

Hemicycle – The half circle of columns or piers at the head of the choir.

Lancet – A slender pointed arch shaped like a lance. Used to describe windows or portions of windows. At Chartres the clerestory windows of each bay have two lancets and an **oculus.**

Lantern – An additional story above the crossing, often beneath a tower, designed to allow light into the central part of the building.

Lintel – Originally the beam across an entry. In Gothic architecture a lintel can also be the horizontal area or **frieze** at the base of the **tympanum.**

Mullion – A slender shaft or colonnette used to divide a window. In Rayonnant architecture the clerestory mullion was brought down into the triforium to connect the two elements visually.

Narthex – A porch, interior vestibule, or entry. At Saint-Denis the narthex is in the west end between the façade and the nave.

Oculus – Simply a round window opening. At Chartres the aisle windows are topped by an oculus. A **rose** or **rosette** window may also be called an oculus. An oculus may be plain or have three or four petals in the shape of a **trefoil** or **quatrefoil.**

Pier – A rectangular vertical support usually with its own base and capital.

Pilaster – A flattened pier placed against a pier, column, or wall. The western side of the transepts at Notre-Dame in Paris use pilasters.

Pilier Cantonné – A column or pier with attached shafts rising from the base. The Chartres pier is a pilier cantonné.

Plate Tracery – See **Tracery.**

Portal – A term reserved for a major entrance, as opposed to a door.

Portico – A small porch-like structure. At Laon the towers have porticoes on the corners.

Quatrefoil – An opening or design with four lobes or petals. A **trefoil** has three lobes.

Rayonnant – An architectural style begun in the 1220s and 1230s around Paris and in Troyes. The development of bar tracery and the glazing of the triforium were translated into an elegant, linear style that was applied to the entire building, which avoided the three-dimensional features of High Gothic architecture. The term "Rayonnant" was adopted by archeologists of the nineteenth century and based on the radiating form of rose windows, considered emblematic of the style.

Rib – A slender arch used in vaults to support the surface of the vault. The *longitudinal rib* spans the sides of the vault along a wall. The *transverse rib* spans the ends of the vault across the aisle or nave. This may also be called the transverse arch. The *diagonal rib* reaches from one corner to another diagonally across the vault and was crucial to the development of Gothic architecture.

Rose Window – A large round window, usually at the top of a façade, with radial patterns.

Rosette – A small round window.

Spandrel – The triangular wall surface in the corner above an arch. See frontispiece.

Springing – The point from which an arch or rib rises from its support. See frontispiece. Nave vaults typically spring from a supporting pier or colonnette at the base or in the middle of the clerestory.

Stringcourse – A unbroken horizontal molding that marks the division between stories. At Amiens the **foliated stringcourse** divides the arcade and the triforium.

Tracery – Stonework that creates a decorative pattern in windows and wall surfaces. *Plate tracery* is not really tracery but openings in the walls to create windows such as the aisle windows at Chartres. In the 1220s, builders began to design windows in which the patterns, *bar tracery*, were created by using separate stone shafts to divide the window spaces. This tracery is separate rather than part of the wall structure as at Chartres. Good examples of bar tracery may be seen at Amiens, Reims, Saint-Denis, and Troyes.

Trefoil – A three-lobe or petal design.

Transept – The arm that crosses between the nave and choir at right angles. The **crossing** refers just to that area at the intersection of the main axis of the church and the transept arms. *Transept arms* – The portion of the transept that extends from the crossing to the transept façades at right angles to the nave and choir.

Triforium – An arcaded wall passage below the clerestory. In Early Gothic churches the triforium is between the gallery and the clerestory. In High Gothic churches it is between the arcade and clerestory.

Trumeau – The central post of a doorway.

Tympanum – The triangular area at the top of a portal between the lintel and the arch above it.

Vault – An arched ceiling. A *barrel vault* is a half-cylindrical vault, also called a tunnel vault. Romanesque churches used the barrel vault. A barrel vault may be round or pointed. A *rib vault* is a vault comprised of slender, diagonal arches or ribs that provide support for the webbing or cells of the vault. See line drawings fig. 7.

SUGGESTED READING

Adams, Henry, *Mont-Saint-Michel and Chartres*, New York: G.P. Putnam's Sons, 1980. Written at the beginning of the twentieth century, Adams's classic is still one of the most evocative and interesting books on medieval architecture.

Bony, Jean, *French Gothic Architecture in the 12th and 13th Centuries*, Berkeley, Calif.: University of California Press, 1983. Bony's masterwork is an indispensable guide to the rise and flowering of Gothic architecture, and his descriptions of Gothic space are unsurpassed.

Cantor, Norman F., *The Civilization of the Middle Ages*, New York: HarperCollins, 1993. This is a superb narrative overview of medieval history. Cantor's emphasis on social, intellectual, and religious developments, rather than political and military events, demonstrates how the Middle Ages became the foundation for Western civilization.

Erlain-Brandenburg, Alain, *Notre-Dame de Paris*, John Goodman, trans., New York: Harry N. Abrams, Inc., 1998. A beautiful history of this great cathedral with marvelous photographs by Carolyn Rose.

Mark, Robert, *Experiments in Gothic Structure*, Cambridge, Mass.: MIT Press, 1982. For the more technically minded, Mark's book is a fascinating exploration of the structural forces at play in Gothic cathedrals.

Medieval France, An Encyclopedia, Kibler, William W. and Zinn, Grover A., editors, New York: Garland Publishing, Inc., 1995. This hefty encyclopedia is an invaluable companion to the study of the Middle Ages with scholarly yet accessible articles on almost every aspect of medieval art and life.

Miller, Malcolm, *Chartres Cathedral*, Andover, Hampshire, U.K.: Pitkin Unichrome, 2000. Malcolm Miller has been guiding pilgrims through Chartres Cathedral over forty years. His recently revised book gives us a clear understanding of the stained glass and sculpture of the cathedral as well as its architectural history. The photographs by Sonia Halliday and Laura Lushington are outstanding.

Platt, Polly, *Savoir Flair, 211 Tips for Enjoying France and the French*, London: Culture Crossings, Ltd., 2000. A humorous and practical guide that contains helpful suggestions on almost every aspect of traveling in France.

Stoddard, Whitney S., *Art and Architecture in Medieval France*, New York: Icon Editions, Harper and Row, 1966. Professor Stoddard's general history is still one of the most enjoyable companions to the full range of medieval art and architecture.

Trachtenberg, Marvin, and Hyman, Isabel, *Architecture, From Pre-History to Post-Modernism*, New York: Harry N. Abrams, Inc., 1986. This is a splendid survey of all architecture by two pre-eminent architectural historians. Marvin Trachtenberg's chapters on Romanesque and Gothic architecture are vivid explanations of the development and great accomplishments of medieval architecture. His use of language is unsurpassed in capturing the artistic and structural essence of these great buildings.

NOTES

INTRODUCTION

1. Trachtenberg, Marvin, and Hyman, Isabel, *Architecture, From Pre-History to Post-Modernism*, (New York: Harry N. Abrams, Inc., 1986), p. 225.
2. Focillon, Henri, *Art of the West in the Middle Ages, Volume II, Gothic Art* (Oxford: Phaidon Press, Ltd., 1963), page 3.
3. Trachtenberg and Hyman, p. 225.
4. Branner, Robert, *Gothic Architecture* (New York: George Braziller, Inc., 1963), p. 17.
5. Stoddard, Whitney S., *Art and Architecture in Medieval France* (New York: Icon Editions, Harper and Row, 1966), p. 5.
6. Bony, Jean, *French Gothic Architecture in the 12th and 13th Centuries* (Berkeley: University of Califonria Press, 1983), p. 17; Stoddard, p. 10.
7. Branner, Robert, *Saint Louis and the Court Style in Gothic Architecture* (London: A. Zwemmer Ltd., 1965), p. 1.
8. Huizinga, Johan, *The Autumn of the Middle Ages*, Rodney J. Payton and Ulrich Mammitzsch, trans. (Chicago: The University of Chicago Press, 1996), p. 1.
9. Von Simpson, Otto, *The Gothic Cathedral* (New York: Pantheon Books, 1965), p. xviii.
10. Bony, pp. 51-52.
11. Trachtenberg and Hyman, p. 227.
12. Murray, Stephen, "Notre-Dame of Paris and the Anticipation of Gothic," *Art Bulletin*, Vol. LXXX, No. 2, June 1998, pp. 229-253.
13. Branner, *Gothic Architecture*, p. 27.
14. Bony, p. 49.
15. Bony, pp. 57-58.
16. Bony, p. 32.
17. Branner, *Gothic Architecture*, p. 24.
18. Bony, p. 131.
19. Trachtenberg and Hyman, p. 259.
20. Mark, Robert, *Experiments in Gothic Structure* (Cambridge, Mass., MIT Press, 1982), p. 99.
21. Bony, 357-358.

AMIENS

1. Murray, Stephen, *Notre-Dame, Cathedral of Amiens* (Cambridge: Cambridge University Press, 1996), p. 57.
2. Murray, *Amiens*, pp. 13-14.
3. Trachtenberg and Hyman, p. 241.
4. Murray, *Amiens*, p. 193, n. 4.
5. Murray, *Amiens*, p. 168.
6. Murray, *Amiens*, p. 101.
7. Murray, *Amiens*, p. 102.
8. Bony, p. 280.
9. Bony, p. 397.

BEAUVAIS

1. Murray, Stephen, *Beauvais Cathedral, Architecture of Transcendence* (Princeton, N.J.: Princeton University Press, 1989), p. 121.
2. Murray, *Beauvais*, p. 29.
3. Mark, *Gothic Structure*, pp. 70–75.
4. Murray, *Beauvais*, p. 151, also pp. 112–120.
5. Bony, p. 293.
6. Murray, *Beauvais*, p. 17.
7. Murray, *Beauvais*, p. 18.
8. Murray, *Beauvais*, p. 150.

BOURGES

1. Branner, Robert, *The Cathedral of Bourges and its Place in Gothic Architecture* (Cambridge, Mass.: MIT Press, 1989), pp. 201-205.
2. Bony, p. 220.
3. Stoddard, p. 223.
4. Bony, p. 220.
5. Quoted in *France, A Phaidon Cultural Guide* (Oxford: Phaidon Press, Ltd., 1985), p. 118.

CHARTRES

1. Bony, p. 239.
2. Bony, p. 233.
3. Branner, *Bourges*, p. 177.
4. Trachtenberg and Hyman, p. 238.
5. Mark, p. 41.
6. Hollengreen, Lauren, "Cathedral and Cloister, Imagery and Audiences, The Case of Chartres," (New York City: College Art Association Meeting, February 2000).
7. Adams, Henry, *Mont-Saint-Michel and Chartres* (New York: G.P. Putnam's Sons, 1980), p. 47.
8. Miller, Malcolm, *Chartres Cathedral*, (London:

Pitkin Pictorials, 1985), pp. 30-40.

9. Miller, pp. 75-77.

LAON

1. Trachtenberg and Hyman, p. 241.
2. Scully, Vincent, *Architecture, The Natural and the Manmade* (New York: St. Martin's Press, 1991), p. 141.
3. Bony, p. 141.
4. Grodecki, Louis, *Gothic Architecture* (New York: Harry N. Abrams, Inc., 1976), p. 32.

NOYON

1. Seymour, Charles, Jr., *Notre-Dame of Noyon in the Twelfth Century* (New York: W.W. Norton, Inc., 1968), p. 1.
2. Stoddard, p. 122.
3. Bony, p. 110.
4. Bony, pp. 166-172.
5. Bony, p. 125.

PARIS, NOTRE-DAME

1. Erlain-Brandenburg, Alain, *Notre-Dame de Paris*, John Goodman, trans., (New York: Harry N. Abrams, Inc., 1998), p. 46.
2. *Medieval France, An Encyclopedia*, William W. Kibler and Grover A. Zinn, eds. (New York: Garland Publishing, Inc., 1995), p. 701.
3. Murray, "Notre-Dame of Paris," p. 229-253.
4. Erlain-Brandenburg, p. 153.
5. Bony, p. 137.
6. Trachtenberg and Hyman, p. 235.
7. Bony, pp. 202-203.
8. *Medieval France, An Encyclopedia*, p. 702.
9. Aubert, Marcel, *Gothic Cathedrals of France and Their Treasures* (London: Nicholas Kaye Ltd., 1959), p. 49.
10. Erlain-Brandenburg, pp. 158-161.
11. Erlain-Brandenburg, pp. 165-167.

PARIS, THE SAINTE-CHAPELLE

1. Trachtenberg and Hyman, p. 246.
2. Branner, *The Court Style*, p. 57.

PARIS, ROYAL ABBEY OF SAINT-DENIS

1. Scully. pp. 129-30.

2. Scully, p. 130.
3. Trachtenberg and Hyman, p. 230.
4. Stoddard, p. 108.
5. Bruzelius, Caroline Astrid, *The 13th-Century Church at St-Denis* (New Haven: Yale University Press, 1985), pp. 34-36.
6. Bruzelius, p. 35.

REIMS

1. Murray, *Beauvais*, p. 4.
2. Bony p. 275.
3. Bony p. 270.
4. Trachtenberg and Hyman, p. 238.
5. Bony, p. 401.

SOISSONS

1. *Michelin Illustrated Guide to the Battlefields, Soissons, Before and During the War* (Clermont-Ferrand: Michelin & Cie, 1919), p. 24.
2. Bony, p. 13, fig. 11. A striking photograph from above of the rebuilding of the nave vaults.
3. Bony, pp. 172-175.
4. Stoddard, p. 193.
5. Bony, p. 134.

TROYES

1. Stoddard p. 295.
2. Murray, Stephen, *Building Troyes Cathedral, The Late Gothic Campaigns* (Bloomington: Indiana University Press, 1987), p. 6.
3. Murray, *Troyes*, pp. 3-4.
4. Murray, *Troyes*, pp. 56-57.

READING STAINED-GLASS WINDOWS

1. Quoted in Stoddard, pp. 266-267.
2. Hayward, Jane, *The Year 1200*, Vol. II, Florens Deuchler, ed., (New York: The Metropolitan Museum of Art, 1970), pp. 67-68.
3. *Medieval France, An Encyclopedia*, p. 889.
4. Hayward, p. 70.
5. Brown, Sarah and O'Connor, David, *Medieval Craftsmen, The Glass Painters* (Toronto: University of Toronto Press, 1991), p. 48.
6. Hayward, p. 71.